T0055002

Beauty: A Very Short Introduction

VERY SHORT INTRODUCTIONS are for anyone wanting a stimulating and accessible way into a new subject. They are written by experts, and have been translated into more than 45 different languages.

The series began in 1995, and now covers a wide variety of topics in every discipline. The VSI library now contains over 500 volumes—a Very Short Introduction to everything from Psychology and Philosophy of Science to American History and Relativity—and continues to grow in every subject area.

Titles in the series include the following:

AFRICAN HISTORY John Parker and
 Richard Rathbone
AGEING Nancy A. Pachana
AGNOSTICISM Robin Le Poidevin
AGRICULTURE Paul Brassley and
 Richard Soffe
ALEXANDER THE GREAT
 Hugh Bowden
ALGEBRA Peter M. Higgins
AMERICAN HISTORY Paul S. Boyer
AMERICAN IMMIGRATION
 David A. Gerber
AMERICAN LEGAL HISTORY
 G. Edward White
AMERICAN POLITICAL
 HISTORY Donald Critchlow
AMERICAN POLITICAL PARTIES
 AND ELECTIONS L. Sandy Maisel
AMERICAN POLITICS
 Richard M. Valelly
THE AMERICAN PRESIDENCY
 Charles O. Jones
AMERICAN SLAVERY
 Heather Andrea Williams
THE AMERICAN WEST Stephen Aron
AMERICAN WOMEN'S HISTORY
 Susan Ware
ANAESTHESIA Aidan O'Donnell
ANARCHISM Colin Ward
ANCIENT EGYPT Ian Shaw
ANCIENT GREECE Paul Cartledge
THE ANCIENT NEAR EAST
 Amanda H. Podany
ANCIENT PHILOSOPHY Julia Annas

ANCIENT WARFARE Harry Sidebottom
ANGLICANISM Mark Chapman
THE ANGLO-SAXON AGE John Blair
ANIMAL BEHAVIOUR
 Tristram D. Wyatt
ANIMAL RIGHTS David DeGrazia
ANXIETY Daniel Freeman and
 Jason Freeman
ARCHAEOLOGY Paul Bahn
ARISTOTLE Jonathan Barnes
ART HISTORY Dana Arnold
ART THEORY Cynthia Freeland
ASTROPHYSICS James Binney
ATHEISM Julian Baggini
THE ATMOSPHERE Paul I. Palmer
AUGUSTINE Henry Chadwick
THE AZTECS David Carrasco
BABYLONIA Trevor Bryce
BACTERIA Sebastian G. B. Amyes
BANKING John Goddard and
 John O. S. Wilson
BARTHES Jonathan Culler
BEAUTY Roger Scruton
THE BIBLE John Riches
BLACK HOLES Katherine Blundell
BLOOD Chris Cooper
THE BODY Chris Shilling
THE BOOK OF MORMON
 Terryl Givens
BORDERS Alexander C. Diener and
 Joshua Hagen
THE BRAIN Michael O'Shea
THE BRICS Andrew F. Cooper
BRITISH POLITICS Anthony Wright

BUDDHA Michael Carrithers
BUDDHISM Damien Keown
BUDDHIST ETHICS Damien Keown
BYZANTIUM Peter Sarris
CANCER Nicholas James
CAPITALISM James Fulcher
CATHOLICISM Gerald O'Collins
CAUSATION Stephen Mumford and
 Rani Lill Anjum
THE CELL Terence Allen and
 Graham Cowling
THE CELTS Barry Cunliffe
CHEMISTRY Peter Atkins
CHILD PSYCHOLOGY Usha Goswami
CHINESE LITERATURE Sabina Knight
CHOICE THEORY Michael Allingham
CHRISTIAN ART Beth Williamson
CHRISTIAN ETHICS D. Stephen Long
CHRISTIANITY Linda Woodhead
CIRCADIAN RHYTHMS Russell Foster
 and Leon Kreitzman
CITIZENSHIP Richard Bellamy
CLASSICAL MYTHOLOGY
 Helen Morales
CLASSICS Mary Beard and
 John Henderson
CLIMATE Mark Maslin
CLIMATE CHANGE Mark Maslin
COGNITIVE NEUROSCIENCE
 Richard Passingham
THE COLD WAR Robert McMahon
COLONIAL AMERICA Alan Taylor
COLONIAL LATIN AMERICAN
 LITERATURE Rolena Adorno
COMBINATORICS Robin Wilson
COMMUNISM Leslie Holmes
COMPLEXITY John H. Holland
THE COMPUTER Darrel Ince
COMPUTER SCIENCE Subrata Dasgupta
CONFUCIANISM Daniel K. Gardner
CONSCIOUSNESS Susan Blackmore
CONTEMPORARY ART
 Julian Stallabrass
CONTEMPORARY FICTION
 Robert Eaglestone
CONTINENTAL PHILOSOPHY
 Simon Critchley
CORAL REEFS Charles Sheppard
CORPORATE SOCIAL
 RESPONSIBILITY Jeremy Moon

COSMOLOGY Peter Coles
CRIMINAL JUSTICE Julian V. Roberts
CRITICAL THEORY
 Stephen Eric Bronner
THE CRUSADES Christopher Tyerman
CRYSTALLOGRAPHY A. M. Glazer
DADA AND SURREALISM
 David Hopkins
DANTE Peter Hainsworth and
 David Robey
DARWIN Jonathan Howard
THE DEAD SEA SCROLLS Timothy Lim
DECOLONIZATION Dane Kennedy
DEMOCRACY Bernard Crick
DEPRESSION Jan Scott and
 Mary Jane Tacchi
DERRIDA Simon Glendinning
DESIGN John Heskett
DEVELOPMENTAL BIOLOGY
 Lewis Wolpert
DIASPORA Kevin Kenny
DINOSAURS David Norman
DREAMING J. Allan Hobson
DRUGS Les Iversen
DRUIDS Barry Cunliffe
THE EARTH Martin Redfern
EARTH SYSTEM SCIENCE Tim Lenton
ECONOMICS Partha Dasgupta
EGYPTIAN MYTH Geraldine Pinch
EIGHTEENTH-CENTURY BRITAIN
 Paul Langford
THE ELEMENTS Philip Ball
EMOTION Dylan Evans
EMPIRE Stephen Howe
ENGLISH LITERATURE Jonathan Bate
THE ENLIGHTENMENT
 John Robertson
ENVIRONMENTAL
 ECONOMICS Stephen Smith
ENVIRONMENTAL
 POLITICS Andrew Dobson
EPICUREANISM Catherine Wilson
EPIDEMIOLOGY Rodolfo Saracci
ETHICS Simon Blackburn
THE ETRUSCANS Christopher Smith
EUGENICS Philippa Levine
THE EUROPEAN UNION John Pinder
 and Simon Usherwood
EVOLUTION Brian and
 Deborah Charlesworth

EXISTENTIALISM Thomas Flynn
THE EYE Michael Land
FAMILY LAW Jonathan Herring
FASCISM Kevin Passmore
FEMINISM Margaret Walters
FILM Michael Wood
FILM MUSIC Kathryn Kalinak
THE FIRST WORLD WAR
 Michael Howard
FOOD John Krebs
FORENSIC PSYCHOLOGY David Canter
FORENSIC SCIENCE Jim Fraser
FORESTS Jaboury Ghazoul
FOSSILS Keith Thomson
FOUCAULT Gary Gutting
FREE SPEECH Nigel Warburton
FREE WILL Thomas Pink
FREUD Anthony Storr
FUNDAMENTALISM Malise Ruthven
FUNGI Nicholas P. Money
THE FUTURE Jennifer M. Gidley
GALAXIES John Gribbin
GALILEO Stillman Drake
GAME THEORY Ken Binmore
GANDHI Bhikhu Parekh
GEOGRAPHY John Matthews and
 David Herbert
GEOPOLITICS Klaus Dodds
GERMAN LITERATURE Nicholas Boyle
GERMAN PHILOSOPHY Andrew Bowie
GLOBAL CATASTROPHES Bill McGuire
GLOBAL ECONOMIC HISTORY
 Robert C. Allen
GLOBALIZATION Manfred Steger
GOD John Bowker
GRAVITY Timothy Clifton
THE GREAT DEPRESSION AND THE
 NEW DEAL Eric Rauchway
HABERMAS James Gordon Finlayson
THE HEBREW BIBLE AS LITERATURE
 Tod Linafelt
HEGEL Peter Singer
HERODOTUS Jennifer T. Roberts
HIEROGLYPHS Penelope Wilson
HINDUISM Kim Knott
HISTORY John H. Arnold
THE HISTORY OF ASTRONOMY
 Michael Hoskin
THE HISTORY OF CHEMISTRY
 William H. Brock

THE HISTORY OF LIFE
 Michael Benton
THE HISTORY OF MATHEMATICS
 Jacqueline Stedall
THE HISTORY OF MEDICINE
 William Bynum
THE HISTORY OF TIME
 Leofranc Holford-Strevens
HIV AND AIDS Alan Whiteside
HOLLYWOOD Peter Decherney
HUMAN ANATOMY
 Leslie Klenerman
HUMAN EVOLUTION Bernard Wood
HUMAN RIGHTS Andrew Clapham
THE ICE AGE Jamie Woodward
IDEOLOGY Michael Freeden
INDIAN PHILOSOPHY Sue Hamilton
THE INDUSTRIAL REVOLUTION
 Robert C. Allen
INFECTIOUS DISEASE Marta L. Wayne
 and Benjamin M. Bolker
INFINITY Ian Stewart
INFORMATION Luciano Floridi
INNOVATION Mark Dodgson and
 David Gann
INTELLIGENCE Ian J. Deary
INTERNATIONAL
 MIGRATION Khalid Koser
INTERNATIONAL RELATIONS
 Paul Wilkinson
IRAN Ali M. Ansari
ISLAM Malise Ruthven
ISLAMIC HISTORY Adam Silverstein
ISOTOPES Rob Ellam
ITALIAN LITERATURE
 Peter Hainsworth and David Robey
JESUS Richard Bauckham
JOURNALISM Ian Hargreaves
JUDAISM Norman Solomon
JUNG Anthony Stevens
KABBALAH Joseph Dan
KANT Roger Scruton
KNOWLEDGE Jennifer Nagel
THE KORAN Michael Cook
LATE ANTIQUITY Gillian Clark
LAW Raymond Wacks
THE LAWS OF THERMODYNAMICS
 Peter Atkins
LEADERSHIP Keith Grint
LEARNING Mark Haselgrove

LEIBNIZ Maria Rosa Antognazza
LIBERALISM Michael Freeden
LIGHT Ian Walmsley
LINGUISTICS Peter Matthews
LITERARY THEORY Jonathan Culler
LOCKE John Dunn
LOGIC Graham Priest
MACHIAVELLI Quentin Skinner
MAGIC Owen Davies
MAGNA CARTA Nicholas Vincent
MAGNETISM Stephen Blundell
MARINE BIOLOGY Philip V. Mladenov
MARTIN LUTHER Scott H. Hendrix
MARTYRDOM Jolyon Mitchell
MARX Peter Singer
MATERIALS Christopher Hall
MATHEMATICS Timothy Gowers
THE MEANING OF LIFE
 Terry Eagleton
MEASUREMENT David Hand
MEDICAL ETHICS Tony Hope
MEDIEVAL BRITAIN John Gillingham
 and Ralph A. Griffiths
MEDIEVAL LITERATURE
 Elaine Treharne
MEDIEVAL PHILOSOPHY
 John Marenbon
MEMORY Jonathan K. Foster
METAPHYSICS Stephen Mumford
MICROBIOLOGY Nicholas P. Money
MICROECONOMICS Avinash Dixit
MICROSCOPY Terence Allen
THE MIDDLE AGES Miri Rubin
MILITARY JUSTICE Eugene R. Fidell
MINERALS David Vaughan
MODERN ART David Cottington
MODERN CHINA Rana Mitter
MODERN FRANCE
 Vanessa R. Schwartz
MODERN IRELAND Senia Pašeta
MODERN ITALY Anna Cento Bull
MODERN JAPAN
 Christopher Goto-Jones
MODERNISM Christopher Butler
MOLECULAR BIOLOGY Aysha Divan
 and Janice A. Royds
MOLECULES Philip Ball
MOONS David A. Rothery
MOUNTAINS Martin F. Price
MUHAMMAD Jonathan A. C. Brown

MUSIC Nicholas Cook
MYTH Robert A. Segal
THE NAPOLEONIC WARS
 Mike Rapport
NELSON MANDELA Elleke Boehmer
NEOLIBERALISM Manfred Steger and
 Ravi Roy
NEWTON Robert Iliffe
NIETZSCHE Michael Tanner
NINETEENTH-CENTURY BRITAIN
 Christopher Harvie and
 H. C. G. Matthew
NORTH AMERICAN INDIANS
 Theda Perdue and Michael D. Green
NORTHERN IRELAND
 Marc Mulholland
NOTHING Frank Close
NUCLEAR PHYSICS Frank Close
NUMBERS Peter M. Higgins
NUTRITION David A. Bender
THE OLD TESTAMENT
 Michael D. Coogan
ORGANIC CHEMISTRY
 Graham Patrick
THE PALESTINIAN-ISRAELI
 CONFLICT Martin Bunton
PANDEMICS Christian W. McMillen
PARTICLE PHYSICS Frank Close
THE PERIODIC TABLE Eric R. Scerri
PHILOSOPHY Edward Craig
PHILOSOPHY IN THE ISLAMIC
 WORLD Peter Adamson
PHILOSOPHY OF LAW
 Raymond Wacks
PHILOSOPHY OF SCIENCE
 Samir Okasha
PHOTOGRAPHY Steve Edwards
PHYSICAL CHEMISTRY Peter Atkins
PILGRIMAGE Ian Reader
PLAGUE Paul Slack
PLANETS David A. Rothery
PLANTS Timothy Walker
PLATE TECTONICS Peter Molnar
PLATO Julia Annas
POLITICAL PHILOSOPHY
 David Miller
POLITICS Kenneth Minogue
POPULISM Cas Mudde and
 Cristóbal Rovira Kaltwasser
POSTCOLONIALISM Robert Young

POSTMODERNISM Christopher Butler
POSTSTRUCTURALISM
 Catherine Belsey
PREHISTORY Chris Gosden
PRESOCRATIC PHILOSOPHY
 Catherine Osborne
PRIVACY Raymond Wacks
PSYCHIATRY Tom Burns
PSYCHOLOGY Gillian Butler and
 Freda McManus
PSYCHOTHERAPY Tom Burns and
 Eva Burns-Lundgren
PUBLIC ADMINISTRATION
 Stella Z. Theodoulou and Ravi K. Roy
PUBLIC HEALTH Virginia Berridge
QUANTUM THEORY
 John Polkinghorne
RACISM Ali Rattansi
REALITY Jan Westerhoff
THE REFORMATION Peter Marshall
RELATIVITY Russell Stannard
RELIGION IN AMERICA Timothy Beal
THE RENAISSANCE Jerry Brotton
RENAISSANCE ART
 Geraldine A. Johnson
REVOLUTIONS Jack A. Goldstone
RHETORIC Richard Toye
RISK Baruch Fischhoff and John Kadvany
RITUAL Barry Stephenson
RIVERS Nick Middleton
ROBOTICS Alan Winfield
ROMAN BRITAIN Peter Salway
THE ROMAN EMPIRE Christopher Kelly
THE ROMAN REPUBLIC
 David M. Gwynn
RUSSIAN HISTORY Geoffrey Hosking
RUSSIAN LITERATURE Catriona Kelly
THE RUSSIAN REVOLUTION
 S. A. Smith
SAVANNAS Peter A. Furley
SCHIZOPHRENIA Chris Frith and
 Eve Johnstone
SCIENCE AND RELIGION
 Thomas Dixon
THE SCIENTIFIC REVOLUTION
 Lawrence M. Principe
SCOTLAND Rab Houston
SEXUALITY Véronique Mottier
SHAKESPEARE'S COMEDIES Bart van Es

SIKHISM Eleanor Nesbitt
SLEEP Steven W. Lockley and
 Russell G. Foster
SOCIAL AND CULTURAL
 ANTHROPOLOGY
 John Monaghan and Peter Just
SOCIAL PSYCHOLOGY Richard J. Crisp
SOCIAL WORK Sally Holland and
 Jonathan Scourfield
SOCIALISM Michael Newman
SOCIOLOGY Steve Bruce
SOCRATES C. C. W. Taylor
SOUND Mike Goldsmith
THE SOVIET UNION Stephen Lovell
THE SPANISH CIVIL WAR
 Helen Graham
SPANISH LITERATURE Jo Labanyi
SPORT Mike Cronin
STARS Andrew King
STATISTICS David J. Hand
STUART BRITAIN John Morrill
SYMMETRY Ian Stewart
TAXATION Stephen Smith
TELESCOPES Geoff Cottrell
TERRORISM Charles Townshend
THEOLOGY David F. Ford
TIBETAN BUDDHISM
 Matthew T. Kapstein
THE TROJAN WAR Eric H. Cline
THE TUDORS John Guy
TWENTIETH-CENTURY BRITAIN
 Kenneth O. Morgan
THE UNITED NATIONS
 Jussi M. Hanhimäki
THE U.S. CONGRESS Donald A. Ritchie
THE U.S. SUPREME COURT
 Linda Greenhouse
THE VIKINGS Julian Richards
VIRUSES Dorothy H. Crawford
VOLTAIRE Nicholas Cronk
WAR AND TECHNOLOGY
 Alex Roland
WATER John Finney
WILLIAM SHAKESPEARE
 Stanley Wells
WITCHCRAFT Malcolm Gaskill
THE WORLD TRADE
 ORGANIZATION Amrita Narlikar
WORLD WAR II Gerhard L. Weinberg

Roger Scruton

BEAUTY

A Very Short Introduction

OXFORD
UNIVERSITY PRESS

OXFORD
UNIVERSITY PRESS

Great Clarendon Street, Oxford OX2 6DP
Oxford University Press is a department of the University of Oxford.
It furthers the University's objective of excellence in research, scholarship, and
education by publishing worldwide in

Oxford New York

Auckland Cape Town Dar es Salaam Hong Kong Karachi
Kuala Lumpur Madrid Melbourne Mexico City Nairobi
New Delhi Shanghai Taipei Toronto

With offices in

Argentina Austria Brazil Chile Czech Republic France Greece
Guatemala Hungary Italy Japan Poland Portugal Singapore
South Korea Switzerland Thailand Turkey Ukraine Vietnam

Oxford is a registered trade mark of Oxford University Press
in the UK and in certain other countries

Published in the United States
by Oxford University Press Inc., New York

British Library Cataloguing in Publication Data
Data available

Library of Congress Cataloging in Publication Data
Data available

Typeset by SPI Publisher Services, Pondicherry, India
Printed and bound by
CPI Group (UK) Ltd, Croydon, CR0 4YY

ISBN 978-0-19-955952-7 (Hbk.)
978-0-19-922975-8 (Pbk.)

Contents

Preface xi

List of illustrations xv

1 Judging beauty 1

2 Human beauty 29

3 Natural beauty 49

4 Everyday beauty 67

5 Artistic beauty 82

6 Taste and order 112

7 Art and *erōs* 124

8 The flight from beauty 139

9 Concluding thoughts 162

Notes and further reading 165

Index of names 179

Index of subjects 184

Preface

Beauty can be consoling, disturbing, sacred, profane; it can be exhilarating, appealing, inspiring, chilling. It can affect us in an unlimited variety of ways. Yet it is never viewed with indifference: beauty demands to be noticed; it speaks to us directly like the voice of an intimate friend. If there are people who are indifferent to beauty, then it is surely because they do not perceive it.

Yet judgements of beauty concern matters of taste, and maybe taste has no rational foundation. If so, how do we explain the exalted place of beauty in our lives, and why should we lament the fact—if fact it is—that beauty is vanishing from our world? And is it the case, as so many writers and artists since Baudelaire and Nietzsche have suggested, that beauty and goodness may diverge, so that a thing can be beautiful precisely in respect of its immorality?

Moreover, since it is in the nature of tastes to differ, how can a standard erected by one person's taste be used to cast judgement on another's? How, for example, can we pretend that one type of music is superior or inferior to another when comparative judgements merely reflect the taste of the one who makes them?

That familiar relativism has led some people to dismiss judgements of beauty as purely 'subjective'. No tastes can be criticized, they

argue, since to criticize one taste is simply to give voice to another; hence there is nothing to learn or to teach that could conceivably deserve the name of 'criticism'. This attitude has put in question many of the traditional disciplines in the humanities. The studies of art, music, literature and architecture, freed from the discipline of aesthetic judgement, seem to lack the firm anchor in tradition and technique that enabled our predecessors to regard them as central to the curriculum. Hence the current 'crisis in the humanities': is there any point in studying our artistic and cultural inheritance, when the judgement of its beauty has no rational grounds? Or if we do study it, should this not be in a sceptical spirit, by way of questioning its claims to objective authority, and deconstructing its posture of transcendence?

When each year the Turner prize, founded in memory of England's greatest painter, is awarded to yet another bundle of facetious ephemera, is this not proof that there are no standards, that fashion alone dictates who will and who will not be rewarded, and that it is pointless to look for objective principles of taste or a public conception of the beautiful? Many people answer yes to these questions, and as a result renounce the attempt to criticize either the taste or the motives of the Turner-prize judges.

In this book I suggest that such sceptical thoughts about beauty are unjustified. Beauty, I argue, is a real and universal value, one anchored in our rational nature, and the sense of beauty has an indispensable part to play in shaping the human world. My approach to the topic is not historical, neither am I concerned to give a psychological, still less an evolutionary, explanation of the sense of beauty. My approach is philosophical, and the principal sources for my argument are the works of philosophers. The point of this book is the argument that it develops, which is designed to introduce a philosophical question and to encourage you, the reader, to answer it.

Some parts of this book started life elsewhere, and I am grateful to the editors of the *British Journal of Aesthetics*, the *Times Literary Supplement*, *Philosophy* and *City Journal* for permission to re-work material that has already appeared in their pages. I am also grateful to Christian Brugger, Malcolm Budd, Bob Grant, John Hyman, Anthony O'Hear and David Wiggins, for helpful comments on previous drafts. They saved me from many errors, and I apologize for the errors that remain, which are all my fault.

R.S.

Sperryville, Virginia,
May 2008.

List of illustrations

1 Baldassare Longhena, Sta Maria della Salute, Venice **8**
© Fratelli Alinari Museum of the History of Photography, Florence/Alinari Archives, Florence

2 Sir Christopher Wren, St Paul's Cathedral viewed up Ludgate Hill **9**
© Peter Titmuss/Alamy

3 A humble but harmonious street: Barn Hill, Stamford **12**
© Robin Weaver/Collections

4 Simone Martini, *The Annunciation*, 1333, Uffizi Gallery, Florence **46**
© Alinari Archives, Florence/reproduced with the permission of Ministero per i Beni e le Attività Culturali

5 Herefordshire hunting country **62**
© Alan Greeley/Collections

6 Alpine gorge **62**
© David Young/fotoLibra

7 Winding pathway at Little Sparta, garden of Ian Hamilton Findlay **68**
© Robin Gillanders

8 A door from a Georgian pattern-book: *The Architect, or Practical House Carpenter*, by Asher Benjamin, 1830 **70**

9 A table laid for guests **71**
© Michael Paul/StockFood/Getty Images

10 Palladian window **74**
© Oxford University Press

11 Ingmar Bergman, *Wild Strawberries*, 1957 **87**
© Svensk Filmindustri/Album/akg-images

12 Vincent Van Gogh, *The Yellow Chair*, 1888, National Gallery, London **92**
© 2006 TopFoto.co.uk

13 First statement of melody from Samuel Barber, *Adagio for Strings*, 1936 **106**
© 1939 (renewed) by G. Schirmer, Inc. (ASCAP). All rights reserved. International copyright secured. Used by Permission

14 James Abbott McNeill Whistler (attr.), *Nocturne in Grey and Silver, the Thames* **116**
© Art Gallery of New South Wales, Sydney/The Bridgeman Art Library

15 Michelangelo, Laurentian Library staircase **121**
© Alinari Archives, Florence

16 Titian, *Venus of Urbino*, 1538, Uffizi Gallery, Florence **126**
© Alinari Archives, Florence

17 François Boucher, *The Triumph of Venus*, 1740 **126**
© Nationalmuseum, Stockholm/The Bridgeman Art Library

18 Sandro Botticelli, *The Birth of Venus*, c. 1485, Uffizi Gallery, Florence **127**
© Alinari Archives, Florence

19 Rembrandt Van Rijn, *Susannah and the Elders*, 1647 **128**
© Gemäldegalerie, Berlin/The Bridgeman Art Library

20 Edward Manet, *Olympia*, 1863, Musée d'Orsay, Paris **129**
© Roger-Viollet/TopFoto.co.uk

21 François Boucher, *Blonde Odalisque*, 1752, Alte Pinakothek, Munich **134**
© bpk/Bayerische Staatsgemäldesammlungen

22 Francesco Guardi, *Scene with Marine Landscape*, Museum of Castel Vecchio, Verona **146**
© Alinari Archives, Florence

23 Poussin, *The Israelites Dancing Around the Golden Calf*, National Gallery, London **149**
© 1999 TopFoto.co.uk

24 A serene temple Buddha: sacred art **150**
© ullstein bild/akg-images

25 Garden gnomes **158**
© iStockphoto

26 William Hogarth, title page from *The Analysis of Beauty*, 1753 **163**
© Trustees of the British Museum

Chapter 1
Judging beauty

We discern beauty in concrete objects and abstract ideas, in works
of nature and works of art, in things, animals and people, in
objects, qualities and actions. As the list expands to take in just
about every ontological category (there are beautiful propositions
as well as beautiful worlds, beautiful proofs as well as beautiful
snails, even beautiful diseases and beautiful deaths), it becomes
obvious that we are not describing a property like shape, size or
colour, uncontroversially present to all who can find their way
around the physical world. For one thing: how could there be a
single property exhibited by so many disparate types of thing?

Well, why not? After all, we describe songs, landscapes, moods,
scents and souls as blue: does this not illustrate the way in which a
single property can occur under many categories? No, is the
answer. For while there is a sense in which all those things can
be blue, they cannot be blue in the way that my *coat* is blue.
In referring to so many types of thing as blue, we are using a
metaphor—one that requires a leap of the imagination if it is to be
rightly understood. Metaphors make connections which are not
contained in the fabric of reality but created by our own associative
powers. The important question about a metaphor is not what
property it stands for, but what experience it suggests.

But in none of its normal uses is 'beautiful' a metaphor, even if, like many a metaphor, it ranges over indefinitely many categories of object. So why do we call things beautiful? What point are we making, and what state of mind does our judgement express?

The true, the good and the beautiful

There is an appealing idea about beauty which goes back to Plato and Plotinus, and which became incorporated by various routes into Christian theological thinking. According to this idea beauty is an ultimate value—something that we pursue for its own sake, and for the pursuit of which no further reason need be given. Beauty should therefore be compared to truth and goodness, one member of a trio of ultimate values which justify our rational inclinations. Why believe p? Because it is true. Why want x? Because it is good. Why look at y? Because it is beautiful. In some way, philosophers have argued, those answers are on a par: each brings a state of mind into the ambit of reason, by connecting it to something that it is in our nature, as rational beings, to pursue. Someone who asked 'why believe what is true?' or 'why want what is good?' has failed to understand the nature of reasoning. He doesn't see that, if we are to justify our beliefs and desires at all, then our reasons must be anchored in the true and the good.

Does the same go for beauty? If someone asks me 'why are you interested in x?' is 'because it is beautiful' a final answer—one that is immune to counter-argument, like the answers 'because it is good', and 'because it is true'? To say as much is to overlook the subversive nature of beauty. Someone charmed by a myth may be tempted to believe it: and in this case beauty is the enemy of truth. (Cf. Pindar: 'Beauty, which gives the myths acceptance, renders the incredible credible', *First Olympian Ode*.) A man attracted to a woman may be tempted to condone her vices: and in this case beauty is the enemy of goodness. (Cf. L'Abbé Prévost, *Manon Lescaut*, which describes the moral ruin of the Chevalier des Grieux by the beautiful Manon.) Goodness and truth never compete, we

assume, and the pursuit of the one is always compatible with a proper respect for the other. The pursuit of beauty, however, is far more questionable. From Kierkegaard to Wilde the 'aesthetic' way of life, in which beauty is pursued as the supreme value, has been opposed to the life of virtue. The love of myths, stories and rituals, the need for consolation and harmony, the deep desire for order all have drawn people to religious beliefs regardless of whether those beliefs are true. The prose of Flaubert, the imagery of Baudelaire, the harmonies of Wagner, the sensuous forms of Canova have all been accused of immorality, by those who believe that they paint wickedness in alluring colours.

We don't have to agree with such judgements in order to acknowledge their point. The status of beauty as an ultimate value is questionable, in the way that the status of truth and goodness are not. Let us at least say that this particular path to the understanding of beauty is not easily available to a modern thinker. The confidence with which philosophers once trod it is due to an assumption, made explicit already in the *Enneads* of Plotinus, that truth, beauty and goodness are attributes of the deity, ways in which the divine unity makes itself known to the human soul. That theological vision was edited for Christian use by St Thomas Aquinas, and embedded in the subtle and comprehensive reasoning for which that philosopher is justly famous. But it is not a vision that we can assume, and I propose for the time being to set it to one side, considering the concept of beauty without making any theological claims.

Aquinas's own view of the matter is worth noting, however, since it touches on a deep difficulty in the philosophy of beauty. Aquinas regarded truth, goodness and unity as 'transcendentals'—features of reality possessed by all things, since they are aspects of being, ways in which the supreme gift of being is made manifest to the understanding. His views on beauty are more implied than stated; nevertheless he wrote as though beauty too is such a transcendental (which is one way of explaining the point already

made, that beauty belongs to every category). He also thought that beauty and goodness are, in the end, identical, being separate ways in which a single positive reality is rationally apprehended. If that is so, however, what is ugliness, and why do we flee from it? And how can there be dangerous beauties, corrupting beauties, and immoral beauties? Or, if such things are impossible, why are they impossible, and what is it that misleads us into thinking the opposite? I don't say that Aquinas has no answer to those questions. But they illustrate the difficulties encountered by any philosophy that places beauty on the same metaphysical plane as truth, so as to plant it in the heart of being as such. The natural response is to say that beauty is a matter of appearance, not of being; and perhaps also that in exploring beauty we are investigating the sentiments of people, rather than the deep structure of the world.

Some platitudes

That said, we should take a lesson from the philosophy of truth. Attempts to define truth, to tell us what truth deeply and essentially is, have seldom carried conviction, since they always end by presupposing what they need to prove. How can you define truth, without already assuming the distinction between a true definition and a false one? Wrestling with this problem, philosophers have suggested that a theory of truth must conform to certain logical platitudes, and that these platitudes—innocuous though they may seem to the untheoretical eye—provide the ultimate test of any philosophical theory. For example there is the platitude that if a sentence s is true, so is the sentence 's is true', and vice versa. There are the platitudes that one truth cannot contradict another, that assertions claim to be true, that our assertions are not true simply because we say so. Philosophers say profound-seeming things about truth. But often the air of profundity comes at the cost of denying one or other of those elementary platitudes.

It would help to define our subject, therefore, if we were to begin from a list of comparable platitudes about beauty, against which our theories might be tested. Here are six of them:

(i) Beauty pleases us.

(ii) One thing can be more beautiful than another.

(iii) Beauty is always a reason for attending to the thing that possesses it.

(iv) Beauty is the subject-matter of a judgement: the judgement of taste.

(v) The judgement of taste is about the beautiful object, not about the subject's state of mind. In describing an object as beautiful, I am describing it, not me.

(vi) Nevertheless, there are no second-hand judgements of beauty. There is no way that you can argue me into a judgement that I have not made for myself, nor can I become an expert in beauty, simply by studying what others have said about beautiful objects, and without experiencing and judging for myself.

This last platitude may be doubted. I might swear by a certain music critic, whose judgements of pieces and performances I take as gospel. Isn't that like adopting my scientific beliefs from the opinions of experts, or my legal beliefs from the judgements of the courts? The answer is no. When I put my trust in a critic, this is tantamount to saying that I defer to his judgement, even when I have made no judgement of my own. But my own judgement waits upon experience. It is only when I have heard the piece in question, in the moment of appreciation, that my borrowed opinion can actually become a judgement of *mine*. Hence the comedy of this dialogue from Jane Austen's *Emma*:

'Mr Dixon, you say, is not, strictly speaking, handsome.'

'Handsome! Oh! no—far from it—certainly plain. I told you he was plain.'

'My dear, you said that Miss Campbell would not allow him to be plain, and that you yourself—'

'Oh! as for me, my judgement is worth nothing. Where I have a
great regard, I always think a person well-looking. But I have what
I believed the general opinion, when I called him plain.'

In this dialogue the second speaker, Jane Fairfax, is ignoring her
experience of Mr Dixon's looks, so that in describing him as plain
she is not making a judgement of her own but reporting the
judgement of others.

A paradox

The first three of those platitudes apply to the attractive and the
enjoyable. If something is enjoyable then that is a reason for taking
an interest in it, and some things are more enjoyable than others.
There is also a sense in which you cannot judge something to be
enjoyable at second hand: your own enjoyment is the criterion of
sincerity, and when reporting on some object that others find
enjoyable the best you can sincerely say is that it is *apparently*
enjoyable, or that it *seems* to be enjoyable, since others find it so.
However, it is not at all clear that the judgement that something is
enjoyable is about *it* rather than the nature and character of
people. Certainly we judge between enjoyable things: it is right to
enjoy some things, wrong to enjoy others. But these judgements
focus on the state of mind of the subject, rather than a quality in
the object. We can say all that we want to say about the rightness
and wrongness of our enjoyments without invoking the idea that
some things are *really* enjoyable, others only apparently so.

With beauty matters are otherwise. Here the judgement focuses on
the *object judged*, not the subject who judges. We distinguish true
beauty from fake beauty—from kitsch, schmaltz and whimsy. We
argue about beauty, and strive to educate our taste. And our
judgements of beauty are often supported by critical reasoning,
which focuses entirely on the character of the object. All these points
seem obvious and yet, when combined with the other platitudes that

I have identified, they generate a paradox which threatens to undermine the entire subject of aesthetics. The judgement of taste is a genuine judgement, one that is supported by reasons. But these reasons can never amount to a deductive argument. If they could do so, then there could be second-hand opinions about beauty. There could be experts on beauty who had never experienced the things they describe, and rules for producing beauty which could be applied by someone who had no aesthetic tastes.

It is true that artists often attempt to invoke beauties other than those they create: Wordsworth invokes the beauty of the Lakeland landscape; Proust the beauty of a sonata of Vinteuil; Mann the beauty of Joseph and Homer the beauty of Helen of Troy. But the beauty that we perceive in these invocations resides in *them*, not in the things described. It is possible that a bust of Helen might one day be dug from the soil of Troy and authenticated as a true likeness, even though you and I are struck by the ugliness of the woman depicted, and appalled to think of a war being fought for so charmless a cause. I have been half in love with the woman portrayed in Janáček's second quartet, and half in love with the one immortalized in *Tristan und Isolde*. Those works bear unimpeachable witness to the beauty that inspired them. Yet, to my chagrin, photographs of Kamila Stösslová and Mathilde Wesendonck show a pair of ungainly frumps.

The paradox, then, is this. The judgement of beauty makes a claim about its object, and can be supported by reasons for its claim. But the reasons do not compel the judgement, and can be rejected without contradiction. So are they reasons or aren't they?

Minimal beauty

Here it is important to make room for our second platitude. Things can often be compared and ranked according to their beauty, and there is also a minimal beauty—beauty in the lowest degree, which might be a long way from the 'sacred' beauties of art

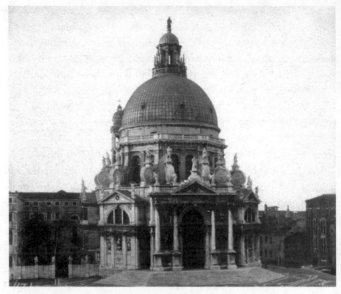

1. Baldassare Longhena, Sta Maria della Salute, Venice: beauty enhanced by a modest setting

and nature which are discussed by the philosophers. There is an aesthetic minimalism exemplified by laying the table, tidying your room, designing a website, which seems at first sight quite remote from the aesthetic heroism exemplified by Bernini's *St Teresa in Ecstasy* or Bach's *Well-Tempered Clavier*. You don't wrestle over these things as Beethoven wrestled over the late quartets, nor do you expect them to be recorded for all time among the triumphs of artistic achievement. Nevertheless, you want the table, the room or the website to look right, and looking right matters in the way that beauty generally matters—not by pleasing the eye only, but by conveying meanings and values which have weight for you and which you are consciously putting on display.

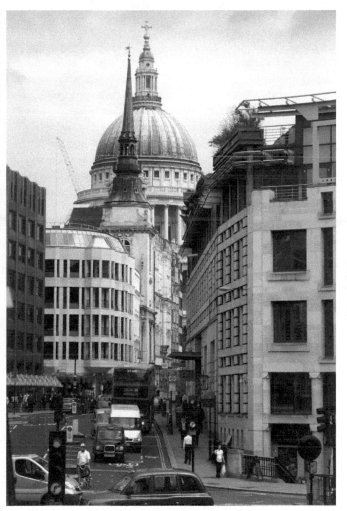

2. Sir Christopher Wren, St Paul's Cathedral, London: beauty destroyed by an arrogant setting

This platitude is of great importance in understanding architecture. Venice would be less beautiful without the great buildings that grace the waterfronts—Longhena's church of Sta Maria della Salute, the Ca' d'Oro, the Ducal Palace. But these buildings are set among modest neighbours, which neither compete with nor spoil them—neighbours whose principal virtue resides precisely in their neighbourliness, their refusal to draw attention to themselves or to claim the exalted status of high art. Ravishing beauties are less important in the aesthetics of architecture than things that fit appropriately together, creating a soothing and harmonious context, a continuous narrative as in a street or a square, where nothing stands out in particular, and good manners prevail.

Much that is said about beauty and its importance in our lives ignores the minimal beauty of an unpretentious street, a nice pair of shoes or a tasteful piece of wrapping paper, as though these things belonged to a different order of value from a church by Bramante or a Shakespeare sonnet. Yet these minimal beauties are far more important to our daily lives, and far more intricately involved in our own rational decisions, than the great works which (if we are lucky) occupy our leisure hours. They are part of the context in which we live our lives, and our desire for harmony, fittingness and civility is both expressed and confirmed in them. Moreover, the great works of architecture often depend for their beauty on the humble context that these lesser beauties provide. Longhena's church on the Grand Canal would lose its confident and invocatory presence, were the modest buildings which nestle in its shadow to be replaced with cast-concrete office-blocks, of the kind that ruin the aspect of St Paul's.

Some consequences

Our second platitude is not without consequences. We need to take seriously the suggestion that judgements of value tend to be *comparative*. When we judge things in respect of their goodness and beauty, our concern is very often to rank alternatives, with a

view to choosing between them. The pursuit of absolute or ideal beauty may distract us from the more urgent business of getting things right. It is well and good for philosophers, poets and theologians to point towards beauty in its highest form. But for most of us it is far more important to achieve order in the things surrounding us, and to ensure that the eyes, the ears and the sense of fittingness are not repeatedly offended.

Another consideration follows, which is that the emphasis on beauty might in certain cases be self-defeating, by implying that our choices are between different degrees of a single quality, so that we must always aim for what is most beautiful in everything that we choose. In fact too much attention to beauty might defeat its own object. In the case of urban design, for example, the goal is, in the first instance, to fit in, not to stand out. If you want to stand out, then you have to be worthy of the attention that you claim, like Longhena's church. This does not mean that the humble and harmonious street is *not* beautiful. Rather, it suggests that we can understand its beauty better if we describe it in another and less loaded way, as a form of fittingness or harmony. Were we to aim in every case at the kind of supreme beauty exemplified by Sta Maria della Salute, we should end with aesthetic overload. The clamorous masterpieces, jostling for attention side by side, would lose their distinctiveness, and the beauty of each of them would be at war with the beauty of the rest.

This point leads to another, which is that 'beautiful' is by no means the only adjective that we deploy in making judgements of this kind. We praise things for their elegance, their intricacy, their fine patina; we admire music for its expressiveness, its discipline, its orderliness, we appreciate the pretty, the charming and the attractive—and we will often be far more confident in such judgements than in an unqualified assertion that a thing is beautiful. To speak of beauty is to enter another and more exalted realm—a realm sufficiently apart from our everyday concerns as to be mentioned only with a certain hesitation. People who are always

11

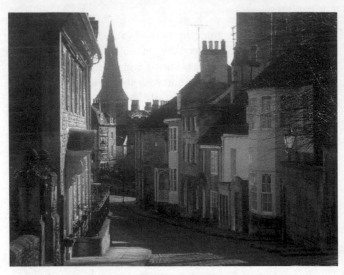

3. Humble harmony: the street as a home

in praise and pursuit of the beautiful are an embarrassment, like people who make a constant display of their religious faith. Somehow, we feel, such things should be kept for our exalted moments, and not paraded in company, or allowed to spill out over dinner.

Of course we might agree that to be pretty, expressive, elegant or whatever is to be to that extent beautiful—but only to that extent, and not to the extent that Plato, Plotinus or Walter Pater would have us go, by way of declaring our aesthetic commitments. In making this qualified admission we would be pleading for aesthetic common sense. But common sense also points to the fluidity of our language. 'She is very pretty—yes, beautiful!' is a cogent statement; but so too is 'She is very pretty, but hardly *beautiful*.' Delight is more important than the terms used to express it, and the terms themselves are in a certain measure

12

anchorless, used more to suggest an effect than to pinpoint the
qualities that give rise to it.

Two concepts of beauty

The judgement of beauty, it emerges, is not merely a statement
of preference. It demands an act of attention. And it may be
expressed in many different ways. Less important than the final
verdict is the attempt to show what is right, fitting, worthwhile,
attractive or expressive in the object: in other words, to identify the
aspect of the thing that claims our attention. The word 'beauty' may
very well not figure in our attempts to articulate and to harmonize
our tastes. And this suggests a distinction between the judgement
of beauty, considered as a justification of taste, and the emphasis
on *beauty*, as a distinctive way of appealing to that judgement.
There is no contradiction in saying that Bartók's score for *The
Miraculous Mandarin* is harsh, rebarbative, even ugly, and at the
same time praising the work as one of the triumphs of early
modern music. Its aesthetic virtues are of a different order from
those of Fauré's *Pavane*, which aims only to be exquisitely
beautiful, and succeeds.

Another way of putting the point is to distinguish two concepts of
beauty. In one sense 'beauty' means aesthetic success, in another
sense it means only a certain *kind* of aesthetic success. There are
works of art which we regard as set apart by their pure beauty—
works that 'take our breath away', like Botticelli's *Birth of Venus*,
Keats's *Ode to a Nightingale* or Susanna's aria in the garden in
Mozart's *Marriage of Figaro*. Such works are sometimes described
as 'ravishing', meaning that they demand wonder and reverence,
and fill us with an untroubled and consoling delight. And because
words, in the context of aesthetic judgement, are loose and
slippery, we often reserve the term 'beautiful' for works of this kind,
meaning to lay special emphasis on their kind of enrapturing
appeal. Likewise with landscapes and people we encounter the
pure and breathtaking examples, which render us speechless,

content merely to bathe in their glow. And we praise such things for their 'sheer' beauty—implying that, should we attempt to analyse their effect on us, words would fail.

We might even go so far as to say, of certain works of art, that they are *too* beautiful: that they ravish when they should disturb, or provide dreamy intoxication when what is needed is a gesture of harsh despair. This could be said, I think, of Tennyson's *In Memoriam* and maybe of Fauré's *Requiem* too—even though both are, in their ways, supreme artistic achievements.

All this suggests that we should be wary of paying too much attention to words, even to the word that defines the subject-matter of this book. What matters, first and foremost, is a certain kind of judgement, for which the technical term 'aesthetic' is now in common use. The suggestion that there might be a supreme aesthetic value, for which the term 'beauty' should be more properly reserved, is one that we must bear in mind. For the moment, however, it is more important to understand beauty in its general sense, as the subject-matter of aesthetic judgement.

Means, ends and contemplation

There is a widespread view, which is less a platitude than a first shot at a theory, which distinguishes the interest in beauty from the interest in getting things done. We appreciate beautiful things not for their utility only, but also for what they are in themselves— or more plausibly, for how they *appear* in themselves. 'With the good, the true and the useful,' wrote Schiller, 'man is merely in earnest; but with the beautiful he *plays*.' When our interest is entirely taken up by a thing, as it appears in our perception, and independently of any use to which it might be put, then do we begin to speak of its beauty.

The thought here gave rise in the eighteenth century to an important distinction between the fine and the useful arts. Useful

arts, like architecture, carpet-weaving and carpentry, have a function, and can be judged according to how well they fulfil it. But a functional building or carpet is not, for that reason, beautiful. In referring to architecture as a useful *art* we are emphasizing another aspect of it—the aspect that lies beyond utility. We are implying that a work of architecture can be appreciated not only as a means to some goal, but also as an end in itself, as a thing intrinsically meaningful. In wrestling with the distinction between the fine and useful arts (*les beaux arts et les arts utiles*) Enlightenment thinkers made the first steps towards our modern conception of the work of art, as a thing whose value resides in *it* and not in its purpose. 'All art is quite useless,' wrote Oscar Wilde, not wishing to deny, however, that art has very powerful effects, his own drama of *Salomé* being one lurid instance.

That said, we should recognize that the distinction between aesthetic and utilitarian interests is no more clear than the language used to define it. What exactly is meant by those who say we are interested in a work of art *for its own sake*, on account of its *intrinsic* value, as an *end in itself*? These terms are philosophical technicalities, which indicate no clear contrast between aesthetic interest and the utilitarian approach that is imposed on us by the needs of everyday decision making. Other epochs did not recognize the distinction that we now so frequently make between art and craft. Our word 'poetry' comes from Greek *poiēsis*, the skill of making things; the Roman *artes* comprised every kind of practical endeavour. And to take our second platitude about beauty seriously is to be sceptical towards the whole idea of the beautiful as a realm apart, untainted by mundane practicalities.

Maybe we shouldn't be too troubled by that commonsensical scepticism, however. Even if it is not yet clear what is meant by intrinsic value, we have no difficulty in understanding someone who says, of a picture or a piece of music that appeals to him, that he could look at it or listen to it forever, and that it has, for him, no other purpose than itself.

Wanting the individual

Suppose Rachel points to a peach in a bowl and says 'I want that peach.' And suppose you hand her another peach from the same bowl and she responds: 'No, it is *that* peach I wanted.' You would be puzzled by this. Surely, any ripe peach would do just as well, if the purpose is to eat it. 'But that's just it,' she says: 'I don't want to eat it. I want it, that particular peach. No other peach will do.' What is it that attracts Rachel to this peach? What explains her claim that it is just *this* peach and no other that she wants?

One thing that would explain this state of mind is the judgement of beauty: 'I want that peach because it is so beautiful.' Wanting something for its beauty is wanting *it*, not wanting to do something with it. Nor, having obtained the peach, held it, turned it around, studied it from every angle, would it be open to Rachel to say 'good, that's it, I'm satisfied'. If she had wanted it for its beauty then there is no point at which her desire could be satisfied, nor is there any action, process or whatever, following which the desire is over and done with. She can want to inspect the peach for all sorts of reasons, even for no reason at all. But wanting it for its beauty is not wanting to inspect it: it is wanting to contemplate it—and that is something more than a search for information or an expression of appetite. Here is a want without a goal: a desire that cannot be fulfilled since there is nothing that would count as its fulfilment.

Suppose someone now offers Rachel another peach from the bowl, saying 'take this, it will do just as well'. Would this not show a failure to understand her motive? She is interested in *this*: the particular fruit that she finds so beautiful. No substitute can satisfy her interest, since it is an interest in the individual thing, as the thing that it is. If Rachel wants the fruit for some further purpose— to eat it, say, or to throw it at the man who is bothering her—then some other object might have served her purpose. In such a case,

her desire is not for the individual peach but for any member of a functionally equivalent class.

The example resembles one given by Wittgenstein in his *Lectures on Aesthetics*. I sit down to listen to a Mozart quartet; my friend Rachel enters the room, takes out the disk and replaces it with another—say a quartet by Haydn—saying 'try this, it will do just as well'. Rachel has shown that she does not understand my state of mind. There is no way in which my interest in the Mozart could be satisfied by the Haydn: although of course it can be eclipsed by it.

The point here is not easy to state exactly. I might have chosen the Mozart as therapy, knowing that it had always helped me to relax. The Haydn might be every bit as therapeutic, and in that sense an appropriate substitute for the Mozart. But then, it is a substitute as *therapy*, and not as music. In that sense I could have substituted a warm bath for the Mozart, or a ride out on my horse—equally effective therapies for tension. But the Haydn cannot satisfy my interest in the Mozart, for the simple reason that my interest in the Mozart is an interest in *it*, for the particular thing that it is, and not for any purpose that it serves.

A caveat

There is a danger involved in taking the eighteenth-century distinction between the fine and the useful arts too seriously. On one reading it might seem to imply that the utility of something— a building, a tool, a car—must be entirely *discounted* in any judgement of its beauty. To experience beauty, it might seem to imply, we should concentrate on pure form, detached from utility. But this ignores the fact that knowledge of function is a vital preliminary to the experience of form. Suppose someone places in your hand an unusual object, which could be a knife, a hoof-pick, a surgeon's scalpel, an ornament or any one of a number of other things. And suppose that he asks you to pronounce on its beauty. You might reasonably say that, until you know what the thing is

supposed to do, you can have no view in the matter. Learning that it is a boot-pull, you might then respond: yes, as boot pulls go, it really is rather beautiful, but how shapeless and clumsy as a knife.

The architect Louis Sullivan went further, arguing that beauty in architecture (and by implication in the other useful arts) arises when form follows function. In other words, we experience beauty when we see how the function of a thing generates and is expressed in its observable features. The slogan 'form follows function' thereafter became a kind of manifesto, persuading a whole generation of architects to treat beauty as a by-product of functionality, rather than (what it had been for the Beaux-Arts school against which Sullivan was in rebellion) the defining goal.

There is a deep controversy here, whose contours will become clear only as the argument of this book unfolds. But let us add a caveat to the caveat, by pointing out that, *pace* Sullivan, when it comes to beautiful architecture function follows form. Beautiful buildings change their uses; merely functional buildings get torn down. Sancta Sophia in Istanbul was built as a church, became a barracks, then a stable, then a mosque and then a museum. The lofts of Lower Manhattan changed from warehouses to apartments to shops and (in some cases) back to warehouses—retaining their charm meanwhile and surviving precisely because of that charm. Of course knowledge of *architectural* function is important to the judgement of beauty; but architectural function is bound up with the aesthetic goal: the column is there to add dignity, to support the architrave, to raise the building high above its own entrance and so to give it a distinguished place in the street, and so on. In other words, when we take beauty seriously, function ceases to be an independent variable, and becomes absorbed into the aesthetic goal. This is another way of emphasizing the impossibility of approaching beauty from a purely instrumental viewpoint. Always there is the demand that we approach beauty for its own sake, as a goal that qualifies and limits whatever other purposes we might have.

Beauty and the senses

There is an ancient view that beauty is the object of a *sensory* rather than an intellectual delight, and that the senses must always be involved in appreciating it. Hence, when the philosophy of art became conscious of itself at the beginning of the eighteenth century, it called itself 'aesthetics', after the Greek *aisthēsis*, sensation. When Kant wrote that the beautiful is that which pleases *immediately*, and *without concepts* he was providing a rich philosophical embellishment to this tradition of thinking. Aquinas too seems to have endorsed the idea, defining the beautiful in the first part of the *Summa* as that which is pleasing to sight (*pulchra sunt quae visa placent*). However he modifies this statement in the second part, writing that 'the beautiful relates only to sight and hearing of all the senses, since these are the most cognitive (*maxime cognoscitive*) among them'. And this suggests, not only that he did not confine the study of beauty to the sense of sight, but that he was less concerned with the sensory impact of the beautiful than with its intellectual significance—even if it is a significance that can be appreciated only through seeing or hearing.

The issue here might seem to be simple: is the pleasure in beauty a sensory or an intellectual pleasure? But then, what is the difference between the two? The pleasure of a hot bath is sensory; the pleasure of a mathematical puzzle intellectual. But between those two there are a thousand intermediary positions, so that the question of where aesthetic pleasure lies on the spectrum has become one of the most vexed issues in aesthetics. Ruskin, in a famous passage of *Modern Painters*, distinguished merely sensuous interest, which he called *aesthesis*, from the *true* interest in art, which he called *theoria*, after the Greek for contemplation— not wishing, however, to assimilate art to science, or to deny that the senses are intimately involved in the appreciation of beauty. Most thinkers have avoided Ruskin's linguistic innovation and

retained the term *aesthesis*, recognizing, however, that this does not denote a *purely* sensory frame of mind.

A beautiful face, a beautiful flower, a beautiful melody, a beautiful colour—all these are indeed objects of a kind of sensory enjoyment, a relishing of the sight or sound of a thing. But what about a beautiful novel, a beautiful sermon, a beautiful theory in physics or a beautiful mathematical proof? If we tie the beauty of a novel too closely to the *sound* of it, then we must consider a novel in translation to be a completely different work of art from the same novel in its original tongue. And this is surely to deny what is really interesting in the art of the novel—which is the unfolding of a story, the controlled release of information about an imaginary world, and the reflections that accompany the plot and reinforce its significance.

Moreover, if we tie beauty too closely to the senses, we might find ourselves wondering why so many philosophers, from Plato to Hegel, have chosen to exclude the senses of taste, touch and smell from the experience of beauty. Are not wine-buffs and gourmets devoted to their own kind of beauty? Are there not beautiful scents and flavours as well as beautiful sights and sounds? Does not the vast critical literature devoted to the assessment of food and wine suggest a close parallel between the arts of the stomach and the arts of the soul?

Here, very briefly, is how I would respond to those thoughts. In appreciating a story we certainly are more interested in *what is being said* than in the sensory character of the sounds used to say it. Nevertheless, if stories and novels were simply reducible to the information contained in them, it would be inexplicable that we should be constantly returning to the words, reading over favourite passages, allowing the sentences to percolate through our thoughts, long after we have assimilated the plot. The order in which a story unfolds, the suspense, the balance between narrative and dialogue and between both and commentary—all these are

sensory features, in that they depend upon anticipation and release, and the orderly unfolding of a narrative in our perception. To that extent a novel is directed to the senses—but not as an object of sensory delight, like a luxurious chocolate or a fine old wine. Rather as something presented *through* the senses, *to* the mind.

Take any short story by Chekhov. It does not matter that the sentences in translation sound nothing like the Russian original. Still they present the same images and events in the same suggestive sequence. Still they imply as much as they say, and withhold as much as they reveal. Still they follow each other with the logic of things observed rather than things summarized. Chekhov's art captures life as it is lived and distils it into images that contain a drama, as a drop of dew contains the sky. Following such a story we are constructing a world whose interpretation is at every point controlled by the sights and sounds that we imagine.

As for taste and smell, it seems to me that philosophers have been right to set these on the margins of our interest in beauty. Tastes and smells are not capable of the kind of systematic organization that turns sounds into words and tones. We can relish them, but only in a sensual way that barely engages our imagination or our thought. They are, so to speak, insufficiently intellectual to prompt the interest in beauty.

Those are only brief hints towards conclusions that demand far more argument than I can here afford to them. I propose that, rather than emphasize the 'immediate', 'sensory', 'intuitive' character of the experience of beauty, we consider instead the way in which an object *comes before us*, in the experience of beauty. When we refer to the 'aesthetic' nature of our pleasure in beauty it is presentation, rather than sensation, that we have in mind.

Judging beauty

Disinterested interest

Setting those observations side by side with our six platitudes we can draw a tentative conclusion, which is that we call something beautiful when we gain pleasure from contemplating it as an individual object, for its own sake, and in its *presented form*. This is so even of those objects like landscapes and streets which are, properly speaking, not individuals, but unbounded collections of odds and ends. Such complex entities are *framed* by aesthetic interest, held together, as it were, under a unified and unifying gaze.

It is difficult to date the rise of modern aesthetics precisely. But it is undeniable that the subject took a great step forward with the *Characteristics* (1711), of the third Earl of Shaftesbury, a pupil of Locke and one of the most influential essayists of the eighteenth century. In that work Shaftesbury explained the peculiar features of the judgement of beauty in terms of the *disinterested* attitude of the judge. To be interested in beauty is to set all interests aside, so as to attend to the thing itself. Kant (*The Critique of Judgement*, 1795) took up the point, building from the idea of disinterest a highly charged aesthetic theory. According to Kant we take an 'interested' approach to things or people whenever we use them as means to satisfy one of our interests: for example, when we use a hammer to drive in a nail or a person to carry a message. Animals have only 'interested' attitudes: in everything they are driven by their desires, needs and appetites, and treat objects and other animals as instruments to fulfil those things. We, however, make a distinction in our thinking and behaviour, between those things that are means to us, and those which are also *ends in themselves*. Towards some things we take an interest that is not governed by interest but which is, so to speak, entirely *devoted* to the object.

That way of putting things is controversial, not least because—as in all his writings—Kant is subtly coaxing us towards the

endorsement of a system, with far-reaching implications for everything that we think. Nevertheless we can understand what he is getting at through a homely example. Imagine a mother cradling her baby, looking down on it with love and delight. We don't say that she has an *interest* that this baby satisfies, as though some other baby might have done just the same job for her. There is no interest of the mother's that the baby serves, nor does she have an *end* to which the baby is a means. The baby itself is her interest— meaning, it is the object of interest for its own sake. If the woman were motivated by an interest that she has—say, an interest in persuading someone to employ her as a baby-minder—then the baby itself would cease to be the full and final focus of her state of mind. Any other baby that enabled her to make the right noises and the right expressions would have done just as well. One sign of a disinterested attitude is that it does not regard its object as one among many possible substitutes. Clearly, no other baby would 'do just as well' for the mother doting on the creature that she holds in her arms.

Disinterested pleasure

To be disinterested towards something is not necessarily to be uninterested in it, but to be interested in a certain way. We often say of people who generously extend their help to others in times of trouble, that they act disinterestedly—meaning that they are not motivated by self-interest or by any interest other than the interest in doing *just this*, namely helping their neighbours. They have a *disinterested interest*. How is that possible? Kant's answer was that it is not possible if all our interests are determined by our desires: for an interest that stems from my desire aims at the fulfilment of that desire, which is an interest of *mine*. Interests can be disinterested, however, if they are determined by (spring from) reason alone.

From this—already controversial—way of putting it, Kant went on to draw a striking conclusion. There is a certain kind of

disinterested interest, he argued, which is an interest of reason: not an interest of mine, but an interest of reason *in* me. This is how Kant explains the moral motive. When I ask myself not what I want to do, but what I ought to do, then I stand back from myself, and put myself in the position of an impartial judge. The moral motive comes from setting all my interests aside, and addressing the question before me by appealing to reason alone—and that means appealing to considerations that any rational being would be equally able to accept. From that posture of disinterested enquiry we are led inexorably, Kant thought, to the categorical imperative, which tells us to act only on that maxim which we can will as a law for all rational beings.

In another sense, however, the moral motive is *interested*: the interest of reason is also the determining principle of my will. I am making up my mind to do something, and to do what reason requires—that is what the word 'ought' implies. In the case of the judgement of beauty, however, I am *purely* disinterested, abstracting from practical considerations and attending to the object before me with all desires, interests and goals suspended.

This stringent idea of disinterest seems to jeopardize the first of our platitudes: the connection between beauty and pleasure. When an experience pleases me I have a desire to repeat it, and that desire is an interest of mine. So what could we possibly mean by a disinterested *pleasure*? How can reason have a pleasure 'in me', and whose pleasure is it anyway? Surely we are drawn to beautiful things as we are drawn to other sources of enjoyment, by the pleasure that they bring. Beauty is not the source of disinterested pleasure, but simply the object of a universal interest: the interest that we have in beauty, and in the pleasure that beauty brings.

We can approach Kant's thought more sympathetically, however, if we distinguish among pleasures. These are of many kinds, as we can see by comparing the pleasure that comes from a drug, the pleasure taken in a glass of wine, the pleasure that your son has

passed his exam and pleasure in a painting or a work of music. When my son tells me he has won the mathematics prize at school I feel pleasure: but my pleasure is an interested pleasure, since it arises from the satisfaction of an interest of mine—my parental interest in my son's success. When I read a poem, my pleasure depends upon no interest other than my interest in *this*, the very object that is before my mind. Of course, other interests *feed into* my interest in the poem: my interest in military strategy draws me to the *Iliad*, my interest in gardens to *Paradise Lost*. But the pleasure in a poem's beauty is the result of an interest in *it*, for the very thing that it is.

I may have been obliged to read the poem in order to pass an exam. In such a case I feel pleasure at having read it. Such a pleasure is again an interested pleasure, one that stems from my interest in *having read* the poem. I am pleased *that* I have read the poem: the word 'that' here playing a critical role in defining the nature of my pleasure. Our language partly reflects this complexity in the concept of pleasure: we distinguish pleasure *from*, pleasure *in*, and pleasure *that*. As Malcolm Budd has expressed it: disinterested pleasure is never pleasure *in a fact*. Nor—as I argued earlier—is the pleasure in beauty purely sensory, like the pleasure of a warm bath, even though we take pleasure *in* a warm bath. And it is certainly not like the pleasure that follows a snort of cocaine, which is not pleasure *in* the cocaine but merely pleasure *from* it.

Disinterested pleasure is a kind of pleasure *in*. But it is focused on its object and dependent on thought: it has a specific 'intentionality', to use the technical term. Pleasure in a hot bath does not depend upon any thought about the bath, and therefore can never be mistaken. Intentional pleasures, by contrast, are part of the cognitive life: my pleasure in the sight of my son winning the long-jump vanishes when I discover it was not my son but a look-alike who triumphed. My initial pleasure was a mistake, and such mistakes can run deep, like Lucretia's mistaken pleasure at the embrace of the man

whom she takes to be her husband, but whom she discovers to be the rapist Tarquin.

Intentional pleasures therefore form a fascinating sub-class of pleasures. They are fully integrated into the life of the mind. They can be neutralized by argument and amplified by attention. They do not arise, as the pleasures of eating and drinking arise, from pleasurable sensations, but play a vital part in the exercise of our cognitive and emotional powers. The pleasure in beauty is similar. But it is not just intentional: it is contemplative, feeding upon the presented form of its object, and constantly renewing itself from that source.

My pleasure in beauty is therefore like a gift offered to the object, which is in turn a gift offered to me. In this respect it resembles the pleasure that people experience in the company of their friends. Like the pleasure of friendship, the pleasure in beauty is *curious*: it aims to understand its object, and to value what it finds. Hence it tends towards a judgement of its own validity. And like every rational judgement this one makes implicit appeal to the community of rational beings. That is what Kant meant when he argued that, in the judgement of taste, I am 'a suitor for agreement', expressing my judgement not as a private opinion but as a binding verdict that would be agreed to by all rational beings just so long as they did what I am doing, and put their own interests aside.

Objectivity

Kant's claim is not that the judgement of taste *is* binding on everyone, but that it is *presented* as such, by the one who makes it. That is a very striking suggestion, but it is borne out by the platitudes that I earlier rehearsed. When I describe something as beautiful I am describing *it*, not my feelings towards it—I am

making a claim, and that seems to imply that others, if they see things aright, would agree with me. Moreover, the description of something as beautiful has the character of a judgement, a verdict, and one for which I can reasonably be asked for a justification. I may not be able to give any cogent reasons for my judgement; but if I cannot, that is a fact about me, not about the judgement. Maybe someone else, better practised in the art of criticism, could justify the verdict. It is a highly controversial question, as I earlier remarked, whether critical reasons are really *reasons*. Kant's position was that aesthetic judgements are universal but *subjective*: they are grounded in the immediate experience of the one who makes them, rather than in any rational argument. Nevertheless, we should not ignore the fact that people are constantly disputing over matters of aesthetic judgement, and constantly trying to achieve some kind of agreement. Aesthetic disagreements are not comfortable disagreements, like disagreements over tastes in food (which are not so much disagreements as differences). When it comes to the built environment, for example, aesthetic disagreements are the subject of fierce litigation and legislative enforcement.

Moving on

We began from certain platitudes about beauty, and moved towards a theory—that of Kant—which is far from platitudinous, and indeed inherently controversial, with its attempt to define aesthetic judgement and to give it a central role in the life of a rational being. I don't say that Kant's theory is right. But it provides an interesting starting point to a subject that remains as controversial today as it was when Kant wrote his third *Critique*. And one thing is surely right in Kant's argument, which is that the experience of beauty, like the judgement in which it issues, is the prerogative of rational beings. Only creatures like us—with language, self-consciousness, practical reason, and moral

judgement—can look on the world in this alert and disinterested way, so as to seize on the presented object and take pleasure in *it*.

Before proceeding, however, it is important to address two questions that I have so far avoided: the question of the evolutionary origins of the sense of beauty, and the related question concerning the place of beauty in sexual desire.

Chapter 2
Human beauty

In the first chapter of this book I identified a state of mind—that involved in our confrontation with beauty—and a judgement that seems to be implicit in it. And I analysed that state of mind with a view to showing how it might explain certain platitudes about beauty which we would all acknowledge to be true. The argument was entirely *a priori*, focusing on distinctions and observations that are assumed to be evident to anyone who understands the terms used to express them. The question we now have to consider, is whether this state of mind has any rational ground, whether it tells us anything about the world in which we live, and whether its exercise is a part of human fulfilment. Such, at any rate, would be the philosophical approach to our topic.

But that is not the approach of the evolutionary psychologists, who argue that we can best understand our states of mind if we identify their evolutionary origins, and the contribution that they (or some earlier version of them) might have made to the reproductive strategies of our genes. In what way is an organism made more likely to pass on its genetic inheritance, by exercising its emotions over beautiful things? That scientific, or scientific-seeming, question is for many people the meaningful residue of aesthetics—the only question that now remains, concerning the nature or value of the sentiment of beauty.

There is a controversy among evolutionary psychologists between those who admit the possibility of group selection and those, like Richard Dawkins, who insist that selection occurs at the level of the individual organism, since it is there, and not in the group, that genes reproduce themselves. Without taking sides in this controversy, we can recognize two broad kinds of evolutionary aesthetics, one which shows the group advantage that attaches to the aesthetic sense, and the other which argues that individuals endowed with aesthetic interests have an enhanced capacity to pass on their genes.

The first kind of theory is advanced by the anthropologist Ellen Dissanayake who, in *Homo Aestheticus*, argues that art and aesthetic interest belong with rituals and festivals—offshoots of the human need to 'make special', to extract objects, events and human relations from everyday uses and to make them a focus of collective attention. This 'making special' enhances group cohesion and also leads people to treat those things which really matter for the survival of the community—be it marriage or weapons, funerals or offices—as things of public note, with an aura that protects them from careless disregard and emotional erosion. The deeply engrained need to 'make special' is explained by the advantage that it has conferred on human communities, holding them together in times of threat, and furthering their reproductive confidence in times of peaceful flourishing.

The theory is interesting and contains an undoubted element of truth; but it falls critically short of explaining what is distinctive of the aesthetic. Although the sense of beauty may be *rooted* in some collective need to 'make special', beauty itself is a special kind of special, not to be confused with ritual, festival or ceremony, even if those things may sometimes possess it. The advantage that accrues to a community through the ceremonial endorsement of the things that matter could accrue without the experience of beauty. There are many other ways in which people set things apart from ordinary functions, and endow them with a precious aura: through

sporting events, for example, like the games described by Homer; or through religious rituals, in which the solemn presence of the gods is invoked to protect whatever institution or practice stands in need of a collective endorsement. From the point of view of anthropology sport and religion are close neighbours of the sense of beauty: but from the point of view of philosophy the distinctions here are just as important as the connections. When people refer to football as 'the beautiful game' they are describing football from the spectator's point of view, as a quasi-aesthetic phenomenon. In itself, as a competitive exercise, in which skill and strength are put through their paces, sport is importantly distinct from both art and religion, and each of the three phenomena has its own special meaning in the life of rational beings.

A similar objection might be made to the more individualistic theory advanced by Geoffrey Miller in *The Mating Mind*, and endorsed by Steven Pinker in *How the Mind Works*. According to this theory the sense of beauty has emerged through the process of sexual selection—a suggestion originally made by Darwin in *The Descent of Man*. As augmented by Miller, the theory suggests that by making himself beautiful the man is doing what the peacock does when he displays his tail: he is giving a sign of his reproductive fitness, to which a woman responds as the peahen responds, claiming him (though in no way conscious that she is doing this) on behalf of her genes. Of course, human aesthetic activity is more intricate than the instinctive displays of birds. Men do not merely wear feathers and tattoos; they paint pictures, write poetry, sing songs. But all these things are signs of strength, ingenuity and prowess, and therefore reliable indices of reproductive fitness. Women are struck with awe, wonder and desire by these artistic gestures, so that Nature takes her course to the mutual triumph of the genes that carry her lasting messages.

But it is clear that strenuous activities short of artistic creation would make an equal contribution to such a genetic strategy. Hence the explanation, even if true, will not enable us to identify

what is specific to the sentiment of beauty. Even if the peacock's tail and the *Art of Fugue* have a common ancestry, the appreciation elicited by the one is of a completely different kind from the appreciation directed at the other. It should be clear from the argument of the first chapter that only rational beings have aesthetic interests, and that their rationality is as engaged by beauty as it is by moral judgement and scientific belief.

A point of logic

The sentiment of beauty may be sufficient to cause a woman to single out a man for his reproductive fitness; but it is not necessary. The process of sexual selection could have occurred without *this* particular way of focusing on another individual. Hence, because we cannot infer that the sentiment of beauty was necessary to the process of sexual selection, we cannot use the fact of sexual selection as a conclusive explanation of the sentiment of beauty, still less as a way of deciphering what that sentiment *means*. Something more needs to be added, concerning the specificity of aesthetic judgement, if we are to have a clear picture of the place of beauty and our response to it in the evolution of our species. And this something more should take seriously such facts as these: that men appreciate women for their beauty just as much as, if not more than, women appreciate men; that women too are active in the production of beauty, both in art and in everyday life; that people associate beauty with their highest endeavours and aspirations, are disturbed by its absence, and regard a measure of aesthetic agreement as essential for life in society. As things stand the evolutionary psychology of beauty offers a picture of the human being and human society with the aesthetic element deprived of its specific intentionality, and dissolved in vague generalities that overlook the peculiar place of aesthetic judgement in the life of the rational agent.

Still, even if the account given by Miller casts little light on the sentiment that it seeks to explain, it is surely reasonable to believe

that there is *some* connection between beauty and sex. May be we are wrong to look for a causal connection between these two aspects of the human condition. Maybe they are more intimately connected than that implies. Maybe it is as Plato so forcefully argued, that the sentiment of beauty is a central component in sexual desire. If so, that must surely have implications not only for the understanding of desire, but also for the theory of beauty. In particular it should cast doubt on the view that our attitude to beauty is intrinsically disinterested. What attitude is more interested than sexual desire?

Beauty and desire

Plato was writing not about sex and sexual difference as we now understand them but about *erōs*, the overwhelming urge which, for Plato, exists at its most significant between people of the same sex, being felt especially by an older man moved by the beauty of a youth. *Erōs* was identified by the Greeks as a cosmic force, like the love that, according to Dante, 'moves the sun and the other stars'. Plato's account of beauty in the *Phaedrus* and the *Symposium* therefore begins from another platitude:

(vii) Beauty, in a person, prompts desire.

Plato believed that this desire is both real, and also a kind of mistake, though a mistake which tells us something important about ourselves and the cosmos. Some argue that it is not beauty that prompts desire, but desire that summons beauty—that, desiring someone, I see him or her as beautiful, this being one of the ways in which the mind, to borrow Hume's metaphor, 'spreads itself upon objects'. But that does not accurately reflect the experience of sexual attraction. Your eyes are captivated by the beautiful boy or girl, and it is from this moment that your desire begins. It may be that there is another and maturer form of sexual desire, which grows from love, and which finds beauty in the no

longer youthful features of a lifelong companion. But that is
emphatically not the phenomenon that Plato had in mind.

However we look at the matter, the seventh platitude creates a
problem for aesthetics. In the realm of art, beauty is an object of
contemplation, not desire. To appreciate the beauty of a painting or
a symphony is not to be prompted to any concupiscent attitude, and
even if, for financial reasons, I may want to steal the painting, there
is no way that I can walk away from the concert hall with a
symphony in my pocket. Does this mean that there are two kinds
of beauty—the beauty of people and the beauty of art? Or does it
mean that the desire aroused by the sight of human beauty is a kind
of mistake that we make, and that really our attitude to beauty tends
to the contemplative in all its forms?

Erōs and platonic love

Plato was drawn to the second of those responses. He identified
erōs as the origin of both sexual desire and the love of beauty. *Erōs*
is a form of love which seeks to unite with its object, and to
make copies of it—as men and women make copies of themselves
through sexual reproduction. In addition to that base form
(as Plato saw it) of erotic love, there is also a higher form, in
which the object of love is not possessed but contemplated, and
in which the process of copying occurs not in the realm of concrete
particulars but in the realm of abstract ideas—the realm of the
'forms' as Plato described them. By contemplating beauty the soul
rises from its immersion in merely sensuous and concrete things,
and ascends to a higher sphere, where it is not the beautiful boy
who is studied, but the form of the beautiful itself, which enters the
soul as a true possession, in the way that ideas generally reproduce
themselves in the souls of those who understand them. This higher
form of reproduction belongs to the aspiration towards immortality,
which is the soul's highest longing in this world. But it is impeded
by too great a fixation on the lower kind of reproduction, which
is a form of imprisonment in the here and now.

According to Plato, sexual desire, in its common form, involves a desire to possess what is mortal and transient, and a consequent enslavement to the lower aspect of the soul, the aspect that is immersed in sensuous immediacy and the things of this world. The love of beauty is really a signal to free ourselves from that sensory attachment, and to begin the ascent of the soul towards the world of ideas, there to participate in the divine version of reproduction, which is the understanding and the passing on of eternal truths. That is the true kind of erotic love, and is manifest in the chaste attachment between man and boy, in which the man takes the role of teacher, overcomes his lustful feelings, and sees the boy's beauty as an object of contemplation, an instance in the here and now of the eternal idea of the beautiful.

That potent collection of ideas has had a long subsequent history. Its intoxicating way of mixing homoerotic love, the career of the teacher, and the redemption of the soul, has touched the hearts of teachers (especially of male teachers) down the centuries. And the heterosexual version of the Platonic myth had an enormous influence on medieval poetry and on Christian visions of women and how women should be understood, inspiring some of the most beautiful works of art in the Western tradition, from Chaucer's *Knight's Tale* and Dante's *Vita Nuova* to Botticelli's *Birth of Venus* and the sonnets of Michelangelo. But it requires only a normal dose of scepticism to feel that there is more wishful thinking than truth in the Platonic vision. How can one and the same state of mind be both sexual love for a boy and (after a bit of self-discipline) delighted contemplation of an abstract idea? That is like saying that the desire for a steak could be satisfied (after a bit of mental exertion) by staring at the picture of a cow.

Contemplation and desire

It is nevertheless true that the object of aesthetic judgement and the object of sexual desire may both be described as beautiful, even though they arouse radically different interests in the one who so

describes them. Someone, looking at the face of an old man, with many interesting creases and wrinkles, with a fine and placid eye and a wise and welcoming expression, might describe the face as beautiful. But we understand that judgement in another way from 'She's beautiful!' said by an eager youth of a girl. The youth is *going after* the girl; he desires her, not just in the sense of wanting to look at her, but in that he wants to hold her and kiss her. The sexual act is described as the 'consummation' of this kind of desire—though we should not think that it is necessarily the thing intended, or that it brings the desire to an end, in the way that drinking a cup of water brings the desire for water to an end.

In the case of the beautiful old man, there is no 'going after' of this kind: no agenda, no desire to possess, or in any other way to gain something from the beautiful object. The old man's face is full of meaning for us, and if we are looking for satisfaction we find it there, in the thing that we contemplate, and in the act of contemplation. It is surely absurd to think that this is the same state of mind as that of the youth in hot pursuit. When, in the course of sexual desire, you contemplate the beauty of your companion, you are standing back from your desire, so as to absorb it into another, larger and less immediately sensuous aim. This is, indeed, the metaphysical significance of the erotic gaze: that it is a search for knowledge—a summons to the other person to shine forth in sensory form and to make himself known.

On the other hand, beauty undoubtedly stimulates desire in the moment of arousal. So is your desire *directed at* the beauty of the other? Is it a desire to do something *with* that beauty? But what *can* you do with another person's beauty? The satisfied lover is as little able to possess the beauty of his beloved as the one who hopelessly observes it from afar. This is one of the thoughts that inspired Plato's theory. What prompts us, in sexual attraction, is something that can be contemplated but never possessed. Our desire might be consummated and temporarily quenched. But it is

not consummated by possessing the thing that inspires it, which lies always beyond our reach, a possession of the other which can never be shared.

The individual object

Plato's theories return us to the difficult idea of wanting the individual. Suppose you want a glass of water. There is, in such a case, no *particular* glass of water that you want. Any glass of water would do—nor does it have to be a glass. And there is something that you want to do with the water—namely, to drink it. After which your desire is *satisfied*, and belongs in the past. That is the normal nature of our sensuous desires: they are indeterminate, they are directed to a specific action, and they are satisfied by that action and brought to an end by it. None of those things is true of sexual desire. Sexual desire is determinate: there is a particular person that you want. People are not interchangeable as objects of desire, even if they are equally attractive. You can desire one person, and then another—you can even desire both at the same time. But your desire for John or Mary cannot be satisfied by Alfred or Jane: each desire is specific to its object, since it is a desire for that person *as* the individual that he is, and not as an instance of a general kind, even though the 'kind' is, at another level, what it is all about. My desire for *this* glass of water could be satisfied by *that* one, since it is not focused on this individual mass of water, but on the stuff that water is.

In certain circumstances you may be released from your desire for one person by making love to another. But this does not mean that the second person has satisfied the very desire that focused on the first. You do not satisfy one sexual desire by swamping it with another, any more than you satisfy your desire to know how a novel ends by becoming unforeseeably engrossed in a movie.

Nor is there a specific thing that you want to do with the person you desire and which is the full content of your feeling. Of course,

there is the sexual act: but there can be desire without the desire for that, and the act does not *satisfy* the desire or bring it to a conclusion, in the way that drinking satisfies and concludes the desire for water. There is a famous description of this paradox in Lucretius, in which the lovers are pictured in the attempt to become one, mingling their bodies in all the ways that desire suggests:

> Just in the raging foam of full desire,
> When both press on, both murmur, both expire,
> They grip, they squeeze, their humid tongues they dart,
> As each wou'd force their way t'other's heart:
> In vain: they only cruise about the coast,
> For bodies cannot pierce, nor be in bodies lost...
>
> (Dryden's translation)

In the sexual act, there is no single goal that is being sought and achieved, and no satisfaction that completes the process: all goals are provisional, temporary, and leave things fundamentally unchanged. And lovers are always struck by the mis-match between the desire and its fulfilment, which is not a fulfilment at all, but a brief lull in an ever-renewable process:

> Agen they in each other wou'd be lost,
> But still by adamantine bars are crossed;
> All wayes they try, successless all they prove
> To cure the secret sore of lingring love.

This returns us to the discussion of 'for its own sake'. The desire for a glass of water is, in the normal case, a desire to do something with it. But the desire of one person for another is simply that—a desire for that person. It is a desire for an individual, which is expressed in, but not fulfilled by, still less cancelled by sexual intimacy. And maybe this has something to do with the place of beauty in sexual desire. Beauty invites us to focus on the individual object, so as to relish his or her presence. And this

focusing on the individual fills the mind and perceptions of the lover. That is why *erōs* seemed to Plato to be so very different from the reproductive urges of animals, which have the appetitive structure of hunger and thirst. As we might put it, the urges of animals are the expression of fundamental *drives*, in which need, rather than choice, is in charge. *Erōs*, on the other hand, is not a drive but a *singling out*, a prolonged stare from I to I which surpasses the urges from which it grows, to take its place among our rational projects.

This is so, even if erotic interest is rooted—as it is clearly rooted—in such a drive. The reproductive urge that we share with other animals underlies our erotic adventures in something like the way that our need to coordinate our bodily movements underlies our interest in dance and music. Humanity is a kind of extended rescue operation, in which drives and needs are lifted from the realm of transferable appetites, and focused in another way, so as to target free individuals, singled out and appreciated as 'ends in themselves'.

Beautiful bodies

No-one was more aware than Plato of the temptation that lies coiled in the heart of desire—the temptation to detach one's interest from the person and attach it to the body, to give up on the morally demanding attempt to possess the other as a free individual and instead to treat him or her as a mere instrument for one's own localized pleasure. Plato did not put the point in quite that way: but it underlies all his writings on the subject of both beauty and desire. There is, he believed, a base form of desire, which targets the body, and a higher form, which targets the soul, and—by means of the soul—the eternal sphere from which we rational beings are ultimately descended.

We don't have to accept that metaphysical vision in order to acknowledge the element of truth in Plato's argument. There is a

distinction, familiar to all of us, between an interest in a person's body and an interest in a person *as embodied*. A body is an assemblage of body parts; an embodied person is a free being revealed in the flesh. When we speak of a beautiful human body we are referring to the beautiful embodiment of a person, and not to a body considered merely as such.

This is evident if we focus on a particular part, like the eye or the mouth. You can see the mouth merely as an aperture, a hole in the flesh through which things are swallowed and from which things emerge. A surgeon might see the mouth in this way, in the course of treating an ailment. That is not the way in which we see the mouth when we are face to face with another person. The mouth is not, for us, an aperture through which sounds emerge, but a speaking thing, continuous with the 'I' whose voice it is. To kiss that mouth is not to place one body part against another, but to touch the other person in his very self. Hence the kiss is compromising—it is a move from one self towards another, and a *summoning* of the other into the surface of his being.

Table manners help to conserve the perception of the mouth as one of the windows of the soul, even in the act of eating. That is why people strive not to speak with a full mouth, or to let food drop from their mouths onto the plate. It is why forks and chopsticks were invented, and why Africans, when they eat with their fingers, shape their hands gracefully so that the food passes without trace into the mouth, which retains its sociable aspect as the food is ingested.

The phenomena here are familiar, though not easy to describe. Recall the queasy feeling that ensues, when—for whatever reason—you suddenly see a *body part* where, until that moment, an embodied person had been standing. It is as though the body has, in that instant, become *opaque*. The free being has disappeared behind his own flesh, which is no longer the person himself but an object, an instrument. When this eclipse of the

person by his body is deliberately produced, we talk of obscenity. The obscene gesture is one that puts the body on display as pure body, so destroying the experience of embodiment. We are disgusted by obscenity for the same reason that Plato was disgusted by physical lust: it involves, so to speak, the eclipse of the soul by the body.

Those thoughts suggest something important about physical beauty. The distinctive beauty of the human body derives from its nature as an embodiment. Its beauty is not the beauty of a doll, and is something more than a matter of shape and proportion. When we find human beauty represented in a statue, such as the Apollo Belvedere or the Daphne of Bernini, what is represented is the beauty of a person—flesh animated by the individual soul, and expressing individuality in all its parts. And when the hero of Hoffmann's tale falls in love with the doll Olympia the tragi-comic effect is due entirely to the fact that Olympia's beauty is merely imagined, and vanishes as the clockwork winds down.

This has enormous significance, as I shall later show, in the discussion of erotic art. But it already points us towards an important observation. Whether it attracts contemplation or prompts desire, human beauty is seen in personal terms. It resides especially in those features — the face, the eyes, the lips, the hands — which attract our gaze in the course of personal relations, and through which we relate to each other I to I. Although there may be fashions in human beauty, and although different cultures may embellish the body in different ways, the eyes, mouth and hands have a universal appeal. For they are the features from which the soul of another shines on us, and makes itself known.

Beautiful souls

In *The Phenomenology of Spirit* Hegel devotes a section to 'the beautiful soul', taking up themes familiar from the literary romanticism of his day, and in particular from the writings of

Goethe, Schiller and Friedrich Schlegel. The beautiful soul is aware of evil, but stands aloof from it in a posture of forgiveness—forgiveness of others, which is also a forgiveness of self. It lives in dread of besmirching its inner purity through too direct an engagement with the real world, and prefers to meditate on its sufferings rather than to cure itself through its deeds. The theme of the beautiful soul was taken up by later writers, and many are the attempts in nineteenth-century literature either to portray or to criticize this increasingly commonplace human type. Even today it is not unusual for someone to describe another as a 'beautiful soul', meaning that his virtue is more an object of contemplation than a real force in the world.

This episode in intellectual history reminds us of the way in which the idea of beauty penetrates our judgement of people. The search for beauty touches on every aspect of a person towards which we might, for however brief a moment and from whatever motive, stand back from direct engagement so as to set it within our own contemplative gaze. As soon as another person becomes important to us, so that we feel in our lives the gravitational pull of his existence, we are to a certain extent astonished by his individuality. From time to time we pause in his presence, and allow the incomprehensible fact of his being in the world to dawn on us. And if we love him and trust him, and feel the comfort of his companionship, then our sentiment, in these moments, is like the sentiment of beauty—a pure endorsement of the other, whose soul shines in his face and gestures as beauty shines in a work of art.

It is unsurprising, therefore, if we so often use the word 'beautiful' to describe the moral aspect of people. As in the case of sexual interest, the judgement of beauty has an irreducibly contemplative component. The beautiful soul is one whose moral nature is perceivable, who is not just a moral agent but a moral *presence*, with the kind of virtue that shows itself to the contemplating gaze. We can feel ourselves in the presence of such a soul when we see selfless concern in action—as in the case of Mother Teresa. But we

can equally feel it when sharing another's thoughts—reading the poems of St John of the Cross, for example, or the diaries of Franz Kafka. In such cases moral appreciation and the sentiment of beauty are inextricably entwined, and both target the individuality of the person.

Beauty and the sacred

Reason, freedom and self-consciousness are names for a single condition, which is that of a creature who does not merely think, feel and do, but who also has the questions: *what* to think, *what* to feel and *what* to do? These questions compel a unique perspective on the physical world. We look on the world in which we find ourselves from a point of view at its very edge: the point of view where *I* am. We are both in the world and not of the world, and we try to make sense of this peculiar fact with images of the soul, the psyche, the self or the 'transcendental subject'. These images do not result from philosophy only: they arise naturally, in the course of a life in which the capacity to justify and criticize our thoughts, beliefs, feelings and actions is the basis of the social order that makes us what we are. The point of view of the subject is therefore an essential feature of the human condition. And the tension between this point of view and the world of objects is present in many of the distinctive aspects of human life.

It is present in our experience of human beauty. And it is equally present in an experience that anthropologists have puzzled over for two centuries or more, and which appears to be a human universal: the experience of the sacred. In every civilization at every period of history people have devoted time and energy to sacred things. The sacred, like the beautiful, includes every category of object. There are sacred words, sacred gestures, sacred rites, sacred clothes, sacred places, sacred times. Sacred things are not of this world: they are set apart from ordinary reality and cannot be touched or uttered without rites of initiation or the privilege of religious office. To meddle with them without some purifying

preparation is to run the risk of sacrilege. It is to desecrate and pollute what is holy, by dragging it down into the sphere of everyday events.

The experiences which focus on the sacred have their parallels in the sense of beauty, and also in sexual desire. Perhaps no sexual experience differentiates human beings from animals more clearly than the experience of jealousy. Animals compete for partners and fight over them. But when victory is established the conflict is over. The jealous lover may or may not fight: but fighting has no bearing on his experience, which is one of deep existential humiliation and dismay. The beloved has been polluted or desecrated in his eyes, has become in some way obscene, in the way that Desdemona, her innocence notwithstanding, becomes obscene in the eyes of Othello. This phenomenon parallels the sense of desecration that attaches to the misuse of holy things. Something held apart and untouchable has been defiled. The medieval romance of *Troilus and Criseyde* describes the 'fall' of Criseyde, from the status of irreplaceable divinity to that of exchangeable goods. And the experience of Troilus, as described by the medieval romancers (Chaucer included) is one of desecration. That which was most beautiful to him has been spoiled, and his despair is comparable to that expressed in the Lamentations of Jeremiah, over the desecration of the temple in Jerusalem. (Some might object that this is a specifically *male* experience, in societies where females are destined for marriage and domesticity. However, it seems to me that some equivalent of Troilus's dismay will be found wherever lovers of either sex make exclusive sexual claims, since these claims are not contractual but *existential*.)

Sacred things are removed, held apart and untouchable—or touchable only after purifying rites. They owe these features to the presence, in them, of a supernatural power—a spirit which has claimed them as its own. In seeing places, buildings and artefacts as sacred we project on to the material world the experience that

44

we receive from each other, when embodiment becomes a 'real presence', and we perceive the other as forbidden to us and untouchable. Human beauty places the transcendental subject before our eyes and within our grasp. It affects us as sacred things affect us, as something that can be more easily profaned than possessed.

Childhood and virginity

If we take those thoughts seriously, then we will recognize that our seventh platitude comes up against a moral obstacle. There is hardly a person alive who is not moved by the beauty of the perfectly formed child. Yet most people are horrified by the thought that this beauty should be a spur to desire, other than the desire to cuddle and comfort. Every hint of arousal is, in these circumstances, a transgression. And yet the beauty of a child is of the same kind as the beauty of a desirable adult, and totally unlike the beauty of an aged face, which has emerged, as it were, from a life of moral trials.

This sense of prohibition does not extend only to children. Indeed, as I shall suggest in Chapter 7, it is integral to mature sexual feeling. It underlies the deep respect for virginity that we encounter, not only in classical and Biblical texts, but in the literatures of almost all the articulate religions. There are no greater tributes to human beauty than the medieval and Renaissance images of the Holy Virgin: a woman whose sexual maturity is expressed in motherhood and who yet remains untouchable, barely distinguishable, as an object of veneration, from the child in her arms. Mary has never been subdued by her body as others are, and stands as a symbol of an idealized love between embodied people, a love which is both human and divine. The Virgin's beauty is a symbol of purity, and for this very reason is held apart from the realm of sexual appetite, in a world of its own. This thought reaches back to Plato's original idea: that beauty is not just an invitation to desire, but also a call to renounce it. In the

Virgin Mary, therefore, we encounter, in Christian form, the Platonic conception of human beauty as the signpost to a realm beyond desire.

This suggests that our seventh platitude should be rewritten in another, more circumspect, form, so as to distinguish between the many interests we have in human beauty:

(vii) It is a non-accidental feature of human beauty that it prompts desire.

This truth is perfectly compatible with the observation that desire itself is inherently bound by prohibitions. Indeed, by pressing up against these prohibitions, the experience of human beauty opens to our vision another realm—divine but no less human—in which beauty lies above and beyond desire, a symbol of redemption. This is the realm that Fra Lippo Lippi and Fra Angelico portrayed in

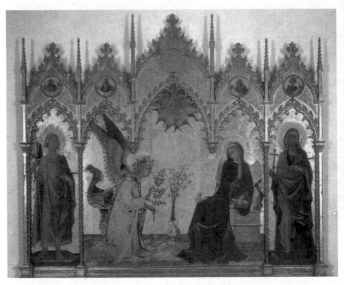

4. Simone Martini, *The Annunciation*: Ave Maria, gratia plena

their images of the Virgin and Child, and which Simone Martini captured through the sublime moment of surprise and acquiescence, in his great *Annunciation*.

Beauty and charm

The idea of the sacred takes us to the upper end of the beauty scale, and it would be wise to come down a step or two, and to remind ourselves of our second platitude, that beauty is a matter of degree. It is true that human beauty—the beauty of the true Venus or Apollo—can call forth all the epithets that naturally belong with the divine. But most attractive people are beautiful to some lesser degree, and the language used to describe them avails itself of a host of quieter predications: pretty, engaging, charming, lovely, attractive. And in using these terms we are offering less by way of a concrete description and more by way of a response. Our response to human beauty, we imply, is a varied and often quite genial thing: seldom the urgent passion that Plato invokes in his theory of *erōs*, or Thomas Mann in his terrifying account of the destruction of Mut-em-enet, wife of Potiphar, by the beauty of the untouchable Joseph.

Disinterested interest

In the last chapter I expressed some sympathy for the view that the judgement of beauty arises from and expresses a 'disinterested interest' in its object. In this chapter, however, we have been exploring the role of beauty in profoundly *interested* states of mind: interested in the way that people are interested in each other. So are there two types of beauty, and is the judgement of beauty ambiguous? My tentative answer is no. The judgement of beauty, even in the context of sexual desire, focuses on how a thing *presents itself* to the contemplating mind. That beauty inspires desire is unsurprising, since beauty resides in the presentation of an individual, and desire yearns for the individual

and delights in another's presented form. But beauty is not an *object* of the desire that it inspires. Moreover, our attitude towards beautiful individuals sets them apart from ordinary desires and interests, in the way that sacred things are set apart—as things that can be touched and used only when all the formalities are addressed and completed.

Indeed, it is not too fanciful to suggest that the beautiful and the sacred are connected in our emotions, and that both have their origin in the experience of embodiment, which is at its most intense in our sexual desires. So, by another route, we arrive at a thought which we could, without too much anachronism, attribute to Plato: the thought that sexual interest, the sense of beauty and reverence for the sacred are proximate states of mind, which feed into one another and grow from a common root. And if there were to be a *real* evolutionary psychology of beauty this thought would have to be included among its premises. On the other hand, our path to this thought has not proceeded by reducing the human to the animal, or the rational to the instinctual. We have arrived at the connection between sex, beauty and the sacred by reflecting on the distinctively human nature of our interest in those things, and by situating them firmly in the realm of freedom and rational choice.

Chapter 3
Natural beauty

When, during the course of the eighteenth century, philosophers and writers began to turn their attention to the subject of beauty, it was not art or people but nature and landscape that dominated their thinking. To some extent this reflected new political conditions, improved means of travel, and a growing awareness of country life. Literary people looked with nostalgia on a simpler and, as they imagined, more innocent relation to the natural world than the one that they enjoyed from their cloistered studies. And the idea of nature as an object to be contemplated, rather than used or consumed, provided some solace to people for whom the comforts of religion were becoming daily more implausible, and daily more remote.

Universality

But there was another, and more philosophical cause, of this interest in natural beauty. If it was to have its place among the objects of philosophical enquiry then beauty, or the pursuit of it, should be a human universal. Kant followed Shaftesbury in supposing that taste is common to all human beings, a faculty rooted in the very capacity for reasoning that distinguishes us from the rest of nature. All rational beings, he believed, have the capacity to make aesthetic judgements; and in a life properly lived taste is a central component.

However, many people seem to live in an aesthetic vacuum, filling their days with utilitarian calculations, and with no sense that they are missing out on the higher life. Kant's response to this is to deny it. People may seem to live in an aesthetic vacuum, he would say, only to those who believe that aesthetic judgement must be exercised in some specific area, such as music, literature or painting. In fact, however, appreciation of the arts is a secondary exercise of aesthetic interest. The primary exercise of judgement is in the appreciation of nature. In this we are all equally engaged, and though we may differ in our judgements, we all agree in making them. Nature, unlike art, has no history, and its beauties are available to every culture and at every time. A faculty that is directed towards natural beauty therefore has a real chance of being common to all human beings, issuing judgements with a universal force.

Two aspects of nature

Most of Kant's examples of natural beauty are organisms—plants, flowers, birds and the creatures of the sea, whose perfection of form and intricate harmony of detail speak to us of an order that lies deep in ourselves. However, in the pioneering work of Joseph Addison and Francis Hutcheson, who had made natural beauty central to the subject of aesthetics, landscapes, scenery and 'views' had occupied a more central place. Kant hardly mentions those things. The difference here is not just a matter of emphasis, but reflects two quite different experiences.

Kant described the judgement of beauty as a 'singular' judgement, which represents its object 'apart from all interest'. This seems to imply that beauty belongs to *individuals*, which can be isolated and perceived as such. But landscapes and views leak out in every direction; they are infinitely porous and with uncertain criteria of identity. We may see them as individuals; but this is our doing, so to speak, not theirs. Even if we succeeded in putting a frame around a landscape by confining it within high hedges, it would not

be inoculated thereby from aesthetic contagion. The invisible suburbs over each horizon affect the appearance of the fields, causing us to see as enclosed and hampered what might otherwise have delighted us as an open vista. And the most beautiful landscape can be thrown into the background by the factory or motorway next door, which marks it indelibly with the sign of human dominance.

Birds, bees and flowers, by contrast, have boundaries—they are *framed* by their own nature. And their individuality is a deep characteristic, which they possess in themselves, regardless of how we perceive them. Like paintings, which are shielded from aesthetic pollution by their frames, organisms possess an air of aesthetic untouchability. Bathed by the aesthetic gaze they separate themselves from all relations, other than the relation with the one who studies them.

Hence it is easy to describe the natural objects that we can hold in our hands, or move into view, as we would describe works of art: and this conditions the kind of pleasure we take in them. They are *objets trouvés*, jewels, treasures, whose perfection seems to radiate from themselves, as from an inner light. Landscapes by contrast are very far from works of art—they owe their appeal not to symmetry, unity and form, but to an openness, grandeur and world-like expansiveness, in which it is we and not they that are contained.

Discovering nature

That distinction is important, though not directly relevant to the first question that we must raise about the cult of natural beauty, which is the question of its historical context. The mastery over nature, its conversion into a safe and common home for our species, and the desire to protect the dwindling wilderness, all fed into the impulse to see the natural world as an object of contemplation, rather than as a means to our goals. However,

the eighteenth-century philosophy of natural beauty was far from achieving the universality to which it aspired. It was a product of its time in the same way as the poems of Ossian and Rousseau's *Nouvelle Héloïse*, just a step away from the romantic landscape art of Friedrich, Wordsworth and Mendelssohn, and as time-bound in its focus as they are. Other eras and other cultures often have had no use for the contemplative attitude towards the natural world. During many periods of history nature has been harsh and inhospitable, something against which we must fight for our livelihood, and which offers no consolation when contemplated with the cool eye of the beholder. And maybe the periods of respite are rare gifts of our 'niggardly stepmother Nature', as Kant elsewhere describes her.

Aesthetics and ideology

Certain thinkers in the Marxist tradition add a further twist to that argument. When the followers of Shaftesbury presented their theories of disinterested interest they were not, such thinkers suggest, describing a human universal but merely presenting, in philosophical idiom, a piece of bourgeois ideology. This 'disinterested' interest becomes available only in certain historical conditions, and is available because it is functional. The 'disinterested' perception of nature, of objects, of human beings and the relations between them, confers on them a trans-historical character. It renders them permanent, ineluctable, part of the eternal order of things. The function of this way of thinking is to inscribe bourgeois social relations into nature, so placing them beyond the reach of social change. In seeing something as an 'end in itself', I immortalize it, lift it out of the world of practical concerns, mystify its connection to society, and to the process of production and consumption on which human life depends.

More generally the idea of the aesthetic encourages us to believe that by isolating objects from their use, and purifying them of the

economic conditions that produced them or which tied them to human interests, we somehow see what they truly are and what they truly mean. We thereby turn our attention away from the economic reality and gaze on the world as though under the aspect of eternity, accepting as inevitable and unchangeable what ought to be subject to politically organized change. Moreover, while rejoicing in the fiction that both people and things are valued as 'ends in themselves', the capitalist economy treats everything and everyone as a means. The ideological lie facilitates the material exploitation, by generating a false consciousness that blinds us to the social truth.

A rejoinder

I have condensed into those paragraphs a tradition of difficult, often flamboyant, argumentation. Readers may wonder why they should be troubled by the attempt to dismiss this or that aspect of our thinking as 'bourgeois ideology', now that the Marxist concept of the 'bourgeoisie' as an economic class has been exploded. However, it would be naive to approach the subject of aesthetics as though the Marxist tradition had played no part in defining it. Versions of the Marxist critique occur in Lukács, Deleuze, Bourdieu, Eagleton and many more, and continue to exert their influence over the humanities, as these are studied in English and American universities. And in all versions the critique presents a challenge. If we cannot justify the very *concept* of the aesthetic, except as ideology, then aesthetic judgement is without philosophical foundation. An 'ideology' is adopted for its social or political utility, rather than its truth. And to show that some concept—holiness, justice, beauty, or whatever—is ideological, is to undermine its claim to objectivity. It is to suggest that there is no such thing as holiness, justice or beauty, but only the belief in it—a belief that arises under certain social and economic relations and plays a part in cementing them, but which will vanish as conditions change.

In response we should transfer the burden of proof. It is true that the *word* 'aesthetic' came into its present use in the eighteenth century; but its purpose was to denote a human universal. The questions I have been discussing in this book were discussed in other terms by Plato and Aristotle, by the Sanskrit writer Bharata two centuries later, by Confucius in the *Analects* and by a long tradition of Christian thinkers from Augustine and Boethius, through Aquinas to the present day. The distinctions between means and ends, between instrumental and contemplative attitudes, and between use and meaning are all indispensable to practical reasoning, and associated with no particular social order. And although the vision of nature as an object of contemplation may have achieved special prominence in eighteenth-century Europe, it is by no means unique to that place and time, as we know from Chinese tapestry, Japanese woodcuts, and the poems of the Confucians and of Basho. If you want to dismiss the concept of aesthetic interest as a piece of bourgeois ideology, then the onus is on you to describe the non-bourgeois alternative, in which the aesthetic attitude would be somehow redundant, and in which people would no longer need to find solace in the contemplation of beauty. That onus has never been discharged. Nor could it be.

The universal significance of natural beauty

Having identified aesthetic interest as essentially contemplative, Kant was naturally inclined to describe its characteristic object as something not made but found. With artefacts our practical reason is often too vigorously engaged, he seemed to think, to permit the stepping back that is required by aesthetic judgement. And he made a distinction between the 'free' beauty that we experience from natural objects, which comes to us without the deployment of any concepts on our part, and the 'dependent' beauty that we experience in works of art, and which depends upon a prior conceptualization of the object. Only towards nature can we achieve a sustained disinterest, when our own purposes—including

the intellectual purposes that depend upon conceptual distinctions—become irrelevant to the act of contemplation.

There is something plausible in the idea that the contemplation of nature is both distinctive of our species and common to its members, regardless of the social and economic conditions into which they are born; and something equally plausible in the suggestion that this contemplation fills us with wonder, and prompts us to search for meaning and value in the cosmos, so as with Blake

> To see a world in a grain of sand
> And a Heaven in a wild flower...

From the earliest drawings in the Lascaux caves to the landscapes of Cézanne, the poems of Guido Gezelle and the music of Messiaen, art has searched for meaning in the natural world. The experience of natural beauty is not a sense of 'how nice!' or 'how pleasant!' It contains a reassurance that this world is a right and fitting place to be—a home in which our human powers and prospects find confirmation.

This confirmation can be obtained in many ways. When, on some wild moor, the sky fills with scudding clouds, the shadows race across the heather, and you hear the curlew's liquid cry from hilltop to hilltop, the thrill that you feel is an endorsement of the things you observe and of you, the observer. When you pause to study the perfect form of a wildflower or the blended feathers of a bird, you experience an enhanced sense of belonging. A world that makes room for such things makes room for you.

Whether we emphasize the comprehensive view or the individual organism, therefore, aesthetic interest has a transfiguring effect. It is as though the natural world, represented in consciousness, justifies both itself and you. And this experience has a metaphysical resonance. Consciousness finds its rationale in transforming the

outer world into something inner—something that will live in memory as an idea. Rilke, in the *Duino Elegies*, goes further, and suggests that the earth too finds its fulfilment in this transformation, achieving, when dissolved in consciousness, the inwardness that redeems both itself and the person who truly observes it.

It is not the knowledge of nature that carries this transforming effect, but the experience. Scientists appreciate the intricacies of the natural world. But science is not sufficient—nor is it necessary—to generate the moments of transfiguration that Wordsworth records in *The Prelude*, or the joy expressed by John Clare in passages like this:

> I see the wild flowers, in their summer morn
> Of beauty, feeding on joy's luscious hours;
> The gay convolvulus, wreathing around the thorn,
> Agape for honey showers;
> And slender kingcup, burnished with the dew
> Of morning's early hours,
> Like gold yminted new...

In the experience of beauty the world *comes home* to us, and we to the world. But it comes home in a special way—through its presentation, rather than its use.

Nature and art

But here a difficulty arises. How do we separate, in our experience and our thinking, the works of nature from the works of man? The thorn around which Clare's convolvulus wreathes surely belongs to a laid blackthorn hedge. The beauty of the English landscape, as recorded by Constable, is minutely dependent upon the work of human beings, both for the arrangement of fields, copses and coverts, and for the hedgerows and walls which are everywhere apparent, and which form an integral part of the

perceived harmony. Constable is portraying a home, a place bent to human uses and bearing in every particular the imprint of human hopes and goals (though censoring out, some say, the real condition of the rural labourer).

In other words the beauty of a landscape is often bound up with its human significance as a quasi-artefact, bearing the visual imprint of a culture. And to appreciate it we must learn with Wordsworth

> To look on nature, not as in the hour
> Of thoughtless youth; but hearing oftentimes
> The still, sad music of humanity…

Kant avoids this difficulty by taking plants and animals as his primary material. But even plants and animals may bear the mark of human design. Some of the most beautiful—horses and tulips for instance—are the products of conscious artifice over centuries. Dogs and horses are shown for their beauty, but the credit goes to their breeders.

Some argue in response that we attribute beauty to natural things only by analogy, seeing the works of nature as though they were works of art. But this is surely implausible. Works of art interest us in part because they represent things, tell stories about things, express ideas and emotions, convey meanings that are consciously intended: and to approach natural objects with similar expectations is to misunderstand them. It is also to miss the true source of their beauty, which is their independence, their apartness, their capacity to show that the world contains things *other* than us, which are just as interesting as we are.

Various writers—notably Allen Carlson and Malcolm Budd—have therefore argued that natural beauty attaches to an object only when it is perceived *as* natural, and only when its appearance is not the object of human design—for it is only in these conditions

that we have any grounds for thinking that there is such a thing as *natural* beauty, with its own place in the realm of intrinsic values.

This is not to say that we should *exclude* human activity from our conception of nature. When I enjoy the pastures and hedgerows of the English landscape I am not merely aware that those things arise from human labour and intention. I appreciate the scene as marked by a way of life, a repeated homebuilding and homecoming. That is why this landscape has such a deep spiritual significance, not for me only, but for Englishmen down the centuries—and for those like John Clare, Paul Nash and Ralph Vaughan Williams who distilled its meaning into art. Nevertheless, I do not see the landscape as expressly designed by people to look as it does, even if they were moved in many things (the laying of that hedge, the symmetries of that fence, the assembling of that dry stone wall) by aesthetic intentions. Nor do I approach the landscape with the constraints and expectations that I bring to my experience of art. I see it as the free elaboration of nature, in which human beings appear because they too are natural, leaving behind them this unintended mark of their presence and unintended record of their griefs and joys.

Allen Carlson has further argued that this 'seeing nature as nature', which lies at the heart of our experience of natural beauty, commits us to approaching nature *as it really is*, and that means adopting the standpoint of the naturalist, exploring what we see in the light of scientific and environmental knowledge. The aesthetic interest in the shape, flight and song of a bird, for example, is the doorway to ornithology, which completes the act of appreciation that began in the experience of beauty. The aesthetic interest in the colours and forms of a landscape leads towards environmental science, and the study of agriculture.

Although there is certainly room for this scientific extension of our interest in natural beauty, we should not forget that the aesthetic interest in nature is an interest in appearances, and not necessarily

in the science that explains them. There is truth in Oscar Wilde's quip, that it is only a shallow person who does not judge by appearances. For appearances are the bearers of meaning and the focus of our emotional concerns. When I am struck by a human face this experience is not a prelude to some anatomical study, nor does the beauty of what I see lead me to think of the sinews, nerves and bones which in some way explain it. On the contrary, to see 'the skull beneath the skin' is to see the body and not the embodied person. Hence, following the argument of the last chapter, it is to miss the beauty of the face. And the same often goes for natural beauty. The ornithologist understands the song of the blackbird as a territorial marker, an adaptation that plays a distinctive role in sexual selection. We hear it as melody—and the concept of melody, which has no place in the experience of the blackbird, has no place in the science of his behaviour. (I return to this point in the chapter that follows.)

The phenomenology of aesthetic experience

Another way of putting that last point is to say that the experience of natural beauty belongs to our 'intentional' rather than our scientific understanding: it is focused on nature as it is represented in our experience, rather than on nature as it is. To understand natural beauty we must clarify *the way natural things appear* when focused in the aesthetic gaze. And the way things appear depends upon the categories we bring to bear on them. When looking on the world disinterestedly I don't just open myself to its presented aspect; I bring myself into relation with it, experiment with concepts, categories and ideas that are shaped by my self-conscious nature.

This process is illustrated in the art of painting. Landscapes painted by Poussin, by Corot, by Harpignies and by Friedrich may record similar arrays of mountains, fields and trees. But the posture of contemplation in each case fills the perception with the distinctive soul of the painter, and creates an image that is

inimitably *his*. Likewise, nature offers to all of us a field of free perception. We can let our faculties rest in the scene before them, receiving and exploring without the need to decipher what is being said to us. Even if human beings had a part in creating the landscape before my eyes, it is not there to communicate some exact artistic intention; its details are thrown down by history, and may change from day to day. But it is this very 'there-ness' of the natural world that enables me to lose myself in it, to see it now from one vantage point, now from another, now under one description, now under another.

Works of art are expressly *presented* as objects of contemplation. They are framed on the wall, contained between the covers of a book, installed in the museum or reverently performed in the concert hall. To change them without the artist's consent is to violate a fundamental aesthetic propriety. Works of art stand as the eternal receptacles of intensely intended messages. And often it is only the expert, the connoisseur or the adept who is fully open to what they mean. Nature, by contrast, is generous, content to mean only herself, uncontained, without an external frame, and changing from day to day.

The sceptic may well say that it is stretching belief to suppose that everyone, including the uneducated and the relentlessly practical, should be given to experiencing natural beauty, when the experience is described in such an involved and philosophical way. But that response mistakes the true nature of phenomenology, which is an attempt to convey how things appear, even to people who themselves have never made that attempt. The most ordinary people fall in love: but how many can describe the intentionality of this strange emotion, or find the concepts which describe the way in which lovers experience the world? Similarly, the most ordinary people make judgements of natural beauty, even though few if any could express what they perceive, when the world before them suddenly changes character, from a thing to be used to a thing to be witnessed.

The sublime and the beautiful

I earlier remarked that 'beautiful' is used both as a general term of aesthetic praise, and more narrowly, to denote a particular kind of grace and charm by which we may be enraptured. In the aesthetic context words have a tendency to slip and slide, behaving more like metaphors than literal descriptions. And the reason for this is plain. We are not, in aesthetic judgement, simply describing some object in the world. We are giving voice to an *encounter*, a meeting of subject and object, in which the response of the first is every bit as important as the qualities of the second. To understand beauty, therefore, we must gain some sense of the variety of our responses to the things in which we discern it.

This point has been evident at least since Edmund Burke's treatise *On the Sublime and Beautiful* of 1756. Burke discerned two radically distinct responses to beauty in general, and to natural beauty in particular: one originating in love, the other in fear. When we are attracted by the harmony, order and serenity of nature, so as to feel at home in it and confirmed by it, then we speak of its beauty; when, however, as on some wind-blown mountain crag, we experience the vastness, the power, the threatening majesty of the natural world, and feel our own littleness in the face of it, then we should speak of the sublime. Both these responses are elevating; both lift us out of the ordinary utilitarian thoughts that dominate our practical lives. And both involve the kind of disinterested contemplation that Kant was later to identify as the core of the aesthetic experience.

The distinction between the sublime and the beautiful was therefore taken up by Kant, who regarded it as fundamental to understanding the judgement of taste. There is no meaningful comparison to be made between the kind of serene and soporific landscape that we know from English pastures and the wild torrents of an Alpine slope or the vast panoply of the stars, the first

5. The beautiful ...

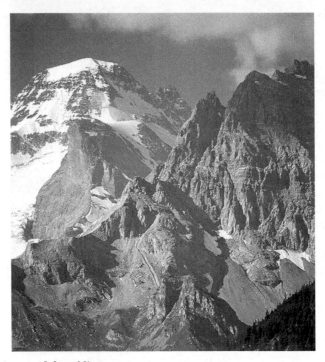

6. ...and the sublime

of which overwhelms us with a vision of nature's infinite power, the second with a vision of her infinite extent. The beautiful landscape prompts us to a judgement of taste; the sublime vista invites another kind of judgement, in which we measure ourselves against the awesome infinity of the world, and become conscious of our finitude and frailty.

In the experience of the sublime, Kant went on to argue (though in a way that commentators have found more suggestive than persuasive) we are presented with an intimation of our own worth, as creatures who are both conscious of the vastness of nature, and also able to affirm ourselves against it. Somehow, in the very awe that we experience before the power of the natural world, we sense our own ability as free beings to measure up to it, and to reaffirm our obedience to the moral law, which no natural force could ever vanquish or set aside.

Landscape and design

Landscapes do not confront us with design as paintings do, and if they say anything to us this is not because they are the middle term in some act of communication. As I suggested, human design may adjust nature at the edges, with boundaries, ploughed fields and plantations, but our reaction to nature is directed to forces that are more deeply embedded in the scheme of things and more longer lasting than any human ambition.

So it would seem at least. Surely, therefore, the kind of meaning that we find in nature, when we contemplate its beauties, cannot have much to do with the kind of meaning that is presented to us in art, where every detail, every word, note or pigment, is saturated with intention, and inspired by an artistic idea. It is not surprising that, while the shelves of libraries groan under the weight of literary criticism, musical analysis, comparative history of art and a hundred other attempts to make sense of our artistic inheritance and to decipher the messages that it contains for us,

the shelves devoted to natural beauty, where we might go to learn whether we should do better to contemplate the hills of Mongolia or those of Andalusia, are empty or non-existent. Criticism fails to get a purchase here, where no art exists to provoke it. The best we have is guide-books.

Although true so far as it goes, that observation ignores two vital features of our encounter with the natural world. The first is the role of nature as raw material for visual art. The great landscape gardeners of the eighteenth century, such as William Kent and Capability Brown, were responding to the taste of their patrons. They lived at a time when cultivated people made discriminations between landscapes, argued over what was or was not in good taste, and set out to build, dig, plant and adjust with intentions comparable to those of the painter whom they would later commission to record the outcome.

Indeed, the cult of the 'picturesque' arose because our responses to landscape and our responses to painting feed into each other. The eighteenth-century habit of decorating the landscape with ruins began from a love of the Roman Campagna not as it is, but as Poussin and Claude had painted it. Tourists in the eighteenth century would often travel with a 'Claude Glass': a small tinted convex mirror, which helped them to appreciate the landscape by compressing and composing it in a manner reminiscent of Claude. And the landscape architects of the day regarded architectural ruins and follies, as well as classical bridges and temples, as continuous with the trees, lakes and artificial mounds of earth which were the raw material of their art. It is difficult to believe that our attitude to natural beauty is founded completely differently from our attitude to art, when the two are so intimately connected. Planning law in Europe has always been sensitive to the threat that buildings pose to natural beauty, and has tried, with limited success, to control the style, size and materials of buildings in the countryside, in order to safeguard our shared aesthetic inheritance. Buildings are not *apart* from the landscape, as the

walls and windows of the gallery are apart from the paintings that hang in it, and which are shielded from their surroundings by their frames. Buildings are *in* the landscape and part of it. Hence the experience of beauty comprehends landscape and architecture equally.

Moreover, beauty and design are connected in our feelings. Although we appreciate the sea-shell, the tree, or the cliff-face without referring to any purpose for which they were made, they each of them inspire the thought of a 'purposiveness without purpose', to use Kant's phrase. In certain passages Kant seems to imply that, although this thought is without rational grounds, and can provide no knowledge, either of the goal of creation, or of the nature of God, it nevertheless contains a kind of wordless intimation of our worth as moral beings, and of the orderliness and 'finality' of our world.

<div style="margin-right: auto; float: right;">Natural beauty</div>

> Hence in a season of calm weather
> Though inland far we be,
> Our Souls have sight of that immortal sea
> Which brought us hither,
> Can in a moment travel thither,
> And see the Children sport upon the shore,
> And hear the mighty waters rolling evermore.
>
> (Wordsworth, *Ode: Intimations*
> *of Immortality*, 161–7)

Kant also believed that natural beauty is a 'symbol' of morality, and suggested that people who take a real interest in natural beauty thereby show that they possess the germ of a morally good disposition—of a 'good will'. His argument for this opinion is elusive: but it is an opinion that he shared with other eighteenth-century writers, including Samuel Johnson and Jean-Jacques Rousseau. And it is an opinion to which we are instinctively drawn, hard though it is to mount an *a priori* argument in its favour.

Purposiveness without purpose

The discussion in this chapter has brought us to a crux. I began from the suggestion that aesthetic judgement, like the pleasure that motivates it, is disinterested. And this seemed to imply that beauty and utility are independent values, so that appreciating something for its beauty is quite distinct from appreciating it as a means to some practical purpose.

However, purpose, interest, and practical reason keep finding their way back into this judgement from which I began by excluding them. The experience of beauty in architecture, for example, cannot be detached from a knowledge of the functions that a building must serve; the experience of human beauty cannot be easily detached from the profoundly interested desire which stems from it. The experience of beauty in art is intimately connected with the sense of artistic intention. And even the experience of natural beauty points in the direction of a 'purposiveness without purpose'. The awareness of purpose, whether in the object or in ourselves, everywhere conditions the judgement of beauty, and when we turn this judgement on the natural world it is hardly surprising if it raises, for us, the root question of theology, namely, what purpose does this beauty serve? And if we say that it serves no purpose but itself, then whose purpose is that? Once again we recognize that the beautiful and the sacred are adjacent in our experience, and that our feelings for the one are constantly spilling over into the territory claimed by the other.

To describe beauty as 'purposive without purpose' is, however, to intensify the mystery. Hence I propose to move away from these exalted regions into the realm of everyday beauty—the realm in which all rational beings live and work, however unconcerned with aesthetic matters they may appear to be. By considering the place of beauty in ordinary practical reasoning, where purpose is at the forefront of our thinking, I will try to show just why aesthetic judgement is a necessary part of doing anything well.

Chapter 4
Everyday beauty

The best place to begin the exploration of everyday beauty is in the garden, where leisure, learning and beauty come together, in a liberating experience of home.

Gardens

Without the core experience of natural beauty, gardens would be unintelligible except as vegetable patches devoted to a human use. Yet even vegetable patches have their aesthetic constraints, being arranged in rows and neatly spaced, so as to satisfy our need for visual order. In the case of pleasure gardens we encounter a universal object of interest, to which people everywhere devote much of their spare time in a labour of pure disinterested enjoyment. And gardens have their own distinctive phenomenology, in which nature is taken up, tamed and made obedient to human visual norms.

A garden is not an open space like a landscape, but a surrounding space. And that which grows and stands in it, grows and stands *around* the observer. A tree in a garden is not like a tree in a forest or a field. It is not simply there, growing from some scattered seed, accidental in both place and time. It enters into a relation with the people who walk in the garden, belongs with them in a kind of conversation. It takes its place as an extension of the human world,

7. Winding path at Little Sparta, Ian Hamilton Finlay: between nature and art

mediating between the built environment and the world of nature. Indeed, there is a phenomenological 'between-ness' that infects all our ordinary ways of enjoying a garden. This experience feeds into our core experience of architectural forms and decorations, as things designed to conquer space and enclose it, to capture it from nature and to present it as *ours*. Hence the frequent, if fanciful, comparison made by treatises of architecture between column and tree-trunk. And hence the forms of garden art, which we might aptly describe as the art of between—the art of being neither art nor nature, but both, each folded over the other so as to be at one, as in the flower borders of Gertrude Jekyll or the garden installations of the Scottish poet Ian Hamilton Finlay.

This attempt to match our surroundings to ourselves and ourselves to our surroundings is arguably a human universal. And it suggests that the judgement of beauty is not just an optional addition to the repertoire of human judgements, but the unavoidable consequence of taking life seriously, and becoming truly conscious of our affairs.

Handiwork and carpentry

The point is yet more evident if we turn to another of those intermediate areas in which ordinary people seem unavoidably drawn into making aesthetic judgements: the area of handiwork and decoration, in which we make choices as to how our surroundings should look.

Suppose you are fitting a door in a wall and marking out the place for the frame. You will step back from time to time and ask yourself: does that look right? This is a real question, but it is not a question that can be answered in functional or utilitarian terms. The door-frame may be just what is needed for the traffic to pass through, it may comply with all requirements of health and safety, but it may simply not look right: too high, too low, too wide, wrong shape and so on. (Indeed, the current building code, which requires that entrance doors be wide enough, and doorsteps low enough, to take a large invalid's wheelchair, makes it all but impossible to design a front door that looks right, in the way that ordinary Georgian pattern-book doors look right.) Those judgements do not refer us to any utilitarian goal, but they are rational for all that. They might be the first step in a dialogue, in which comparisons are made, examples urged, and alternatives discussed. And the subject-matter of this dialogue has something to do with the way things fit together, and a hoped-for harmoniousness in the completion of an ordinary physical task.

That is the kind of example, it seems to me, that Kant ought to have used, in order to establish his point that there is an exercise of the

Fig.1

Fig.2

Fig.3

8. Door from a Georgian pattern-book: how part fits to part

rational faculties that is both purposive, and pointing beyond purpose, to the contemplation of the way things appear. For the example shows not merely that there is indeed such an exercise of the rational faculties, but that it forms an integral part of practical decision-making. There are other examples that bring the point home. Consider what goes on when you lay the table for guests: you will not simply dump down the plates and cutlery anyhow. You will be motivated by a desire for things to look right—not just to yourself but also to your guests. Likewise when you dress for a

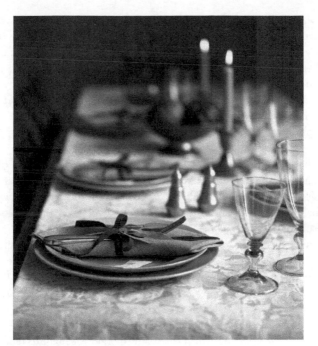

9. The aesthetics of everyday life

party of a dance, even when you arrange the objects on your desk or
tidy your bedroom in the morning: in all these cases you are striving
for the right or appropriate arrangement, and this arrangement has
to do with the way things look. The examples point us to 'the
aesthetics of everyday life', for a long time a neglected topic, the
neglect of which explains, indeed, many of the ways in which people
misunderstand architecture and design, wrongly construing as a
form of high art what is more usually an exercise in discretion.

Beauty and practical reasoning

Like us, non-rational animals live in a world of redundancies.
A horse, faced with a level fence, has infinitely many places at
which he can jump it. If he jumps it is because he wants to—

whether to escape an enemy or to follow the herd. But there is, for the horse, no answer to the question which place in the fence is the right place at which to jump, not because all places are on a par but because there is for the horse no such question. *We* can ask questions like that, since we have the habit of removing redundancies, justifying individual actions, doing not just what achieves our goals but what also achieves them in the most appropriate or fitting way.

This point can be brought out by returning to the case of songbirds. The songs of songbirds have a function in the process of sexual selection, and are emitted at the times of day—after waking and before sleeping—when an active male needs to mark the boundaries of his patch. This function is not a purpose of the bird's: he doesn't have purposes, even if he is motivated by desires, since his life is not lived according to any plans. Moreover, the song is under-determined by the function, which requires only that it be loud enough to be heard by competitors and potential mates, and recognizable either as the voice of the species or, when territories are close together and confined, as the voice of the individual occupant. Not surprisingly, therefore, songbirds tend to utter varied and variable calls, trying out phrases and notes before settling on a few characteristic turns of phrase which feature as refrains in their daily litany.

We hear these phrases as song-like, and we describe birdsong as a kind of music, for that is how we hear it. But there is nothing in the bird's behaviour that could conceivably lead us to say that he has chosen one note as the fitting successor to another, that he has hit on this phrase as exactly the right phrase for the context, that he hears one note as a continuation of the phrase that preceded it, and so on. None of those judgements has an application in ornithology, since they are judgements that apply only to rational beings—beings who don't just hit on one of the infinitely many alternatives before them, but who seek out reasons for doing so,

whether before or after the event, and who hear sequences of sounds in terms of the musical logic that binds them.

How can a rational being close redundancies of the kind that lie open forever in the song of a bird? Let us return to the example of the carpenter. How does the carpenter choose among the possible doorframes that suit the given function? On the basis of what *looks right*. He is judging the object in terms of its appearance, and searching in this appearance for a reason that would justify his choice.

Reason and appearance

Important consequences follow. When I choose a doorframe on the grounds that it looks right I have to confront, whether from myself or from another, the question 'why?' 'It just does' is one possible answer. Or I may make comparisons, search for meanings, look for customs and traditions that vindicate my choice. But what I cannot do is to assign to the appearance a merely instrumental value, for example, by saying that 'doors of that shape attract older customers'. For that would be to abandon my initial judgement. It would be to rest my case not in the way the door appears to me, but in the utility of its appearing that way to others. It would be to retreat to a judgement of utility, one that I could reasonably and sincerely affirm even if the doorframe looked entirely wrong to me.

By contemplating the appearance of the doorframe, the carpenter finds the way to close off the redundancy of choices before him. Since the appearance has been detached in his thinking from the practical considerations that propose infinitely many doorframes as equally suitable, he is now launched on a path of discovery—to find the reasons that would justify *this* frame, and which would justify it on account of the way it looks. He will compare the doorframe with others, and also with the window-frames that are to be placed to either side. He will try to discover what fits to other visual details in the building. He will be trying to match the

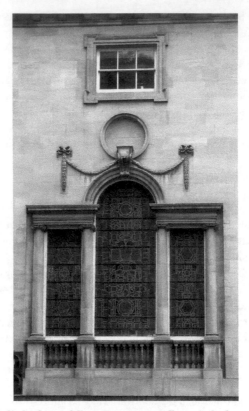

10. Palladio leads, we follow: Worcester College, Oxford

doorframe to the building as a whole, and also to the parts of it. One result of this process of matching is a visual vocabulary: by using identical mouldings in door and window, for example, the visual match becomes easier to recognize and to accept. Another result is what is loosely described as style—the repeated use of shapes, contours, materials and so on, their adaptation to special uses, and the search for a repertoire of visual gestures.

Agreement and meaning

So far you may think that nothing has been added to the
deliberations of the carpenter other than a kind of game he plays
with himself, by way of closing off the redundancies left by real
practical choice. However, two considerations cast doubt on that
response. The first is that the carpenter is not the only person who
will have a view in the matter of the doorframe. Others too will look
at the doorframe and be either pleased or displeased with its
proportions. Some of these will have an interest in the door, as
future residents of the building to which it will be fitted. Others will
have the interest of passers-by and neighbours. But all will have an
interest in the way the door looks: and the less practical their
involvement, the greater that interest will be. Here is the beginning
of what game theorists call a 'coordination problem'.

One way of resolving such a problem is to strive for agreement: if
there is a single choice—or a range of choices—on which we can all
agree, then the problem ceases to be a problem. Even in the
absence of explicit agreement, however, a solution might emerge
over time, as unpopular choices are rejected, and popular choices
endorsed. Thus the great innovators like Palladio suggest forms
and compositions (such as the Palladian window) that elicit the
spontaneous approval of others, while the ordinary builders of
streets adapt by a process of trial and error. Both processes add to
the shared vocabulary of forms, materials and ornaments. A kind
of rational discourse emerges, the goal of which is to build a shared
environment in which we can all be at home, and which satisfies
our need that things look right to everyone. This aspect of the
aesthetic—its socially derived and socially motivated status as a
guide to our shared environment—is something suggested by its
nature as a redundancy closing device.

Redundancy is not a uniform feature of our aims and artefacts.
In some areas—the design of gardens, for instance—redundancies

surround us on every side; in other areas, such as the design of aeroplanes, strict necessity governs almost all that can be done. But even when functionality rules, our sense of beauty alertly distinguishes the fitting from the arbitrary, and the stylish from the improvised. We find more to admire in sleek aerodynamics than in bulbous accretions. But the beautiful aeroplane achieves what the beautiful doorframe achieves for our imaginary carpenter: a fitting solution to a problem that can be solved in more than one way.

The second consideration is that the look of something, when it becomes the object of intrinsic interest, accumulates meaning. You can simply enjoy the look for what it is. But rational beings have an inherent need to interpret, and when the object of their attention is an appearance, then they will interpret the appearance as something intrinsically meaningful. Even so simple a thing as the design for a doorframe will be subject to this need. The carpenter will associate door-shapes with specific forms of social life, with ways of entering and leaving a room, with styles in dress and behaviour. It has long been noticed, indeed, that fashions in dress and fashions in architecture have a tendency to imitate each other, and that both reflect the changing ways in which the human being and the human body are perceived.

Taking those two considerations together, we reach the following interesting suggestion, which is that, whenever people attempt to close up the redundancy of practical reasoning by choosing between appearances, they are also disposed to interpret those appearances as intrinsically meaningful, and to present the meaning that they discover through a kind of reasoned dialogue, the goal of which is to secure some measure of agreement in judgements among those who have an interest in the choice. In saying this, we come very close to the eighteenth-century idea of taste, as a faculty whereby rational beings order their lives through a socially engendered sense of the right and wrong appearance. And it is not unreasonable to suggest that we are beginning to locate a genuine realm of rational life that corresponds to the

philosophical idea of the aesthetic, and which is both important in itself and philosophically problematic.

Style

We depend on the habit of aesthetic judgement to communicate meanings. And one important tool that we use is style. This involves a conscious exploitation of socially engendered norms. The flower in the buttonhole, the jug full of wine, the folded napkin: all such things spark off an experience of recognition in observers, who see a specific meaning in the specific detail precisely because they sense a background order without specific meaning, against which the gesture is to be measured. Why is the wine in a jug and not a bottle? What is it about this jug that draws my attention? Why should it be just *there* on the table? And so on.

Such questions point us in the direction of the allusiveness of style. The jug *alludes* to a certain form of life: the mediterranean life in which rough wine is in plentiful supply, and in frictionless relation to both work and play. That is why the hostess chose a jug of naively decorated earthenware, and why she put it in the middle of the table, signifying the easy-going use of it in which we help ourselves. These may not be *conscious* choices. The hostess is herself discovering, in the aesthetic endeavour, the meaning that she wishes to convey. The example suggests indeed a role for aesthetic choices in promoting self-knowledge—in coming to understand how you yourself fit in to the world of human meanings. Aesthetic choices form a part of what Fichte and Hegel called the *Entäusserung* (the outward projection) of the self and the *Selbstbestimmung* that it generates: the self-certainty that comes through building a presence in the world of others.

Most ways of laying a table are stable explorations of the background: nothing specific is alluded to, and order is the operative goal—an order which does nothing to disturb our perceptions but which radiates a simple message of calm

sociability. The hostess with style turns that order in another direction, alluding to matters that she makes visibly present at the table, and which inhabit the look of things like a narrative.

Through style we grasp what is being emphasized, what is placed in the background, and what is being connected with what. Hence style is one of the features of everyday aesthetic judgement that we carry over into art, where it takes on a wholly new significance. That which secures our part in everyday social existence, in art becomes the shaping spirit of imaginary worlds.

Fashion

It is clear from the argument of this chapter that the search for aesthetic solutions in everyday life is also a kind of covert pursuit of consensus. Even those who dress so as to stand out and draw attention to themselves do so in order that others should recognize their intention. In any normal human community, therefore, the aesthetics of everyday life will express itself through fashion—in other words, through the communal adoption of a style. A fashion is a guide to aesthetic choices which offers some kind of guarantee that others will endorse them. And it permits people to play with appearances, to send recognizable messages to the society of strangers, and to be at one with their own appearance in a world where appearances count.

Fashion arises in the first instance by imitation. Sometimes the imitation is the result of an 'invisible hand'—as when people imitate one another by social contagion. Such is the normal origin of folk costumes, which arise as manners arise, from the mutual dealings of countless people over time, each striving to avoid useless offence and to appear in society as one who belongs there. But imitation can also result from leadership, as it did when Beau Brummel set the fashion for Regency England, or when the Beatles changed the way of dressing, the hair-styles and the language of their generation, along with its musical idiom.

All such phenomena testify to the important place that aesthetic thinking occupies in the life of rational beings. And they offer a kind of proof that, when people think aesthetically, they are, as Kant said, 'suitors for agreement' with their kind.

Permanence and evanescence

Our discussion implies that aesthetic judgement can be exercised in two contrasting ways: to fit in and to stand out. In much of our activity we are 'home building', erecting in the teeth of change and decay, the permanent symbols of a settled form of life. The invisible hand to which I just referred moves of its own accord towards style, grammar and convention: and this is what we witness in vernacular architecture, in folk costumes, in table manners and in the customs and ceremonies of a traditional culture. Conventions create a background of unchanging order in our lives, a sense that there is a right way and a wrong way to proceed. They offer a way to complete our gestures and to make them publicly acceptable, as when a moulding completes an architrave, or a careful wrapping completes a gift. There are cultures in which this aspiration towards the fixed and the permanent takes on a dominating and even crushing form—the ancient Egyptian, for example—so that every aspect of life is shaped and mummified by conventions. In the record left by the Egyptians we witness an everyday life overwhelmed by aesthetic values, in which individual style has been absorbed and extinguished by an inflexible demand for order. More congenial to us is the aesthetic of ancient Rome, in which the aspiration to permanence is combined with an equal sense of the evanescence of life's joys, as expressed in the frescoes at Pompei and Herculaneum, and in the statues and grottoes of the Roman garden.

Although we value permanence, therefore, we are also aware of the fleetingness of our attachments, and have a natural desire to express this awareness in a publicly endorsed aesthetic. Indeed there are cultures—the traditional Japanese being the most

notable—in which the aesthetics of everyday life focuses on what is fleeting, allusive and animated by a poignant regret. Such cultures are every bit as wedded to convention and rule-guidedness as those that emphasize permanence. The Japanese tea ceremony, in which the offering of tea to a guest is elevated to the condition of religious ritual, offers a telling illustration of this aesthetic of transience. Rigorous conventions govern the utensils, the gestures, the flower arrangements and the nature and aspect of the tea hut. And because of these conventions, the areas of freedom—the movements of host and guest through the tea garden, the gestures and expressions as the tea bowl is offered and taken—take on a special significance and poignancy. The goal is precisely to capture the uniqueness and fleetingness of the occasion, as conveyed by the words *ichigo, ichie*: one chance, one meeting.

From the tea ceremony we learn something that we learn also from the vernacular architecture of our European cities—namely that fleeting joys and brief encounters become eternal values, when we set them in ritual and stone.

Fittingness and beauty

I have been analysing a particular form of practical reasoning, in which we choose among alternatives according to a sense of what fits. Fittingness is judged in terms of how things look, and in terms of the meaning contained in how they look. But I have not said anything directly about beauty, nor would my hypothetical carpenter have much use for that word.

However, if we return to our original platitudes, we will quickly see that the kind of judgement I have been discussing in this chapter corresponds exactly to the judgement of beauty. The fittingness I have been describing is pleasing; it is also a reason to attend to the thing that possesses it. It is an object of contemplation for its own sake, and its significance does not reside in some independent use. It is the subject-matter of a reasoned judgement which,

being rooted in experience, cannot be made at second hand. Fittingness is also a matter of degree, in just the way that beauty is a matter of degree. In short what I have been describing in this chapter is that very 'minimal beauty' which is a permanent interest of rational beings, as they strive to achieve order in their surroundings and to be at home in their common world.

It remains now to relate the thoughts of this chapter to those 'higher' forms of beauty which are exemplified by art, and to see if we can say anything further about the kind of meaning that is pursued when we reason in favour of our aesthetic judgements.

Chapter 5
Artistic beauty

Only in the course of the nineteenth century, and in the wake of Hegel's posthumously published lectures on aesthetics, did the topic of art come to replace that of natural beauty as the core subject-matter of aesthetics. And this change was part of the great shift in educated opinion which we know as the romantic movement, and which placed the feelings of the individual, for whom self is more interesting than other and wandering more noble than belonging, at the centre of our culture. Art became the enterprise through which the individual announces himself to the world and calls on the gods for vindication. Yet it has proved singularly unreliable as the guardian of our higher aspirations. Art picked up the torch of beauty, ran with it for a while, and then dropped it in the pissoirs of Paris.

Joking apart

A century ago Marcel Duchamp signed a urinal with the name 'R. Mutt', entitled it 'La Fontaine', and exhibited it as a work of art. One immediate result of Duchamp's joke was to precipitate an intellectual industry devoted to answering the question 'What is art?' The literature of this industry is as tedious as the never-ending imitations of Duchamp's gesture. Nevertheless, it has left a residue of scepticism. If anything can count as art, what is the point or the merit in achieving that label? All that is left is the

curious but unfounded fact that some people look at some things, others look at others. As for the suggestion that there is an enterprise of criticism, which searches for objective values and lasting monuments to the human spirit, this is dismissed out of hand, as depending on a conception of the art-work that was washed down the drain of Duchamp's 'fountain'.

The argument is eagerly embraced, because it seems to emancipate people from the burden of culture, telling them that all those venerable masterpieces can be ignored with impunity, that TV soaps are 'as good as' Shakespeare and Radiohead the equal of Brahms, since nothing is better than anything and all claims to aesthetic value are void. The argument therefore chimes with the fashionable forms of cultural relativism, and defines the point from which university courses in aesthetics tend to begin—and as often as not the point at which they end.

There is a useful comparison to be made here with jokes. It is as hard to circumscribe the class of jokes as it is the class of artworks. Anything is a joke if somebody says so. A joke is an artefact made to be laughed at. It may fail to perform its function, in which case it is a joke that 'falls flat'. Or it may perform its function, but offensively, in which case it is a joke 'in bad taste'. But none of this implies that the category of jokes is arbitrary, or that there is no such thing as a distinction between good jokes and bad. Nor does it in any way suggest that there is no place for the criticism of jokes, or for the kind of moral education that has an appropriate sense of humour as its goal. Indeed, the first thing you might learn, in considering jokes, is that Marcel Duchamp's urinal was one—quite a good one first time round, corny by the time of Andy Warhol's Brillo boxes and downright stupid today.

Art as a functional kind

Works of art, like jokes, have a dominant function. They are objects of aesthetic interest. They may fulfil this function in a rewarding

way, offering food for thought and spiritual uplift, winning for themselves a loyal public that returns to them to be consoled or inspired. They may fulfil their function in ways that are judged to be offensive or demeaning. Or they may fail altogether to prompt the aesthetic interest that they petition for. The works of art that we remember fall into the first two categories: the uplifting and the demeaning. The total failures disappear from public memory. And it really matters which kind of art you adhere to, which you include in your treasury of symbols and allusions, which you carry around in your heart. Good taste is as important in aesthetics as it is in humour, and indeed taste is what it is all about. If university courses do not start from that premise, students will finish their studies of art and culture just as ignorant as when they began. When it comes to art, aesthetic judgement concerns what you ought and ought not to like, and (I shall argue) the 'ought' here, even if it is not exactly a moral imperative, has a moral weight.

It is true, however, that people no longer see works of art as objects of judgement or as expressions of the moral life: increasingly many teachers of the humanities agree with their incoming students, that there is no distinction between good and bad taste, but only between your taste and mine. But imagine someone saying the same thing about humour. Jung Chang and Jon Halliday recount one of the few recorded occasions when the young Mao Ze Dong burst into laughter: it was at the circus, when a tight-rope walker fell from the high wire to her death. Imagine a world in which people laughed only at others' misfortunes. What would that world have in common with the world of Molière's *Tartuffe*, of Mozart's *Marriage of Figaro*, of Cervantes' *Don Quixote* or Laurence Sterne's *Tristram Shandy*? Nothing, save the fact of laughter. It would be a degenerate world, a world in which human kindness no longer found its endorsement in humour, in which one whole aspect of the human spirit would have become stunted and grotesque.

Imagine now a world in which people showed an interest only in replica Brillo boxes, in signed urinals, in crucifixes pickled in urine, or in objects similarly lifted from the debris of life and put on display with some kind of satirical or 'look at me' intention—in other words, the increasingly standard fare of official modern art shows in Europe and America. What would such a world have in common with that of Duccio, Giotto, Velazquez, or even Cézanne? Of course, there would be the fact of putting objects on display, and the fact of our looking at them through aesthetic spectacles. But it would be a world in which human aspirations no longer find their artistic expression, in which we no longer make for ourselves images of the transcendent, and in which mounds of rubbish cover the sites of our ideals.

Art and entertainment

In a striking work published a century ago the Italian philosopher Benedetto Croce pointed to a radical distinction, as he saw it, between art properly so-called, and the pseudo-art designed to entertain, arouse or amuse. The distinction was taken up by Croce's disciple, the English philosopher R. G. Collingwood, who argued as follows. In confronting a true work of art it is not my own reactions that interest me, but the meaning and content of the work. I am being presented with experience, uniquely embodied in this particular sensory form. When seeking entertainment, however, I am not interested in the cause but in the effect. Whatever has the right effect on me is right for me, and there is no question of judgement—aesthetic or otherwise.

The point urged by Croce and Collingwood is exaggerated—why cannot I be interested in a work of art for its meaning, and also be entertained by it? We are not amused *for the sake of* amusement, but for the sake of the joke. Amusement is not opposed to aesthetic interest, since it is already a form of it. It is not surprising, therefore, if, from their exaggerated dismissal of entertainment art,

Croce and Collingwood each derived aesthetic theories as implausible as any in the literature.

Nevertheless they were right to believe that there is a great difference between the *artistic* treatment of a subject-matter and the mere cultivation of effect. The photographic image has to some extent deadened us to the contrast here. While the theatrical stage, like the frame of a painting, shuts out the real world, the camera lets the world in—spreading the same bland endorsement over the actor pretending to die on the pavement and the accidental balloon drifting across the street in the background. And the temptation is to turn this defect into an enticement, by encouraging a kind of 'reality addiction' in the viewer. The temptation is to focus on aspects of real life that grip us or excite us, regardless of their dramatic meaning. Genuine art also entertains us; but it does so by creating a distance between us and the scenes that it portrays: a distance sufficient to engender disinterested sympathy for the characters, rather than vicarious emotions of our own.

An example

Since cinema and its offshoots are most at fault among the arts, in pursuing effect at the cost of meaning, it is fitting to give an example of cinematic art from which that fault is absent. There have been few directors as conscious as Ingmar Bergman, of the temptation posed by the camera, and the need to resist it. You could frame a still from a Bergman film—the dream sequences in *Wild Strawberries*, the Dance of Death in *The Seventh Seal*, the dinner party in *The Hour of the Wolf*—and it would sit on your wall like an engraving, resonant, engaging and composed. It was precisely in order to minimize distraction, to ensure that everything on the screen—light, shade, form and allusion, as much as person and character—is making its own contribution to the drama, that Bergman chose to make *Wild Strawberries* in black and white, even though colour had by then (1957) become the *lingua franca*.

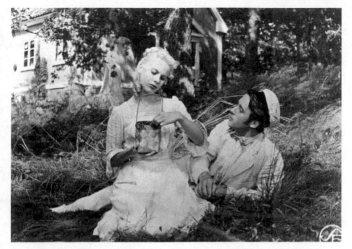

11. **Ingmar Bergman: memory sequence from *Wild Strawberries*: each detail speaks**

The film tells the story of a selfish but distinguished old man who has avoided love, who is approaching the end of his life and sensing its hollowness, and who—through a single day of simple encounters, memories and dreams—is able miraculously to save himself, to accept that he must give love in order to receive it, and who is granted, at the end, a transfiguring vision of his childhood and a final welcome into the world of others. The burden of the story is contained in the dreams and memories—episodes which play a part in the drama that is amplified by the cinematic medium. The camera fuses these episodes with the narrative, pressing them into the present through creating identities where words would enforce only differences. (Thus the faces in the dreams have already acquired another significance in the real events of the day.) The camera stalks the unfolding story like a hunter, pausing to take aim at the present only to bring it into chafing proximity with the past. And the images, often grainy, with sharply foregrounded details, leave many objects lingering like ghosts in the out-of-focus

87

hinterland. In *Wild Strawberries*, things, like people, are saturated with the psychic states of their observers, drawn into the drama by a camera which endows each detail with a consciousness of its own. The result is not whimsical or arbitrary, but on the contrary, entirely objective, turning to realities at every point where the camera might otherwise be tempted to escape from them.

Wild Strawberries is one of many examples of true cinematic art, in which the techniques of the cinema serve a dramatic purpose, presenting situations and characters in the light of our own sympathetic response to them. It illustrates the distinction between aesthetic interest and mere effect: the first creating a distance that the second destroys. The purpose of this distance is not to prevent emotion, but to focus it, by directing attention towards the imaginary other, rather than the present self. Getting clear about the distinction here is one part of understanding artistic beauty.

Fantasy and reality

The distinction can be rephrased as one between imagination and fantasy. True art appeals to the imagination, whereas effects elicit fantasy. Imaginary things are pondered, fantasies are *acted out*. Both fantasy and imagination concern unrealities; but while the unrealities of fantasy penetrate and pollute our world, those of the imagination exist in a world of their own, in which we wander freely and in a condition of sympathetic detachment.

Modern society abounds in fantasy objects, since the realistic image, in photograph, cinema and TV screen, offers surrogate fulfilment to our forbidden desires, thereby permitting them. A fantasy desire seeks neither a literary description, nor a delicate painting of its object, but a simulacrum—an image from which all veils of hesitation have been torn away. It eschews style and convention, since these impede the building of the surrogate, and subject it to judgement. The ideal fantasy is perfectly realized, and

perfectly unreal—an imaginary object that leaves nothing to the imagination. Advertisements trade in such objects, and they float in the background of modern life, tempting us constantly to realize our dreams, rather than to pursue realities.

Imagined scenes, by contrast, are not realized but *represented*; they come to us soaked in thought, and in no sense are they surrogates, standing in place of the unobtainable. On the contrary, they are deliberately placed at a distance, in a world of their own. Convention, framing and restraint are integral to the imaginative process. We enter a painting only via the frame that shuts out the world in which we stand. Convention and style are more important than realization; and when painters endow their images with a *trompe-l'oeil* realism, we often question the result as tasteless or despise it as kitsch.

It is true that art may also play with illusionist effects, as Bernini does in sculpting St Teresa in Ecstasy, or Masaccio in his depiction of the Holy Trinity. But in such cases illusion is a dramatic device, a way of transporting the viewer into heavenly regions, where thought and feeling are purged of their earthly ties. In no sense are Bernini and Masaccio practising deception, or tempting the viewer to indulge his ordinary passions in substitute ways.

In the theatre too, the action is not real but represented, and however realistic, avoids (as a rule) those scenes which are the food of fantasy. In Greek tragedy the murders take place off stage, to be reported in lines that set the chorus in rhythmic motion, spelling out the horror and also containing it, subdued to the metre of the verse. The purpose is not to deprive death of its emotional power, but to contain it within the domain of the imagination—the domain where we wander freely, with our own interests and desires in abeyance.

Although the passions suffered in the theatre are directed towards imaginary objects, they are guided by a sense of reality, and evolve

and develop as our understanding grows. They derive from the sympathy that we feel for our kind, and sympathy is critical—it wishes to know its object, to assess its worth, and not to waste its heartbeats undeservedly. In *The Theory of the Moral Sentiments*, Adam Smith argued that sympathy tends of its own accord towards the standpoint of the impartial spectator. Hence sympathy is never so active, or so controlled by judgement, as in the aesthetic context. Towards the imaginary and the framed we can adopt the disinterested posture that I described in Chapter 1. And, once our own interests have been set aside, we sympathize in a way that we cannot normally afford in our daily transactions. It would be plausible to suggest that this defines one aim of art: to present imaginary worlds, towards which we can adopt, as part of an integral aesthetic attitude, a posture of impartial concern.

Style

True artists control their subject-matter, in order that our response to it should be *their* doing, not *ours*. One way of exerting this control is through style: as Picasso controlled erotic sentiment through his cubist reconstruction of the female face, or Pope controlled misanthropy through the polished logic of the heroic couplet. Style is not exhibited only by art: indeed, as I argued in the last chapter, it is natural to us, part of the aesthetics of everyday life, through which we arrange our environment and place it in significant relation to ourselves. Flair in dressing, for example, which is not the same as an insistent originality, consists rather in the ability to turn a shared repertoire in a personal direction, so that a single character is revealed in each of them. That is what we mean by style, and by the 'stylishness' that comes about when style over-reaches itself and becomes the dominant factor in a person's dress.

Styles can resemble each other, and contain large overlapping idioms—like the styles of Haydn and Mozart or Coleridge and Wordsworth. Or they might be unique, like the style of Van Gogh,

so that anyone who shares the repertoire is seen as a mere copier or *pasticheur*, and not as an artist with a style of his own. Our tendency to think in this way has something to do with our sense of human integrity: the unique style is one that has identified a unique human being, whose personality is entirely objectified in his work: *le style c'est l'homme même*, as Buffon famously put it. (It is interesting to explore our reasons for saying that Mozart, who adapted the musical language of Haydn, is an original composer, whereas Utrillo, who is recognizably himself, even when most obviously following Pissaro or Van Gogh, is entirely derivative.)

Style must be perceivable: there is no such thing as hidden style. It *shows* itself, even if it does so in artful ways that conceal the effort and sophistication, as in the Chopin Mazurkas or the drawings of Paul Klee. At the same time, it becomes perceivable by virtue of our comparative perceptions: it involves a standing out from norms that must also be subliminally present in our perception if the stylistic idioms and departures are to be noticed. Style enables artists to allude to things that they do not state, to summon comparisons that they do not explicitly make, to place their work and its subject-matter in a context which makes every gesture significant, and so achieve the kind of concentration of meaning that we witness in Britten's Cello Symphony or Eliot's *Four Quartets*.

Content and form

That suggestion immediately raises a problem that has become familiar in aesthetics, in literary criticism, and in the study of the arts generally: how can you separate the content of a work of art from its form? And if you *could* separate the content, would that not just show that it is irrelevant to the aesthetic goal, no part of what the work *really* means?

Suppose you ask me what is the content of Van Gogh's famous painting of the yellow chair. What exactly does it *mean*? you ask:

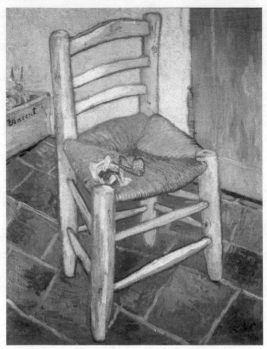

12. Van Gogh, *The Yellow Chair*. A chair is a chair is a chair...

what am I supposed to *understand*, about this chair, or about the world, from looking at this picture? I might reply: it's a chair, that's all. But in that case what's so special about the picture? Wouldn't a photograph of a chair do just as well? Why travel all these miles to see a picture of a chair? I am likely to argue that this painting is saying something special about this particular chair, and also about the world as seen through the image of this chair. I might try to put my thoughts and feelings into words. 'It is an invitation to see the life that spreads from people into all their products, the way in which life radiates from the meanest things,

so that nothing is at rest, all is becoming.' But couldn't he have written that message on the bottom of the canvas? Why does he need a chair to communicate a thought like that? I am likely to respond that my words are only a gesture; that the real meaning of the painting is *bound up with, inseparable from*, the image—that it resides in the very shapes and colours of the chair, is inseparable from Van Gogh's distinctive style, and cannot be translated completely into another idiom.

That kind of argument, whether about painting, about poetry or about music, is now familiar, and is grounded in our ordinary ways of talking about art. We want to say that works of art are meaningful—they are not just interesting forms in which we take an unexplained delight. They are acts of communication, which present us with a meaning; and this meaning must be *understood*. Often we will say of a performer, that he did not understand the role he was playing. We listen to abstract music, like the quartets of Bartók and Schoenberg, and perhaps say that we do not understand them. And all this reference to meaning and understanding suggests that works of art are communicating a content, maybe that each work of art—or at any rate each work of any note—has its own peculiar content, which we must understand if we are to appreciate the work and have a sense of its value. Some works have changed the way we see the world— Goethe's *Faust*, for example, Beethoven's late quartets, Shakespeare's *Hamlet*, Vergil's *Aeneid*, Michelangelo's *Moses*, the Psalms of David and the Book of Job. For people who don't know those works of art the world is a different—and maybe a less interesting—place.

Yet, when it comes to saying, of any particular work of art, just *what* its content might be, we find ourselves very soon reduced to silence. The meaning does not reside in a content that could be identified just anyhow. It is a particular content *as presented*— seen, in other words, as inseparable from form and style. Thus we arrive at what has become a critical commonplace, which is the thesis of the inseparability of form and content. A particular

version of this thesis in the realm of literary criticism goes by the name of the 'heresy of paraphrase'—an expression due to the critic Cleanth Brooks. The heresy to which Brooks referred is that of thinking that the meaning of a poem can be contained in a paraphrase; from which you can easily proceed to the thought that it is a heresy to think that it can be contained in a translation or that it can be conveyed in another style or another art-form or in any other way than in the form of this particular poem.

Brooks is pointing to several distinct features of poetry. First, there is the fact that a line of poetry can express several thoughts simultaneously, whereas a paraphrase will at best lay them out in succession. For instance, the line 'bare ruin'd choirs, where late the sweet birds sang', describes both the trees in autumn and the recently ruined choirs of the monasteries that were still frequented in Shakespeare's youth. A paraphrase would give one of those readings, and then the other; but the power of the line consists partly in the fact that you hear them together, like simultaneous voices in music—and then the doom of autumn invades the image of the ruined monastery, just as the idea of sacrilege invades the image of the leafless tree.

Secondly, there is the fact that poetry is 'polysemous', developing its meaning on several levels—the levels of image, of statement, of metaphor, of allegory and so on. This point was made seven centuries ago in the celebrated letter to Can Grande della Scala explaining the allegorical meaning of the *Divine Comedy*—a letter normally attributed to Dante—and in Dante's *Convivio*. And it became a commonplace of late medieval and early Renaissance poetics. A paraphrase would have to spell out the levels of meaning separately; whereas the power of poetry depends on their being presented simultaneously.

Thirdly meaning is *lost* in any paraphrase. You could paraphrase the first line of Hamlet's famous soliloquy as 'To live or to die: that's the choice'; or 'to exist or not to exist; there's the problem'. But

Shakespeare wanted the verb 'to be', with all its metaphysical resonance, as touching the very mystery of the universe: the mystery of 'contingent being', as Avicenna and Aquinas had described it. Being is *already* a question, and an insoluble one, coming to the surface in Hamlet's existential anxiety with a new and disturbing resonance. It is not just the meaning and association of words that count towards their sense in poetry. The sound too is important—and not just sound: sound as organized by syntax, and shaped as language. So, finally, there is the sheer untranslateability of the semantic atmosphere in poetry. How could you render in English the ineffable melancholy of 'Les sanglots longs | Des violons | De l'automne'? 'The long sighs of autumn's violins' is just absurd, though it means the same.

And yet, we don't want to conclude that the meaning of a poem, or of any other work of art, is simply mysterious, so intimately bound up with the form that nothing can be said about it. I have said a lot about those examples already. True, there are examples where it is difficult to say anything—the poems of Celan, for instance. The imagery might be too dense to disentangle, too much a matter of suggestion, concerned indeed to avoid direct statement, lest the intensity of the experience be lost. But such exceptional cases merely prove the point, by being exceptional. For the most part you can say much about the meaning of a poem, a painting—even a work of music. But what you say will not explain the particular intensity of meaning which makes the work of art into the irreplaceable vehicle of its content.

Representation and expression

Here philosophers make a distinction between two kinds of meaning in art: representation and expression. The distinction goes back to Croce and Collingwood, though it corresponds to thoughts that have been around for far longer. It seems that works of art can be meaningful in at least two ways—by presenting a world (whether real or imaginary) that is independent of

themselves, as in prose narrative, theatre or figurative painting, or by carrying their meaning intrinsically within them. The first kind of meaning is often called 'representation', since it implies a symbolic relation between the work and its world. Representation can be judged to be more or less realistic—in other words, more or less in conformity with the generality of the things and situations described. It admits of translation and paraphrase; two works of art can represent the same thing, situation or event—as Mantegna's and Grünewald's Crucifixions both represent the crucifixion of Jesus (though how differently it is not necessary to emphasize).

An accurate representation may also be meaningless as a work of art—either because what it represents is meaningless, or because it fails to convey anything meaningful about its subject-matter, like the nymphs of Bouguereau. All those features caused Croce to dismiss representation as inessential to the aesthetic enterprise. It is at best a frame upon which artists compose, but never in itself the source of the meaning of their work. Of course, you must still understand the representational content of a work if you are to grasp its artistic meaning: and this may require critical, historical and iconographical knowledge—knowledge that is not always easy to obtain, as we know from attempts to decipher Rembrandt's *Nightwatch*, or Shakespeare's *The Phoenix and the Turtle*. But someone could understand a representation and take no aesthetic interest in it; and it can be a good representation without eliciting such an interest—as most B movies are good representations of absurd events involving boring people to no artistic purpose.

Expression and emotion

According to Croce, therefore, the burden of artistic meaning lies not with representation but with expression. And expression is the vehicle of aesthetic value. Works of art express things, and even abstract art, like instrumental music or abstract painting, can be an effective milieu for expression. So how do we understand

expression, and why is it a value? One suggestion is that works of art express emotion, and that this is of value to us because it acquaints us with the human condition, and arouses our sympathies for experiences that we do not otherwise undergo. But clearly works of art don't express emotion in the way that you express your anger by shouting at your son, or your love by speaking to him affectionately. Most works of art are not created in a sudden heat of passion; nor do we have the knowledge that will enable us to say what passion (if any) motivated the artist. Even when artists refer to the emotion that is allegedly conveyed by their work, we may not believe that their description is the correct one. Beethoven prefaced the slow movement of Op. 132 with the description 'Hymn of thanksgiving from the convalescent to the Godhead in the Lydian mode'. Suppose you respond by saying 'To me it is just a serene expression of contentment, and convalescence has nothing to do with it.' Does that show that you have not understood the movement? Why is Beethoven any better placed than you to put words to the feeling conveyed by his music? Maybe you, as critic, are better able to describe the emotional content of a piece of music than the composer. There are plenty of artists who are awoken by criticism to the meaning of their own works: such, for example, was T. S. Eliot's response to Helen Gardner's book about his poetry—namely, at last I know what it means.

In fact all attempts to describe the emotional content of works of art seem to fall short of their target. The feeling does not have an independent life: it is there in the notes, the pigments and the words, and attempts to extract it and trap it in a description seem lame and inadequate when set beside the work. In response to this objection Croce presented an ingenious theory. Representation, he argued, deals in concepts—characterizations that can be translated from medium to medium and still retain their sense. Thus a Constable sketch of Yarmouth represents the very same place as the Yarmouth scenes in *David Copperfield*. Both describe the Yarmouth flats in general terms; both contain messages that can be conveyed in other ways and by other media.

Representation, whether in words or images, is a relation between a work and a world, and the work applies to its world in the same way that concepts apply to the things that fall under them, by describing those things in general terms. Expression does not deal in concepts but in intuitions—particular experiences, that are conveyed by communicating their uniqueness. Two works of art can represent the same thing; but they cannot express the same thing—for a work expresses an intuition only by presenting its individual character, the character that requires just *these* words, or just *these* images, if it is to be put across. That is what is going on in art—the communication of individual experiences, in the unique form that identifies their individuality. And that is why artistic expression is so valuable—it presents us with the unconceptualized uniqueness of its subject-matter.

Ingenious though that theory is, it takes away with one hand what it gives with the other. It seems to be saying that a work of art has meaning because of the intuition that is expressed by it. But the intuition can be identified only through its artistic expression. If asked to identify the intuition expressed by some given work of art, the only answer is to point to that work of art, and to say that it is the intuition contained in *this*. That which seemed like a relation (expression) is no such thing, and to say that a work of art expresses an intuition is like saying that it is identical with itself. We are back with the old form and content problem—wanting to insist on a distinction, in order only to dismiss it as unreal.

There have been many attempts in recent years to revisit and reanimate the distinction between representation and expression, and also to give accounts of expression that will show why it is important, and how it captures that element of the aesthetic experience that we are inclined to describe in terms of meaning. We have witnessed semantic, semiotic, cognitive and similar theories, and attempts—in the philosophy of music especially—to show how emotion is expressed in art, and why this is important.

None of these theories, in my view, has advanced the subject very far.

Musical meaning

Readers might wonder why, in a book devoted to the idea of beauty, it is necessary to explore the recondite problem of artistic meaning. But it is precisely beauty that leads us to this problem. Art moves us because it is beautiful, and it is beautiful in part because it means something. It can be meaningful without being beautiful; but to be beautiful it must be meaningful. An example from music might clarify this. Consider Samuel Barber's solemn *Adagio for Strings*—surely one of the most expressive pieces in the instrumental repertoire. How do we understand its expressive power? It is not telling a story about a state of mind, that could have been told in another way by another work: it is unfolding its own singular grave expression. The beauty of the music is bound up with this expression: there are not two qualities here, the beauty and the expression, but one quality. This leads us immediately to the problem that I have been discussing: what is the difference between the one who understands the expression, and the one who does not?

But the example also points to a solution. For it reminds us that there are two uses of the term 'expression': a transitive use, which invites the question 'expression of what?', and an intransitive use, which forbids that question. *Espressivo* in a musical score is always understood intransitively. The question: 'how can I play this expressively if you don't tell me what it means?' would normally be dismissed as absurd. Performers show their understanding of an expressive work of music not by identifying some state of mind which it is 'about', but by playing with understanding. They must fit themselves into the groove of the work. This process of 'fitting' is mirrored too in the audience, who 'move along with' the music, as though inwardly dancing to its step.

Hence although Croce's theory of art as intuition is far too stringent, it is pointing to a puzzle about beauty in art. Why are we so often tempted to speak of expression in this intransitive way? And why is expression a part of beauty? Such questions have animated the discussion of music ever since E. T. A. Hoffman's famous essay on Beethoven's Fifth Symphony, and long before Croce made the concept of expression central to aesthetics.

Musical formalism

Hanslick's essay *On the Musically Beautiful* of 1854 was to become a pivotal document in the dispute between the followers of Brahms, for whom the art of music was essentially architectural, consisting in the elaboration of tonal structures, and the followers of Wagner, who had defended the view that music is a dramatic art, giving form and coherence to our states of mind. Hanslick's argument was that music can express definite emotions only if it can present definite objects of emotion, since emotions are founded on thoughts about their objects. But music is an abstract art, incapable of presenting definite thoughts. Hence the assertion that a piece of music is expressive of some emotion becomes empty: nothing can be said in answer to the question 'expressive of what?'

Hanslick argued instead that music is understood as 'forms moved through sound'. This is the essential feature, and emotional associations are no more than that—*associations*, which have no claim to be the meaning of what we hear. Musical understanding is not a matter of lapsing into a self-centred reverie, prompted by the music, perhaps, but in no way controlled by it. Understanding consists in appreciating the various movements contained in the musical surface, hearing how they develop from each other, respond to each other and work towards resolution and closure. The pleasure that this causes is not unlike the pleasure of pattern in architecture, especially the kind of pattern that is achieved against awkwardnesses and obstacles, like the obstacle presented to

Longhena at Sta Maria della Salute, in which a circular dome had to meet an octagonal base.

But what is meant by musical movement? Consider the theme of the last movement of Beethoven's *Eroica* symphony. This consists largely of silences. It begins on E-flat, continues through a long silence during which it seems to rise to B-flat, drops an octave, and so on. We can describe the movement easily enough, in terms of a beginning, a process that endures, and movements up and down the pitch-spectrum. But nothing *actually* moves, and most of the movement occurs when there is nothing to be heard. We also hear a kind of causal connection: that first note brings the second into being. But there is no such connection in reality. Talk of musical movement seems to be a deeply embedded metaphor. If that is so, however, Hanslick's theory is not really distinguished from that of the romantics whom he attacks. They agree that music moves, but add that, granted that metaphor, why not help yourself to another—namely, that music moves as the heart moves, when it is moved by feeling? In other words, beauty in music is not just a matter of form: it involves an emotional content.

Form and content in architecture

In considering 'the aesthetics of everyday life' I made much of the small-scale practical reasoning whereby a carpenter fits part to part in the construction of a door. And there is a tradition in architectural thinking going back to Alberti's Ten Books of Architecture (*De re aedificatoria*, 1452) which sees architectural beauty (*concinnitas*) as the appropriate fitting of part to part. This parallels the formalist approach advocated by Hanslick and is just as incomplete and just as unsustainable in architectural criticism as in the discussion of music. Consider again Longhena's Church of Sta Maria della Salute. This was dismissively described by Ruskin in *Stones of Venice*, as one of those 'contemptible edifices' which 'have good stage effect so long as we do not approach them', criticizing 'the meagre windows in the sides of the cupola and the

ridiculous disguise of the buttresses under the form of colossal scrolls', adding that the buttresses are in any case 'a hypocrisy', since the cupola is a timber construction that needs no such support. Ruskin saw in the forms and aspect of this church the theatrical insincerity of the Counter-Reformation (the 'Grotesque Renaissance'), in which incense and flowing robes smother the hand-made truths of real piety. Geoffrey Scott, in his great work of criticism, *The Architecture of Humanism* (1914), responded with what he took to be a purely formal account of the church's beauty and perfection:

> The ingenious pairing [of the volutes] makes a perfect transition from the circular plan to the octagonal. Their heaped and rolling form is like that of a heavy substance that has slidden to its final and true adjustment. The great statues and pedestals which they support seem to arrest the outward movement of the volutes and to pin them down upon the church. In silhouette, the statues serve (like the obelisks on the lantern) to give a pyramidal contour to the composition, a line which more than any other gives mass its unity and strength ... There is hardly an element in the church which does not proclaim the beauty of mass and the power of mass to give essential simplicity and dignity even to the richest and most fantastic dreams of the baroque ...

Scott says nothing—or nothing clear—about the content of the church, not mentioning its ostensible invocation of the Virgin queen of the sea, who reaches out to save the shipwrecked sailor, and in general brushing aside its religious iconography. On the other hand, when we look at the detail of Scott's description, we see that it is a sequence of metaphors and similes: 'their heaped and rolling form (two metaphors) is like that of a heavy substance (simile) ... the great statues and pedestals ... seem to arrest the outward movement (simile) ... the essential simplicity and dignity of the baroque (metaphors) ...'. This purely 'formal' description, in other words, is logically on a par with the most adventurous attempt to describe the *meaning* of the church, and could easily be

pushed in that direction. Isn't this use of mass to create simplicity and dignity an exact parallel of the Counter-Reformation vision of the church, as dignifying ordinary life, and standing over it in a posture of fertile guardianship? Notice the way the statues balance themselves on the rolling form of the volutes, as though riding and controlling the waves—a symbol of the safety offered to 'those in peril on the sea'. The church is like a meeting between prayer and comfort: between the prayers of the sailor, symbolized by chapels which turn to each point of the compass, and the safety promised by Mary, *stella maris*, present in the all-embracing dome.

To point to these analogies and symbolic connections is as legitimate in the criticism of architecture as it is in the expressionist criticism of music. Browning produced a celebrated instance of such expressionist criticism, by way of a comment on a work composed in the shadow of the Salute (*A Toccata of Galuppi's*, the voice here being that of an imagined Victorian Englishman, summoning the world of Galuppi as he listens):

> What? Those lesser thirds so plaintive, sixths diminished, sigh
> on sigh,
> Told them something? Those suspensions, those solutions—
> 'Must we die?'
> Those commiserating sevenths—'Life might last, we can but try!'

Baldassare Longhena's church expresses the civic vitality and sea-going adventurism which, by his namesake Baldassare Galuppi's day, were fading away. It seems odd to make a radical distinction between form and content, when the attempt to describe either involves the same recourse to metaphor, and the same building of bridges between experiences. Both Scott and Browning are invoking the way in which aesthetic judgement brings one experience to bear on another, and so transforms it. And, as Browning shows, the resulting transformation can bring an unexpected insight into the human heart.

Meaning and metaphor

It seems therefore that our best attempts at explaining the beauty of works of abstract art like music and architecture involve linking them by chains of metaphor to human action, life and emotion. If we are to understand the nature of artistic meaning, therefore, we must first understand the logic of figurative language.

Figurative uses of language aim not to describe things but to connect them, and the connection is forged in the feeling of the perceiver. The connection may be made in many ways: through metaphor, metonymy, simile, personification or a transferred name. Sometimes a writer places two things side by side, using no figure of speech, but simply letting the experience of one leak into the experience of the other. Here is an example from *Antony and Cleopatra*:

> Her tongue will not obey her heart, nor can
> Her heart inform her tongue—the swan's down feather,
> That stands upon the swell at the full of tide,
> And neither way inclines ...

A striking image, rich in implications, which entirely transforms the audience's sense of Octavia's hesitation. That is the kind of transformation at which metaphors aim: dead metaphors achieve nothing, but living metaphors change the way things are perceived. Such is the function of figurative language generally.

Our reflections on the metaphorical nature of our attempts to assign an expressive meaning to music suggest a tentative conclusion. The connection between music and emotion is not established by conventions or a 'theory of musical meaning'. It is established in the experience of playing and hearing. We understand expressive music by fitting it to other elements in our experience, drawing connections with human life, 'matching' the

music to other things that have meaning for us. Thus we praise the Barber *Adagio for Strings* for its noble solemnity. The metaphor is not arbitrary, since it makes a connection with the moral life which explains why we feel at home with the piece, and elevated by it. But it is a metaphor that stands to be justified. If this is a true indication of what the piece *means*, then it must be anchored in the structure and argument of the music. The long step-wise melody in B-flat minor which is less a melody than a melody remembered; the tensions resolved on half cadences, as though pausing for breath but refusing to come to a halt, so that there is a continuous cycle of tension and relaxation; the constant fall of the melodic line that burdens every attempt to rise, until the sudden climb through a pair of diminished fifths, like the last efforts of someone struggling to free himself so as to reach the rock which is his goal, only to find that this rock, the high B flat which was the tonic for which the melody had longed for 12 bars, is without foundation, being now the dominant of E flat minor, lying above an unstable dissonance—all such details are relevant to the judgement and, in describing them, we will be backing up one metaphor with others, making further connections with the mental and moral life. Something similar occurs in the criticism of architecture. Here too metaphor plays a vital role in explaining the value and meaning of a building, and in justifying our metaphorical descriptions we will be arguing as Scott argues in the passage quoted, linking one metaphor to another and one part of the building to another, in an elaborate exploration of the way in which part fits to part, and both to the moral life of the observer.

This suggests a different model of expression from the one presented by Croce and his followers. The Crocean model is of an inarticulate inner state (an 'intuition') becoming articulate and conscious through its artistic expression. The rival model is of an artist fitting things together so as to create links which resonate in the audience's feelings. The question *what* is being expressed ceases to be relevant. What matters is whether *this* belongs (emotionally speaking) with *that*. This notion of belonging or

Barber: Adagio for Strings

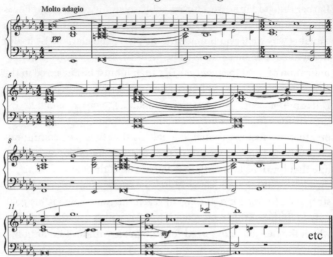

13. Samuel Barber, *Adagio for Strings*: the meaning lies in the notes

fitting recalls the more formal idea of fittingness that we
encountered in the last chapter, when discussing the aesthetics of
everyday life. In art as in life fittingness is at the heart of aesthetic
success. We want things to fit together, in ways that fit to us. This
does not mean that dissonance and conflict have no part in the
artistic enterprise: of course they do. But dissonance and conflict
may also be fitting, like the climactic 9-note dissonance in Mahler's
10th Symphony, or the jarring disarray of Hamlet's encounter with
his mother.

The value of art

Works of art can be praised in many ways. They can be moving and
tragic, melancholy or joyous, balanced, melodious, elegant, and
exciting. Although beauty and meaning are connected in art, some

of the most meaningful works of recent times have been downright ugly and even offensive in their raw-nerve impact—think of Schoenberg's *A Survivor from Warsaw*, Gunther Grass's *Tin Drum*, Picasso's *Guernica*. To call such works beautiful is in a way to diminish and even to trivialize what they are trying to say. But if beauty is only one among many aesthetic values, why should a theory of art tell us anything about it?

Some insight is provided by the connection made by Schiller, in his *Letters on the Aesthetic Education of Man*, between art and play. Art, he suggests, takes us out of our everyday practical concerns, by providing us with objects, characters, scenes and actions with which we can play, and which we can enjoy for what they are, rather than for what they do for us. The artist too is playing—making imaginary worlds with the same spontaneous enjoyment that children experience, when one of them says 'Let's pretend!', or producing objects that focus our emotions and enable us to understand and amend them—as Beethoven does in the late quartets. This activity, Schiller argued, is all the more necessary in that we are torn, in our everyday lives, between the severe demands of reason, which require us to live by the rules, and the temptations of sense, which prompt us to venture forth in search of new experience. In play, elevated by art to the level of free contemplation, reason and sense are reconciled, and we are granted a vision of human life in its wholeness.

In appreciating art we are playing; the artist too is playing in creating it. And the result is not always beautiful, or beautiful in a predictable way. But this ludic attitude is fulfilled by beauty, and by the kind of orderliness which retains our interest and prompts us to search for the deeper significance of the sensory world. Hence, as soon as we are engaged in generating and appreciating objects as ends in themselves, rather than as means to our desires and purposes, we demand that those objects be ordered and meaningful. This 'blessed rage for order' is present in the very first impulse of artistic creation: and the impetus to impose order and

meaning on human life, through the experience of something delightful, is the underlying motive of art in all its forms. Art answers the riddle of existence: it tells us *why* we exist by imbuing our lives with a sense of fittingness. In the highest form of beauty life becomes its own justification, redeemed from contingency by the logic which connects the end of things with their beginning, as they are connected in *Paradise Lost*, in *Phèdre* and in *Der Ring des Nibelungen*. The highest form of beauty, as exemplified in those supreme artistic achievements, is one of the greatest of life's gifts to us. It is the true ground of the value of art, for it is what art, and only art, can give.

Beauty and truth

Keats's vision of the Grecian urn, with its message that 'Beauty is truth, truth beauty—that is all | Ye know on earth, and all ye need to know', arises from a lingering glance at a vanished world. But it records a common experience. Our favourite works of art seem to guide us to the truth of the human condition and, by presenting completed instances of human actions and passions, freed from the contingencies of everyday life, to show the worthwhileness of being human.

The point is perhaps best made through an example. We know what it is to love and be rejected, and thereafter to wander in the world infected by a bleak passivity. This experience, in all its messiness and arbitrariness, is one that most of us must undergo. But when Schubert, in *Die Winterreise*, explores it in song, finding exquisite melodies to illuminate one after another the many secret corners of a desolated heart, we are granted an insight of another order. Loss ceases to be an accident, and becomes instead an archetype, rendered beautiful beyond words by the music that contains it, moving under the impulse of melody and harmony to a conclusion that has a compelling artistic logic. It is as though we looked through the contingent loss of the song-cycle's protagonist to another kind of loss altogether: a *necessary* loss, whose rightness

resides in its completeness. Beauty reaches to the underlying truth of a human experience, by showing it *under the aspect of necessity*.

I find this point difficult to express. And I am aware of the lesson that we must draw from the disputes over form and content. To refer to a truth contained in a work of art is always to risk the corrosive effect of the question: *what* truth? And yet that question must be disallowed. The insight that art provides is available only in the form in which it is presented: it resides in an immediate experience whose consoling power is that it removes the arbitrariness from the human condition—as the arbitrariness of suffering is overcome in tragedy, and the arbitrariness of rejection in Schubert's song-cycle.

Kant wrote in this connection of 'aesthetic ideas'—intimations in sensory form of thoughts that are inexpressible as literal truths, since they lie beyond the reach of the understanding. But Kant's strictures are too severe. For we can make comparative judgements. And these help to flesh out the idea of a truth beyond the work, to which the work is pointing. For example we can ask whether that which is captured by Schubert is captured also by Mahler in his *Lieder eines fahrenden Gesellen*. And the answer is surely 'no'; there is a self-referential character in Mahler's music which in a certain way detracts from its universal significance. One way of expressing this observation is to say that Mahler's song-cycle is not true to the experience that it expresses—that it loses sight of the reality of loss in order to indulge in a sentimental grief over a loss that is not truly regretted. In comparison with this beautiful but flawed work of art, the sublime truthfulness of the Schubert makes itself known.

Art and morality

During the nineteenth century there arose the movement of 'art for art's sake': *l'art pour l'art*. The words are those of Théophile Gautier, who believed that if art is to be valued for its own sake

then it must be detached from all purposes, including those of the moral life. A work of art that moralizes, that strives to improve its audience, that descends from the pinnacle of pure beauty to take up some social or didactic cause, offends against the autonomy of the aesthetic experience, exchanging intrinsic for instrumental values and losing whatever claim it might have had to beauty.

It is certainly a failing in a work of art that it should be more concerned to convey a message than to delight its audience. Works of propaganda, such as the socialist realist sculptures of the Soviet period or (their equivalent in prose) Mikhail Sholokhov's *Quiet Flows the Don*, sacrifice aesthetic integrity to political correctness, character to caricature, and drama to sermonizing. On the other hand, part of what we object to in such works is their *untruthful* quality. The lessons urged upon us are neither compelled by the story nor illustrated in the exaggerated figures and characters; the propaganda message is not part of the aesthetic meaning but extraneous to it—an intrusion from the everyday world which only loses conviction when thrust on us in the midst of aesthetic contemplation.

By contrast, there are works of art which contain intense moral messages in an aesthetically integrated frame. Consider John Bunyan's *Pilgrim's Progress*. The advocacy of the Christian life is here embodied in schematic characters and transparent allegory. But the book is written with such immediacy and such a true feeling for the weight of words and the seriousness of sentiment, that the Christian message becomes an integral part of it, rendered beautiful by the compelling words. We encounter in Bunyan a unity of form and content that forbids us from dismissing the work as a mere exercise in propaganda.

At the same time, even while admiring *Pilgrim's Progress* for its truthfulness, we may reject its underlying beliefs. Bunyan is showing the lived reality of Christian discipleship, and atheists, Jews and Muslims can find truth in his story—truth to the human

condition and to the heart of one who has glimpsed in his life's disorder the hope of a better world. Nor does Bunyan's moralizing offend, since it emerges from experiences honestly captured and vividly confessed to.

Works of art are forbidden to moralize, only because moralizing destroys their true moral value, which lies in the ability to open our eyes to others, and to discipline our sympathies towards life as it is. Art is not morally neutral, but has its own way of making and justifying moral claims. By eliciting sympathy where the world withholds it an artist may, like Tolstoy in *Anna Karenina*, oppose the bonds of a too constrictive moral order. By romanticizing characters who deserve no such treatment an artist can also, like Berg (and Wedekind) in *Lulu*, endow narcissism and selfishness with a deceptive appeal. Many of the aesthetic faults incurred by art are moral faults—sentimentality, insincerity, self-righteousness, moralizing itself. And all of them involve a deficiency in that moral truthfulness for which, in the last section, I praised Schubert's never-to-be-surpassed song-cycle.

Chapter 6
Taste and order

In a democratic culture people are inclined to believe that it is presumptuous to claim to have better taste than your neighbour. By doing so you are implicitly denying his right to be the thing that he is. You like Bach, she likes U2; you like Leonardo, he likes Mucha; she likes Jane Austen, you like Danielle Steele. Each of you exists in his own enclosed aesthetic world, and so long as neither harms the other, and each says good morning over the fence, there is nothing further to be said.

The common pursuit

But things are not so simple, as the democratic argument already implies. If it is so offensive to look down on another's taste, it is, as the democrat recognizes, because taste is intimately bound up with our personal life and moral identity. It is part of our rational nature to strive for a community of judgement, a shared conception of value, since that is what reason and the moral life require. And this desire for a reasoned consensus spills over into the sense of beauty.

This we discover as soon as we take into account the public impact of private tastes. Your neighbour fills her garden with kitsch mermaids and Disneyland gnomes, polluting the view from your window; she designs her house in a ludicrous Costa Brava

style, in loud primary colours that utterly ruin the tranquil atmosphere of the street, and so on. Now her taste has ceased to be a private matter and inflicted itself on the public realm. We begin to dispute the matter: you appeal to the town council, arguing that her house and garden are not in keeping with the street, that this particular part of town is scheduled to retain a Georgian serenity, that her house clashes with the classical facades of adjacent buildings. (In a recent British case a house-owner, influenced by art-school fashions, erected a plastic sculpture of a shark on his roof, to give the appearance of a great fish that had crashed through the tiles into the attic. Protests from neighbours and the local planning officer led to a prolonged legal battle, which the house-owner—an American, who no longer lives in the house—eventually won.)

We know from experience that there is much to argue about here, and that argument does not aim to win by whatever means, but rather to generate a *consensus*. Implicit in our sense of beauty is the thought of community—of the agreement in judgements that makes social life possible and worthwhile. That is one of the reasons why we have planning laws—which, in the great days of Western civilization, have been extremely strict, controlling the heights of buildings (nineteenth-century Helsinki), the materials to be used in construction (eighteenth-century Paris), the tiles to be used in roofing (twentieth-century Provence), even the crenelations on buildings that face the thoroughfares (Venice, from the fifteenth century onwards).

Nor is this desire for consensus confined to the public realm of architecture and garden design. Think of clothes, interior décor, and bodily ornaments: here too we can be put on edge, excluded or included, made to feel inside or outside the implied community, and we strive by comparison and discussion to achieve a consensus within which we can feel at home. Many of the clothes we wear have the character of uniforms, designed to express and confirm our inoffensive membership of the community (the office

suit, the tuxedo, the baseball cap, the school uniform), or perhaps our solidarity with a community of offenders (the 'convict' style of black American 'gangstas'). Others, like women's party clothes, are designed to draw attention to our individuality, though without offending the proprieties. As I suggested earlier, fashion is integral to our nature as social beings: it arises from, and also amplifies, the aesthetic signals with which we make our social identity apparent to the world. We begin to see why concepts like decorum and propriety are integral to the sense of beauty: but they are concepts that range equally across the aesthetic and the moral spheres.

However, there are also private arts like music and literature. Why are we so concerned that our children should learn to like the things that *we* regard as beautiful? Why do we worry when children are drawn to literature that is, in our eyes, ugly, stupefying, sentimental or obscene? Plato believed that the various modes of music are connected with specific moral characteristics of those who dance or march to them, and that in a well-ordered city only those modes would be permitted which are in some way fitted to the virtuous soul. This is a striking and in its way plausible claim, though the concept of 'fit' is explained by Plato through a theory of imitation (*mimēsis*) that is no longer plausible.

Subjectivity and reasons

Someone might respond that there is no real argument here— consensus, if it is achieved, arises in some other way, by emotional infection, rather than by reasoning. You like Brahms, say, and I detest him. So you invite me to listen to your favourite pieces, and after a while they 'work on me'. Maybe I am influenced by my friendship for you, and make a special effort on your behalf. How it happens, I do not know—but if it happens, that I come to like Brahms, then this is not a rational decision, nor a rational conclusion of mine: it is a change comparable to that undergone by children when, having begun life by hating greens, they learn at

last to relish them. An experience that repelled them now attracts them; but it was not an *argument* that persuaded them. A change of taste is not a 'change of mind', in the way that a change of belief or even of moral posture is a change of mind. This doesn't mean that there are no extraneous reasons that might *justify* the change in taste. After all, there are extraneous reasons that justify the child's graduation from burgers to broccoli. Greens are far more healthy, maybe part of a superior lifestyle, maybe even a spiritual improvement, as the Vegans argue. But those reasons are not internal to the change in taste: they rationalize the change, but do not produce it—since it is not the kind of change that *could* be produced by rational argument.

We are in deep water here. But it is worth meditating on what actually happens, when you argue about matters of aesthetic taste. We have been listening to Brahms's Fourth Symphony, say, and you ask me how I like it. 'Heavy, lugubrious, oily, gross,' I say. You play me the first subject of the first movement on the piano. 'Listen,' you say. And you invert the sixths so that they become thirds, and I hear how the theme goes down one ladder of thirds and up another. You show me how the harmonies are also organized by third progressions, and how the ensuing themes unfold from the same melodic and harmonic cells that generate the opening melody. After a while I understand that there is a kind of minimalism at work here—everything emerges from a concentrated seed of musical material, and after a while I hear this happening and then—suddenly—it all sounds right to me, the heaviness and oiliness vanish in a moment, and instead I hear a kind of breaking into leaf and flower of a beautiful plant.

Or take another example: we are looking at a Whistler 'Nocturne'. You find it vapid, maybe (following a famous judgement of Ruskin's) reprehensible in its focus on momentary effects, and in its refusal to explore the deeper realities. This painting, you say, draws a veil over the toil and trouble of modern life; it sees as charm and evocation what is in fact labour and exploitation. And

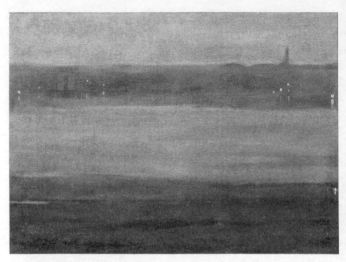

14. Whistler, *Nocturne in Grey and Silver*: surface shadow, or a deeper darkness?

all this is summarized in the title: *Nocturne in grey and silver*, as though you could abstract the human energy that made this effect, and judge it as a play of lighted colours.

Yes, I respond, you can see it that way. But the painting is not just an impression: its very shadowy quality indicates the extent to which people and their projects have darkened the world. There is no denial, here, of labour and its exploitation, but on the contrary, an attempt to see in the shadow-filled moment, the extent of man's trespass on the natural order. The title opens our minds to this, in fact: a 'nocturne' is a human creation, and a recent one, not known before the industrial revolution and the retreat of the property-owning classes into their drawing rooms, to be entertained at the piano by willowy aesthetes. Silver and grey are the colours of widowhood, and the atmosphere of the painting is one of melancholy recognition that, thanks to human industry, the sheen of the world is henceforth to be an artificial one. To justify this judgement, I will refer to the shades of colour, to the

prominent shapes in the canvas, which are the shapes of man-made things, and to the points of light which are man-made lights. As our discussion proceeds, unfolding the two rival interpretations of the painting, as pure impression and as social comment, the aspect of the picture will perhaps shift from one to the other—so that the painting seems to contain a lesson, reminding us that we can to some extent choose how the new world of industry should be seen.

We can find simpler, and logically more transparent, cases of this kind of change in aspect—like the celebrated duck-rabbit discussed by Wittgenstein. There may be a right and wrong way to see such figures—and I can reason you out of seeing a duck, where you ought to be seeing a rabbit. (Say the figure appears on a packet of rabbit food.) Such cases are not exceptional. On the contrary, in every perspective picture there are choices to make, concerning what size to attribute to which figure, and what distance to see between the various grounds. And the reasoning here will be like that which I gave in connection with the Whistler: reasoning concerning the meaning of the picture, and how you should see the picture if the meaning is, as it were, properly to *inhabit* it.

The criticism of poetry, too, follows this pattern. When you describe Blake's 'Oh rose, thou art sick: | The invisible worm | That flies in the night' as an evocation of sexual desire and the worm of jealousy, and I reply with a theory of its Christian iconology, and interpret the worm and the bed of crimson joy as lust and the soul respectively, you begin to hear the words differently—that 'dark secret love' has a new resonance, and one that is filled with ominous meaning for your own life. Such criticism is not just saying: here is what the poem means, as though you could now discard the poem and make do with my superior translation. The poetry is not a means to its meaning, as though a translation would do just as well. I want you to experience the poem differently, and my critical argument is aimed precisely at a change in your perception.

The argument can be mounted for architecture, for sculpture, for novels and plays; it can be mounted for natural objects too, such as landscapes and flowers. In every case we recognize that there is such a thing as reasoning, which has a changed perception as its goal. Moreover, any argument that did not aim at a changed perception could not be considered as a critical argument: it would not be a relevant reflection on its object, as an object of aesthetic judgement. You can confirm this by considering how you might answer questions like the following: is the Grand Canyon breathtaking or corny? Is *Bambi* moving or kitsch? Is *Madame Bovary* tragic or cruel? Is *The Magic Flute* childish or sublime? These are real questions, and hotly disputed too. But to argue them is to present an *experience* and to present it as *appropriate* or *right*.

The search for objectivity

Suppose you accept, in broad outline, what I have just argued for—namely that there is a kind of reasoning that has aesthetic judgement as its goal, and that this judgement is bound up with the experience of the one who makes it. You might still question whether this kind of reasoning is objective, in the sense of being based in, and invoking, standards that are persuasive to all rational beings. Indeed, there are important considerations to the contrary.

First, taste is rooted in a broader cultural context, and cultures (at least in the sense that we here have in mind) are not universal. The whole point of the concept of culture is to mark out the significant *differences* between the forms of human life, and the satisfactions that people take in them. Consider the ragas of Indian classical music: these belong to a long-standing tradition of listening and performance, and this tradition is dependent on the discipline associated with religious rituals and a devout way of life. Conventions, allusions and applications resonate in the minds and ears of those who play and enjoy this music, and the difference between a good and a bad performance cannot be established in terms that might equally be used to evaluate a Mozart symphony or a work of jazz.

Secondly, as noted in Chapter 1, there is no deductive relation between premises and conclusion when the conclusion is a judgement of taste. I am always free to reject a critical argument, in a way that I am not free to reject a valid scientific inference or a valid moral claim.

Finally, we must recognize that any attempt to lay down objective standards threatens the very enterprise that it purports to judge. Rules and precepts are there to be transcended, and because originality and the challenging of orthodoxies are fundamental to the aesthetic enterprise, an element of freedom is built into the pursuit of beauty, whether the minimal beauty of everyday arrangements, or the higher beauties of art.

How might we respond to such arguments? First, it is important to recognize that cultural variation does not imply the absence of cross-cultural universals. Nor does it imply that those universals, if they exist, are not rooted in our nature, or that they do not feed into our rational interests at a very fundamental level. Symmetry and order; proportion; closure; convention; harmony, and also novelty and excitement: all these seem to have a permanent hold on the human psyche. Now of course those words are all vague and multiply ambiguous, and you might well object that they are themselves likely to fragment along the fracture lines that divide culture from culture in the human lot. The early medievals regarded the fourth as harmonious, the third as dissonant: for us, if anything, it is the other way round. *Harmonia* for the Greeks consisted in the relation between successive sounds in a melody, and not the consonance of simultaneous notes. And so on.

Objectivity and universality

But that brings me to a more important observation, which is that, in the matter of aesthetic judgement, objectivity and universality come apart. In science and morality, the search for objectivity is the search for universally valid results—results that

must be accepted by every rational being. In the judgement of beauty the search for objectivity is for valid and heightened forms of human experience—forms in which human life can flower according to its inner need and achieve the kind of fruition that we witness in the Sistine Chapel ceiling, in *Parsifal* or in *Hamlet*. Criticism is not aiming to show that you *must* like *Hamlet*, for example: it is aiming to expose the vision of human life which the play contains, and the forms of belonging which it endorses, and to persuade you of their value. It is not claiming that this vision of human life is universally available. This does not mean that no cross-cultural comparisons can be made: it is certainly possible to compare a play like *Hamlet* with a puppet play by Chikamatsu, for example: indeed, it has been done. There are works of Japanese theatre that satirize human life (the Kabuki comedy *Hokaibo*, for example), and works which exalt it, and the question whether Beaumarchais's *Le Mariage de Figaro* is a profounder treatment of human sexuality than *Hokaibo* is a perfectly meaningful one.

The objection that aesthetic reasons are purely persuasive simply reiterates the point, that aesthetic judgement is rooted in subjective experience. So is the judgement of colour. And is it not an objective fact that red things are red, blue things blue?

Rules and originality

The final objection is, however, more serious. There may be rules of taste, but they do not guarantee beauty, and the beauty of a work of art may reside precisely in the act of transgressing them. Bach's Forty-Eight illustrate all the rules of fugal composition: but they do so by obeying them *creatively*, by showing how they can be used as a platform from which to rise to a higher realm of freedom. *Merely* obeying them would be a recipe for dullness, as in all the exercises from which we begin our lessons in counterpoint. Likewise in architecture, there may be buildings which we understand as entirely rule-governed, like the Parthenon: but this does not explain their perfection. The serenity and solidity of the

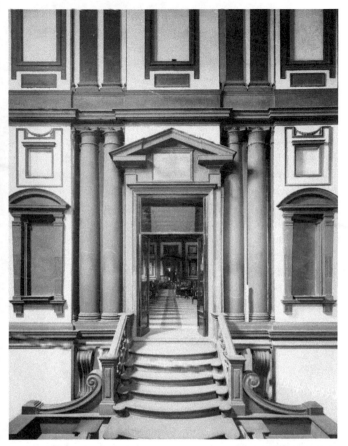

15. Michelangelo: Laurentian Library staircase: beauty and order that mock the rules

Parthenon come about through that extra creative something—the scale, proportions, detailing that arise from the thinking that begins when the rule-following stops. And again there are beauties that arise from the overt defiance of rules, as in Michelangelo's Laurentian library.

It is fairly obvious that there is no 'rule-following' or 'rule defying' in nature. Yet there are symmetries, harmonies, proportions, and also the aesthetically challenging lack of those things. Eighteenth-century thinkers, who wished to take natural beauty as their paradigm of the object of taste, were therefore quick to adopt Burke's contrast between the sublime and the beautiful. So too in art, we might usefully distinguish those works that please us on account of the order, harmony, and rule-governed perfection which they display, like the fugues of Bach, the Holy Virgins of Bellini, or the lyrics of Verlaine, and those which, on the contrary, please us by challenging and disturbing our routines, by throwing off the shackles of conformity and by standing out from the traditions to which they belong, like *King Lear* or Tchaikovsky's Sixth Symphony. But as soon as we make this distinction we realize that, even in the most orderly and rule-governed work, there is no way of fixing a 'standard of taste' by appeal to the rules. It is not the rules, but the use of them, that appeals in a Bach fugue or a Bellini Virgin. Those who seek a standard in the rules open themselves to refutation, when it is pointed out that obedience to the rules is neither necessary nor sufficient for beauty. For if it were sufficient then once again we could acquire taste at second hand; and if it were necessary, then originality would cease to be a mark of success.

The standard of taste

Where then should we look for standards in the judgement of beauty? Or is our search destined to be vain? In a celebrated essay Hume tried to shift the focus of the discussion, arguing roughly as follows: taste is a form of preference, and this preference is the premise, not the conclusion of the judgement of beauty. To fix the standard, therefore, we must discover the *reliable judge*, the one whose taste and discriminations are the best guide to...

Guide to what? There is a potential circle here: beauty is what the reliable critic discerns, and the reliable critic is the one who

discerns beauty. But such a circle is what we must expect: for Hume, seeing an object as beautiful is a matter of 'gilding or staining it with the colours borrowed from internal sentiment'. The standard, if it exists, does not lie in the qualities of the object but in the sentiments of the judge. So, Hume suggests, let us get away from the fruitless discussion of beauty, and simply concentrate on the qualities we admire, and ought to admire, in a critic—qualities such as delicacy and discernment.

However, this opens us to another kind of scepticism: why should it be *those* qualities that we admire? Even if it seemed natural, in the Scotland of Hume's day, to admire delicacy and discernment, it seems less natural today, when facetiousness and ignorance, so unfairly left out by the austere sages of the Enlightenment, are demanding, and receiving, their share of attention.

Is this where we should leave the topic? I think not. For Hume's argument suggests that the judgement of taste reflects the character of the one who makes it, and character matters. The characteristics of the good critic, as Hume envisaged them, point to virtues which, in Hume's thinking, are vital to the good conduct of life, and not just to the discrimination of aesthetic qualities. In the last analysis there is as much objectivity in our judgements of beauty as there is in our judgements of virtue and vice. Beauty is therefore as firmly rooted in the scheme of things as goodness. It speaks to us, as virtue speaks to us, of human fulfilment: not of things that we want, but of things that we ought to want, because human nature requires them. Such, at least, is my belief, and in the next two chapters I will try to justify it.

Chapter 7
Art and *erōs*

I have discussed four kinds of beauty: human beauty, as an object of desire; natural beauty, as an object of contemplation; everyday beauty, as an object of practical reason; and artistic beauty, as a form of meaning and an object of taste. In order to pursue the investigation to another level I want to consider, in this chapter, the interaction of the first kind of beauty with the last. I shall ask the question how beauty, as an object of desire, might be represented in art as an object of contemplation. The argument will take us deeper into the concept of individuality, will cast light upon both sexual desire and the aesthetic enterprise, and will give us new reasons for thinking that there is, after all, a standard of taste.

Individuality

Human beings are alone among the animals in revealing their individuality in their faces. The mouth that speaks, the eyes that gaze, the skin that blushes, all are signs of freedom, character and judgement, and all give concrete expression to the uniqueness of the self within. The great portraitist will ensure that these high-points of bodily expression reveal not just the momentary thoughts but the long-term intentions, the moral stance and the self-conception of the individual who shines in them.

As Kenneth Clark pointed out, in his celebrated study of the nude, the reclining Venus marks a break with antiquity, when the goddess was never shown in a horizontal position. The reclining nude shows the body not as a statue to be worshipped but as a woman to be desired. Even in the *Venus of Urbino*—that most provocative of Titian's female nudes—the lady draws our eyes to her face, which tells us that this body is on offer only in the way that the woman herself is on offer, to the lover who can honestly meet her gaze. To all others the body is out of bounds, being the intimate property of the gaze that looks out from it: not a body but an embodiment, to use the language of Chapter 2. The face individualizes the body, possesses it in the name of freedom, and condemns every covetous glance as a violation. The Titian nude neither provokes nor excites, but retains a detached serenity—the serenity of a person, whose thoughts and desires are not ours but hers.

Titian's reclining Venuses are interestingly compared, in this respect, with the nudes of François Boucher, the brilliant painter-decorator of the Paris of Louis XV. Boucher's nudes are not individualized by their faces. As a matter of fact, they all have the same face, which is not a face at all, but an assemblage of facial parts. The lips just slightly apart as though in anticipation of a kiss; the clear eyes under lowered lashes; the oval contours filled with flushing cheeks that swell like sails in a summer breeze—all such features, brilliantly displayed from every angle and in every light, carry a single meaning, which is that of sexual appetite. The eyes look at things—but only inconsequential things in the picture. No soul shoots out from them, no gaze questions or troubles or enraptures: all is fixed in its stillness—the stillness of creatures too abstract to take ownership of life. The nereids in *The Triumph of Venus*, for example, are not distinct from the goddess; all are one woman, and also infinitely many—separate instances of a universal, whose vacuousness of expression derives from the fact that universals, unlike individuals, have nothing in particular to express. Boucher's painting is a picture of repose, and an

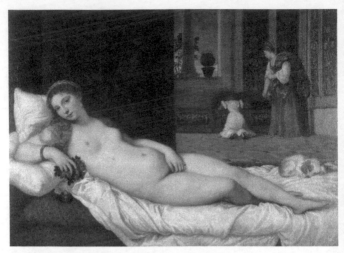

16. Titian, *Venus of Urbino*: desire at home

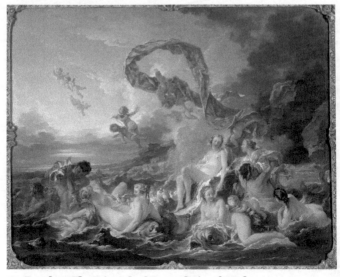

17. Boucher, *The Triumph of Venus*: desire abroad

adoration of the female body—at least as this body was esteemed in eighteenth-century France, with translucent skin, firm girlish breasts, and a ripple of fat around the thighs. Yet there is no-one there! These bodies are unowned, dis-souled, not even the bodies of animals, since they contain the universal template of a human face, voided of the self that animates and redeems it. And this absence of a soul downgrades the painting: it is charming, attractive, decorative, a splendid piece of furniture—but beautiful? We are not so sure.

Heavenly and earthly beauty

It is tempting to compare the painting with its famous predecessor, *The Birth of Venus*. Botticelli's Venus is, from the anatomical point of view, a misshapen caricature, held together by no skeletal structure or muscular tension, a helpless appendage to the face that looks out so wistfully, not at the viewer but past him—and yet who cares? This is a face dreamed of, longed for, unforgettable, the face of an idealized woman—and therefore not the face of any mortal, but a face all the same, and one that both individualizes

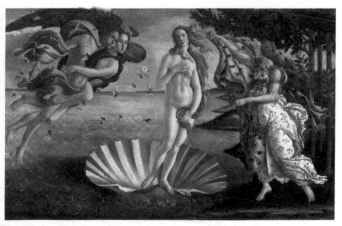

18. **Botticelli**, *The Birth of Venus*: **beyond desire**

19. Rembrandt, *Susannah and the Elders*: shame in the body

and mystifies. Not that we should think of Botticelli's Venus as sensual: this is an early Renaissance Venus, who moves in heavenly spheres, and is outside the reach of mortal longings. And that is why the painting is so haunting: this woman conjured from desire lies beyond the reach of desire as we have known it.

With the reclining Venuses of Titian we are no longer in the heavenly realm, but very much on earth, although an earth of domestic safety and conjugal passion. The face of a Titian nude is that of an individual woman, who has taken possession of her surroundings, and is decidedly at home in them. She reclines among her drapes in full confidence of her personal right to them, immersed in a life that is larger, deeper, more inscrutable than the moment alone. Her body is revealed to us, but she does not show it to us—she is not as a rule conscious of being watched, save perhaps by a dog or a cupid whose calm unembarrassability

merely emphasizes the fact that voyeurs cannot trouble her peace of mind, which is also a peace of body. She is not in a state of excitement, nor does she have cause for shame. She is at one with her body, and this at-oneness is portrayed in her face. Sexual shame changes the contours of the female body and is revealed in both face and limb, as Rembrandt shows so brilliantly in his depiction of *Susannah and the Elders*. Set this beside the Titian and you will quickly see that the body in Titian's picture is neither on offer nor withdrawn, but simply at ease in its freedom, a person revealed in her flesh. And in some mysterious way the beauty of the painting and the beauty of the woman portrayed in it are not two beauties but one.

Erotic art

Anne Hollander has written of the extent to which the nude, in our tradition, is not naked but unclothed: it is a body marked by the shapes and materials of its normal covering. In Titian the body is at rest just as it would be if it were protected from our gaze by a

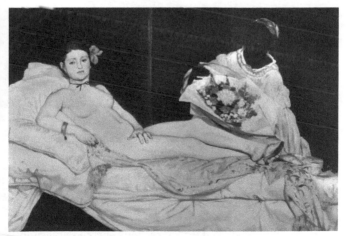

20. Manet, *Olympia*: the body unashamed

veil of clothing: it is a body under invisible clothes. We no more detach it from the face or the personality than we would detach the body of a woman fully dressed. And by painting the body in this way Titian overcomes its eerie quality—its nature as forbidden fruit. This effect would vanish were the face to be replaced by an off-the-shelf stereotype of the kind used by Boucher. In Boucher the face is a pointer to the body, which is its raison d'être. In Titian it is not exactly the other way round: for certainly the emotion of the painting resides in the flesh-tints, the light, softness and promise of the full female form. But in Titian the face keeps vigil over this form, quietly asserting ownership and removing it from our reach. This is erotic art, but in no way concupiscent art: Venus is not being shown to us as a possible object of our own desire. She is being withheld from us, integrated into the personality that quietly looks from those eyes and which is busy with thoughts and desires of its own.

When Manet famously painted the *boulevardienne* of nineteenth-century Paris in the pose of a Titian Venus, his intention was not to present her body as a sexual object, but to reveal another and more hardened kind of subjectivity. The hand on the thigh of Manet's Olympia is not the hand that Titian paints, schooled in innocent caresses and resting with a fairy touch: it is a raw, tough hand that deals in money, that grips far more readily than it strokes, and which is used to fend off cheats, nerds and perverts. The knowing expression neither offers the body nor withholds it, but nevertheless has its own way of saying that this body is wholly mine. Olympia addresses the viewer with a shrewd appraising look that is anything but erotic, and the great bouquet deferentially presented by the servant shows how futile it is to approach such a woman with romantic gestures. There is an intense moment of individualization captured in this painting—a moment related, albeit ironically, to the moment of individualization in the Titian Venus. We are presented with this woman's body through the lens of her own awareness. And the connection between self-identity and self-awareness is made vivid in her tough reclining form,

which is not resting on the bed but ready to spring from it. This is a beautiful painting, but its beauty is not the beauty of the woman who is dandling her slippers on the sheets.

Erōs and desire

The question raised by Plato in the *Symposium* and the *Phaedrus* remains as pertinent today as it was in ancient Greece: what place is there, in sexual desire, for the individual object? Seen as a merely physical urge, desire can be equally satisfied by any member of the relevant sex. In which case the individual cannot be its true object, since he or she is merely an instance of the universal man or woman. Seen as a spiritual force, however, desire is equally indifferent to the individual. If the individual is targeted, it is on account of his or her beauty: and beauty is a universal, which can be neither consumed nor possessed but only contemplated. Either way the individual drops out of consideration as irrelevant— physical desire doesn't reach him, and erotic love transcends him. In both Plato's version and that of the medievals the incarnate individual vanishes as the object of love, etherealized into a discarnate smile like Beatrice in the *Paradiso*.

Gradually, in the aftermath of the Renaissance, the Platonic view of our condition lost its appeal, and erotic feelings began to be represented in art, music and poetry for what they are. In Shakespeare's *Venus and Adonis* the goddess of love has definitively fallen to earth, becoming not merely a symbol of physical passion, but also a victim of it. Milton takes up the story in his portrait of Adam and Eve: a representation of 'the rites mysterious of connubial love' in which the body is all-important, not as an instrument, but as the physical presence of the rational soul. The body is not etherealized in the smile; rather the smile is realized in the body, though 'smiles from Reason flow, and are of love the food', as Milton puts it. So are Adam and Eve fully carnal beings, 'emparadised in one another's arms'.

Milton's aim was not to divide the goddess of love as Plato had divided her, but to show sexual desire and erotic love as intricately connected, each made whole and legitimate by the other. Dryden in England, and Racine in France, likewise portrayed erotic love as it is, a predicament of embodied individuals, for whom will, desire and freedom are all made of flesh. Such writers recognized the erotic as a kind of crux in the human condition, a mystery with which our earthly destiny is entwined, and from which we cannot escape without sacrificing some part of our nature and our happiness. The early Florentine Renaissance, however, remained true to the medieval and Platonist conception of the erotic. In this respect the distance between Dante and Milton parallels the distance between Botticelli and Titian. While the Platonist mind of the Middle Ages and the early Renaissance conceives the object of desire as a premonition of the eternal, the modern mind sees the object of desire as both rational and mortal, with all the poignant and grief-implying helplessness that stems from this.

Art and pornography

The ascent of the soul through love, which Plato describes in the *Phaedrus*, is symbolized in the figure of Aphrodite Urania, and this was the Venus painted by Botticelli, who was incidentally an ardent Platonist, and member of the Platonist circle around Pico della Mirandola. Botticelli's Venus is not erotic: she is a vision of heavenly beauty, a visitation from other and higher spheres, and a call to transcendence. Indeed, she is self-evidently both the ancestor and the descendant of the Virgins of Fra Filippo Lippi: the ancestor in her pre-Christian meaning, the descendant in absorbing all that had been achieved through the artistic representation of the Virgin Mary as the symbol of untainted flesh.

The post-Renaissance rehabilitation of sexual desire laid the foundations for a genuinely erotic art, an art that would display the human being as both subject and object of desire, but also as a free individual whose desire is a favour consciously bestowed.

But this rehabilitation of sex leads us to raise what has become one of the most important questions confronting art and the criticism of art in our time: that of the difference, if there is one, between erotic art and pornography. Art can be erotic and also beautiful, like a Titian Venus. But it cannot be beautiful and also pornographic—so we believe, at least. And it is important to see why.

In distinguishing the erotic and the pornographic we are really distinguishing two kinds of interest: interest in the embodied person and interest in the body—and, in the sense that I intend, these interests are incompatible. (See the discussion in Chapter 2.) Normal desire is an inter-personal emotion. Its aim is a free and mutual surrender, which is also a uniting of two individuals, of you and me—*through* our bodies, certainly, but not merely *as* our bodies. Normal desire is a person to person response, one that seeks the selfhood that it gives. Objects can be substituted for each other, subjects not. Subjects, as Kant persuasively argued, are free individuals; their non-substitutability belongs to what they essentially are. Pornography, like slavery, is a denial of the human subject, a way of negating the moral demand that free beings must treat each other as ends in themselves.

Soft pornography

The point can be put in terms of a distinction introduced in Chapter 5. Pornography addresses a fantasy interest, while erotic art addresses an interest of the imagination. Hence the first is explicit and depersonalized, while the second invites us into the subjectivity of another person and relies on suggestion and allusion rather than explicit display.

The purpose of pornography is to arouse vicarious desire; the purpose of erotic art is to portray the sexual desire of the people pictured within it—and if it also arouses the viewer, as Correggio does from time to time, then this is an aesthetic defect, a 'fall' into

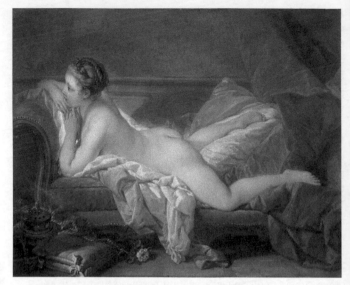

21. Boucher, *Blonde Odalisque*: the shameless body

another kind of interest than that which has beauty as its target. Hence erotic art veils its subject matter, in order that desire should not be traduced and expropriated by the observer. The supreme achievement of erotic art is to cause the body to veil *itself*—to make the flesh itself into an expression of the decency that forbids the voyeur, so that the subjectivity of the nude is revealed even in those parts of the body that are outside the province of the will. This is what Titian achieves, and the result is an erotic art that is both serene and nuptial, an art that removes the body completely from the sullying interest of the Peeping Tom.

Turn now to Boucher's *Blonde Odalisque*, and you will see how very different is the artistic intention. This woman has adopted a pose that she could never adopt when dressed. It is a pose which has little or no place in ordinary life outside the sexual act, and it draws attention to itself, since the woman is looking vacantly away

134

and seems to have no other interest. But there is another way in which Boucher's painting touches against the bounds of decency, and this is in the complete absence of any reason for the Odalisque's pose within the picture. She is alone in the picture, looking at nothing in particular, engaged in no other act than the one we see. The place of the lover is absent and waiting to be filled: and you are invited to fill it.

Of course there are differences between the Odalisque and the tits and bums on page three of *The Sun*. One is the general difference between painting and photography—the first being a representation of fictions, the second a presentation of realities (even when adjusted by the airbrush or the photosoftware). The least that can be said is that the bum on page three is as real as they come and interesting for that very reason. The second difference is connected, namely, that we need know nothing of Boucher's *Odalisque* in order to appreciate its intended effect, save what the picture tells us. There was a model who posed for this canvas; but we understand the canvas neither as a portrait of her nor as a painting about her. The bum on page three has a name and address. Very often the accompanying text tells you a lot about the girl herself, helps you forward with the fantasy of sexual contact. For many people, with reason I think, this makes a decisive moral difference between the page three image and a painting like Boucher's. The woman on page three is being packaged in her sexual attributes, and placed in the fantasies of a thousand strangers. She may not mind this—presumably she doesn't. But in not minding she shows how much she has already lost. No-one is degraded by Boucher's painting, since no-one real occurs in it. This woman—even though the model who sat for her has a name and address (she was Louise O'Murphy, kept for the king's pleasure at the Parc aux Cerfs)—is presented as a figment, in no sense identical with any real human being, despite being painted from life.

The moral question

It is difficult to find your way through the moral morass of soft pornography. In a time like ours, when explicit images of the most blatant kind are available at the touch of a keyboard, when hard core pornography is protected by the US Supreme Court as 'free speech', and when human sexuality is discussed as though modesty, decency and shame were nothing more than oppressive illusions, it is hard to be disapproving towards page three. What harm does it do? Such is the natural response, and when provoked by censorious feminists it is a response with which you can sympathize. Nevertheless we should not deceive ourselves, as some commentators do, into thinking that the interest directed towards page three is an interest in beauty, in an ideal of womanhood or in some higher value than is revealed in the text. On the contrary, the all-important feature of the girl on page three is that she is real, and on display as a sexual object. Even if the attitude towards her is muted, and even if she fills some compensating function in a life deprived of real sexual enjoyment, we should not believe that she competes in the realm of aesthetic interest—not even for the interest directed towards Boucher's *Blonde Odalisque*. Boucher's canvas lies on the dividing line between the aesthetic and the sexual, allowing our thoughts to stray into forbidden territory but not provoking them with the knowledge that this woman is real, ready and available—the knowledge that causes the jump from imagination to fantasy, and from the aesthetic appreciation of female beauty to the desire to embrace the particular instance of it.

The discussion of Titian's Venus indicates, I think, why pornography lies outside the realm of art, why it is incapable of beauty in itself and desecrates the beauty of the people displayed in it. The pornographic image is like a magic wand that turns subjects into objects, people into things—and thereby disenchants them, destroying the source of their beauty. It causes people to hide behind their bodies, like puppets worked by hidden strings. Ever

since Descartes's *cogito*, the idea of the self as an inner homunculus, has cast its shadow over our views of the human person. The Cartesian picture tempts us to believe that we go through life dragging an animal on a lead, forcing it to do our bidding until, at the last, it collapses and dies. I am a subject; my body an object: I am I, it is it. In this way the body becomes a thing among things, and the only way I can rescue it is to assert a right of ownership, to say, this body is not just any old object, but one that belongs to *me*. And that is precisely how the relation between soul and body is viewed in the pornographic image.

There is another and better way of seeing things, however, and it is one that explains much of that old morality that many people now profess to find so puzzling. On this view my body is not my property but—to use the theological term—my incarnation. My body is not an object but a subject, just as I am. I don't own it, any more than I own myself. I am inextricably mingled with it, and what is done to my body is done to me. And there are ways of treating it that cause me to think and feel as I would not otherwise think or feel, to lose my moral sense, to become hardened or indifferent to others, to cease to make judgements or to be guided by principles and ideals. When this happens it is not just I who am harmed: all those who love me, need me or relate to me are harmed as well. For I have damaged the part on which relationships are built.

The old morality, which told us that selling the body is incompatible with giving the self, touched on a truth. Sexual feeling is not a sensation that can be turned on and off at will: it is a tribute from one self to another and—at its height—an incandescent revelation of what you are. To treat it as a commodity, that can be bought and sold like any other, is to damage both present self and future other. The condemnation of prostitution was not just puritan bigotry; it was a recognition of a profound truth, which is that you and your body are not two things but one, and by selling the body you harden the soul. And

137

that which is true of prostitution is true of pornography too. It is not a tribute to human beauty but a desecration of it.

Beauty and *erōs*

In this chapter I have focused on painting, in order to pencil in the borderline between erotic art and sexual fantasy. My intention was to visit for the last time the old Platonic view, that *erōs* is the governing principle of beauty in all its forms, and to show in detail how this misrepresents both the nature of aesthetic interest and the kind of moral education which true art can accomplish. Beauty comes from setting human life, sex included, at the distance from which it can be viewed without disgust or prurience. When distance is lost, and imagination swallowed up in fantasy, then beauty may remain—but it is a spoiled beauty, one that has been prised free from the individuality of the person who possesses it. It has lost its value and gained a price.

Moreover human beauty belongs to our embodiment, and art that 'objectifies' the body, removing it from the realm of moral relations, can never capture the true beauty of the human form. By desecrating the beauty of people, it desecrates itself. The comparison between pornography and erotic art shows us that taste is rooted in our wider preferences, and that these preferences express and encourage aspects of our own moral character. The case against pornography is the case against the interest that it serves—the interest in seeing people reduced to their bodies, objectified as animals, made thing-like and obscene. This is an interest that many people have; but it is an interest at war with our humanity. In judging this interest adversely I move out of the sphere of aesthetic judgement into that of sexual virtue and sexual vice. Pornography therefore offers a vivid illustration of the thesis touched on at the end of the last chapter. The standard of taste is fixed by the virtues of the critic, and these virtues are tried and proved in the moral life.

Chapter 8
The flight from beauty

In the first chapter I distinguished two ideas of beauty—one denoting aesthetic success, the other a specific form of it, the form in which we delight, and are at one with, the presented aspect of the world. Throughout this book I have pointed to aesthetic objects that succeed without necessarily being beautiful in this idealizing sense—either because they are too ordinary, like clothes, or because they attract our attention by disturbing us, like the novels of Zola or the operas of Berg.

Even in Zola and Berg, however, beauty shows its face—as in the lovely invocation of the young Françoise and her cow at the opening of *La Terre* or the equally lovely music with which Berg's orchestra sorrows over Lulu. Zola and Berg, in their different ways, remind us that real beauty can be found, even in what is seedy, painful and decayed. Our ability to *tell the truth* about our own condition, in measured words and touching melodies, offers a kind of redemption from it. The most influential work of twentieth-century English literature, T. S. Eliot's *The Waste Land*, describes the modern city as a soulless desert: but it does so with images and allusions that affirm what the city denies. Our very ability to make this judgement is the final disproof of it. If we can grasp the emptiness of modern life, this is because art points to *another way of being*, and Eliot's poem makes this other way available.

The Waste Land belongs to the tradition of Baudelaire's *Les Fleurs du mal*, Flaubert's *Madame Bovary*, and James's *The Golden Bowl*. It describes what is seedy and sordid in words so resonant of the opposite, so replete with the capacity to feel, to sympathize and to understand, that life in its lowest forms is vindicated by our response to it. This 'redemption through art' occurs only because the artist aims at beauty in the narrow sense. And this is the paradox of *fin-de-siècle* culture: that it continued to believe in beauty, while focusing on all the reasons for doubting that beauty is obtainable outside the realm of art.

Since that time art has taken another turn, refusing to bless human life with anything like a vision of redemption. Art in the tradition of Baudelaire floats like an angel above the world beneath its gaze. It does not avoid the spectacle of human folly, malice and decay; but it invites us to another place, telling us that 'là tout n'est qu'ordre et beauté: | Luxe, calme et volupté'. More recent art cultivates a posture of transgression, matching the ugliness of the things it portrays with an ugliness of its own. Beauty is downgraded as something too sweet, too escapist and too far from realities to deserve our undeceived attention. Qualities that previously denoted aesthetic failure are now cited as marks of success; while the pursuit of beauty is often regarded as a retreat from the real task of artistic creation, which is to challenge comforting illusions and to show life as it is. Arthur Danto has even argued that beauty is both deceptive as a goal and in some way antipathetic to the mission of modern art.

This movement of ideas can be seen as in part a recognition of the ambiguous nature of the term 'beauty'. But it also involves a rejection of beauty in its narrow sense, an affirmation that the old invocations of home, peace, love and contentment are lies, and that art must henceforth devote itself to the real and unpleasant truth of our condition.

The modernist apology

The repudiation of beauty gains strength from a particular vision of modern art and its history. According to many critics writing today a work of art justifies itself by announcing itself as a visitor from the future. The value of art is a shock value: art exists to awaken us to our historical predicament and to remind us of the ceaseless change which is the only permanent thing in human nature.

Historians of painting therefore constantly remind us of the Salon Art of the mid-nineteenth century—art that was not art at all, precisely because it was derived from a repertoire of exhausted gestures—and of the resistance at first encountered by Manet, whom Baudelaire extolled as 'le peintre de la vie moderne'. They remind us of the great force that was released into the world by Manet's iconoclasm, and of the successive shocks to the system as one by one the experiments proceeded, until figurative painting came to be seen by many as a thing of the past.

Historians of music remind us of the last symphony and late quartets of Beethoven, in which the constraints of form seem to be burst asunder by a titanic power; they dwell on the case of *Tristan und Isolde*, whose shifting chromatic harmonies seem to stretch tonality to the very limit, and on the music of Stravinsky, Bartók and Schoenberg—music which at first shocked the world, and which was justified in terms used to justify the abolition of figurative painting. The old language, the historians say, was exhausted: only clichés could result from the attempt to prolong its use. The new language was designed to place music in its historical context, to recognize the present as something detached from the past, a new experience which we seize only by understanding it as 'other' than what has gone before. But in the very moment of seizing the present we become aware of it as past and superseded.

Tradition and orthodoxy

In architecture and literature we find the same story, of art at war with its past, forced to challenge the rule of clichés, and to set off on a path of transgression. However, the story is fed on a one-sided diet of examples. At the moment when Rothko, de Kooning and Pollock were engaged in their (to my mind highly repetitive) experiments, Edward Hopper was producing figurative paintings that showed him to be as much the painter of modern American life as Manet had been the painter of life in nineteenth-century Paris. At the moment when Schoenberg was jettisoning tonality for the twelve-tone serial method, Janáček was composing *Katya Kabanova* and Sibelius beginning his great series of tonal symphonies.

Moreover, there is another, and truer, history of the modern artist which is the story told by the great modernists themselves. It is the history told by T. S. Eliot, in his essays and in *Four Quartets*, by Ezra Pound in the *Cantos*, by Schoenberg in his critical writings and in *Moses und Aron*, and by Pfitzner in *Palestrina*. And it sees the goal of the modern artist not as a break with tradition, but as a recapturing of tradition, in circumstances for which the artistic legacy has made little or no provision. This history does not see the pastness of the present moment, but its present reality, as the *place we have got to*, and whose nature must be understood in terms of a continuum. If, in modern circumstances, the forms and styles of art must be remade, this is not in order to repudiate the old tradition, but in order to restore it. The effort of the modern artist is to express realities which have not been encountered before, and which are especially hard to encompass. But this cannot be done, except by bringing the spiritual capital of our culture to bear on the present moment and to show it as it truly is. For Eliot and his colleagues, therefore, there could be no truly modern art which was not at the same time a search for orthodoxy: an attempt

to capture the nature of the modern experience, by setting it in relation to the certainties of a live tradition.

You may find the result impenetrable, unintelligible or even ugly-- as many do in the case of Schoenberg. But that is certainly not the intention. Schoenberg, like Eliot, sought to *renew* the tradition, not to destroy it, but to renew it as a vehicle in which beauty, rather than banality, would once more be the norm. There is nothing absurd in the view that the gossamer lines of Schoenberg's *Erwartung* have more of real melody than the thick textures of a Vaughan Williams symphony. True, this little melodrama has a nightmarish quality that is far from the consoling beauties of a song by Schubert. But Schoenberg's idiom can be understood as an attempt both to understand the nightmare, and to rein it in—to confine it in a musical form which gives meaning and beauty to catastrophe in the way that Aeschylus gave meaning and beauty to the avenging furies, or Shakespeare and Verdi to the dreadful death of Desdemona.

The modernists feared that the aesthetic endeavour would detach itself from the full artistic intention, and become empty, repetitious, mechanical and cliché-ridden. It was self-evident to Eliot, Matisse and Schoenberg that this was happening all around them, and they set out to protect an endangered aesthetic ideal from the corruptions of popular culture. This ideal had connected the pursuit of beauty with the impulse to consecrate human life and endow it with a more than worldly significance. In short, the modernists set out to reunite the artistic enterprise with its underlying spiritual aim. Modernism was not conceived as a transgression but as a recuperation· an arduous path back to a hard-won inheritance of meaning, in which beauty would again be honoured, as the present symbol of transcendent values. This is not what we see in the consciously 'transgressive' and 'challenging' art of today, which exemplifies a flight from beauty, rather than a desire to recover it.

The flight from beauty

One of Mozart's most endearing works is the comic opera, *Die Entführung aus dem Serail*, which tells the story of Konstanze, shipwrecked and separated from her fiancé Belmonte, and taken to serve in the harem of the Pasha Selim. After various intrigues, Belmonte rescues her, helped by the clemency of the Pasha, who respects Konstanze's chastity, declining to take her by force. This implausible plot permits Mozart to express his Enlightenment conviction that charity is a universal virtue, as real in the Muslim empire of the Turks as in the Christian empire of the enlightened Joseph II (himself hardly Christian). The faithful love of Belmonte and Konstanze inspires the Pasha's clemency. And, even if Mozart's innocent vision is without much historical basis, his belief in the reality of disinterested love is everywhere expressed and endorsed by the music. *Die Entführung* advances a moral idea, and its melodies share the beauty of that idea and persuasively present it to the listener.

In the 2004 production of *Die Entführung* at the Comic Opera in Berlin, the producer Calixto Bieito decided to set the opera in a Berlin brothel, with Selim as pimp, and Konstanze one of the prostitutes. Even during the most tender music, the stage was littered with couples copulating, and every excuse for violence, with or without a sexual climax, was taken. At one point a prostitute is gratuitously tortured, and her nipples bloodily and realistically severed before she is killed. The words and the music speak of love and compassion, but their message is drowned out by the loudly orchestrated scenes of murder and narcissistic sex that litter the stage.

That is an example of a phenomenon with which we are familiar from every aspect of our contemporary culture. It is not merely that artists, directors, musicians and others connected with the arts are in flight from beauty. There is a desire to spoil beauty, in acts of

aesthetic iconoclasm. Wherever beauty lies in wait for us, the desire to pre-empt its appeal can intervene, ensuring that its still small voice will not be heard behind the scenes of desecration. For beauty makes a claim on us: it is a call to renounce our narcissism and look with reverence on the world. (Cf. Iago of Cassio: 'He hath a daily beauty in his life | Which makes me ugly', and the soliloquy of Claggart in Britten's *Billy Budd*, raging against the beauty that shines its light on his own moral worthlessness.)

I have used the word 'desecration', thereby recalling the discussion of the sacred in Chapter 2. To desecrate is to spoil what might otherwise be set apart, in the sphere of consecrated things. We can desecrate a church, a mosque, a graveyard, a tomb; and also a holy image, a holy book or a holy ceremony. We can also desecrate a corpse, a cherished image, even a living human being—in so far as these things contain (as they do) a portent of some original 'apartness'. The fear of desecration is a vital element in all religions. Indeed, that is what the word *religio* originally meant: a cult or ceremony designed to protect some sacred place from sacrilege.

Our need for beauty is not something that we could lack and still be fulfilled as people. It is a need arising from our metaphysical condition, as free individuals, seeking our place in a shared and public world. We can wander through this world, alienated, resentful, full of suspicion and distrust. Or we can find our home here, coming to rest in harmony with others and with ourselves. The experience of beauty guides us along this second path: it tells us that we *are* at home in the world, that the world is already ordered in our perceptions as a place fit for the lives of beings like us. But—and this is again one of the messages of the early modernists—beings like us become at home in the world only by acknowledging our 'fallen' condition, as Eliot acknowledged it in *The Waste Land*. Hence the experience of beauty also points us beyond this world, to a 'kingdom of ends' in which our immortal longings and our desire for perfection are finally answered. As Plato and Kant both saw, therefore, the feeling for beauty is

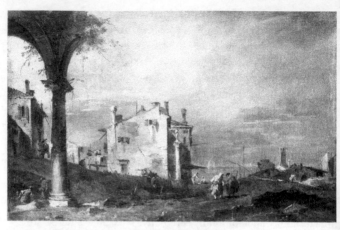

22. Guardi, *Scene with Marine Landscape*: joy in decay

proximate to the religious frame of mind, arising from a humble sense of living with imperfections, while aspiring towards the highest unity with the transcendental.

Look at any picture by one of the great landscape painters—Poussin, Guardi, Turner, Corot, Cézanne—and you will see that idea of beauty celebrated and fixed in images. Those painters do not turn a blind eye to suffering, or to the vastness and threateningness of the universe, of which we occupy so small a corner. Far from it. Landscape painters show us death and decay in the very heart of things: the light on their hills is a fading light; the walls of their houses are patched and crumbling like the stucco on the villages of Guardi. But their images point to the joy that lies incipient in decay, and to the eternal that is implied in the transient.

Even in the brutal presentations of thwarted and malicious life that fill the novels of Zola we find, if not the reality of beauty, at least a distant glimpse of it—recorded in the rhythm of the prose, and in the invocations of stillness amid the futile longings which

drive the characters to their goals. Realism, in Zola as in Baudelaire and Flaubert, is a kind of disappointed tribute to the ideal. The subject-matter is profane; but profane by nature, and not because the writer has chosen to desecrate the few scant beauties that he finds. The art of desecration represents a new departure, and one that we should try to understand, since it lies at the centre of the postmodern experience.

Sacred and profane

Desecration is a kind of defence against the sacred, an attempt to destroy its claims. In the presence of sacred things our lives are judged and in order to escape that judgement we destroy the thing that seems to accuse us.

According to many philosophers and anthropologists, however, the experience of the sacred is a universal feature of the human condition, and therefore not easily avoided. For the most part our lives are organized by transitory purposes. But few of these purposes are memorable or moving to us. Every now and then we are jolted out of our complacency, and feel ourselves to be in the presence of something vastly more significant than our present interests and desires. We sense the reality of something precious and mysterious, which reaches out to us with a claim that in in some way not of this world. This happens in the presence of death, and especially the death of someone loved. We look with awe on the human body from which the life has fled. This is no longer a person, but the 'mortal remains' of a person. And this thought fills us with a sense of the uncanny. We are reluctant to touch the dead body; we see it as in some way not properly a part of our world, almost a visitor from some other sphere.

This experience is a paradigm of our encounter with the sacred. And it demands from us a kind of ceremonial recognition. The dead body is the object of rituals and acts of purification, designed not just to send its former occupant happily into the hereafter—for

these practices are engaged in even by those who have no belief in the hereafter—but in order to overcome the eeriness, the supernatural quality, of the dead human form. The body is being reclaimed for this world, by the rituals which acknowledge that it also stands apart from it. The rituals, to put it in another way, consecrate the body, purify it of its miasma and restore it to its former status as an embodiment. By the same token, the dead body can be desecrated, when it is displayed to the world as a mere heap of discarded flesh—and this is surely one of the primary acts of desecration, one to which people have been given from time immemorial, as when Achilles drags the body of Hector in triumph around the walls of Troy.

There are other occasions when we are in a similar way startled out of our day-to-day preoccupations. In particular, there is the experience of falling in love. This too is a human universal, and it is an experience of the strangest kind. The face and body of the beloved are imbued with the most intense life. But in one crucial respect they are like the body of someone dead: they seem not to belong in the empirical world. The beloved looks on the lover as Beatrice looked on Dante, from a point outside the flow of temporal things. The beloved object demands that we cherish it, that we approach it with an almost ritualistic reverence. And there radiates from those eyes and limbs and words a kind of fullness of spirit that makes everything anew.

The human form is sacred for us because it bears the stamp of our embodiment. The wilful desecration of the human form, either through the pornography of sex or the pornography of death and violence, has become, for many people, a kind of compulsion. And this desecration, which spoils the experience of freedom, is also a denial of love. It is an attempt to remake the world as though love were no longer a part of it. And that, surely, is what is the most important characteristic of the postmodern culture, as exemplified in Bieito's production of *Die Entführung*: it is a loveless culture, which is afraid of beauty because it is disturbed by love.

Idolatry

The dialectic of the sacred and the profane is a leading theme of the Jewish Bible, in which God is constantly revealing himself in mysteries that emphasize his sacred character, and in which the Jews are constantly tempted to profane him, by worshipping images and idols in his place. Why should God be profaned by idolatry, and why are people tempted by it? Why does God decree the terrible genocidal punishment of the Israelites for what (by modern standards) is the casual peccadillo of dancing before the Golden Calf? Does God have no sense of proportion?

Such questions point us to the peculiarity of sacred things, that they do not admit of substitutes. There are not degrees of profanation, but a single and unified thing that profanation is, which is putting a substitute in place of that for which there are no substitutes—the 'I am that I am' that is uniquely itself, and which must be worshipped for the thing that it is and not as a means to an end that could be achieved in some other way or through some

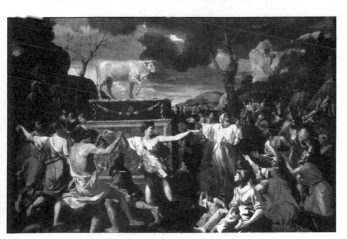

23. Poussin, *The Israelites Dancing around the Golden Calf*: in the world and of the world

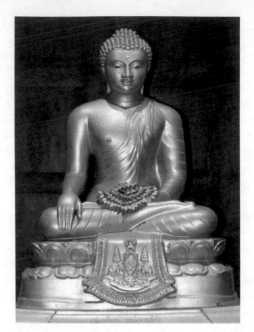

24. Golden Buddha: in the world, but not of the world

rival deity. Idolatry is the paradigm profanation, since it admits into the realm of worship the idea of a *currency*. You can trade in idols, swap them around, try out new versions, see which one responds best to prayer, and which one strikes the best bargains. And all this is a profanation, since it involves trading that which cannot be traded without ceasing to be, which is the sacred object itself.

The object of worship is to be placed apart, *in* the world but not *of* it, to be addressed as the unique thing that it is, in which all the meanings of our lives are somehow summarized and consecrated— 'robed as destinies', in Larkin's words. This is what we mean by calling it sacred. It is a deep question of anthropology why there should be the need for such objects, and a deep question of

theology whether that need corresponds to any objectively existing reality. But it is important to see that the posture towards God that is advocated in the Hebrew Bible, although it is to a certain measure an innovation (as is the very idea that he is God, rather than a god), is one that we understand instinctively, even if we cannot give a rationalization of it, or explain why it has such importance in the life of a religious believer.

Profanation

There are other occasions in which we try to focus on something, to appreciate it for its own sake, as the thing that it is, and in which our attitude, while not one of worship, is nevertheless threatened by the pursuit of substitutes. The most evident example is the one that I have been considering on and off throughout this book—sexual interest, in which the object is idealized, held apart, pursued not as a commodity but for the particular person he or she is. That kind of interest, which is what we mean by erotic love, is at risk—and the principal risk is the appearance, in whatever guise, of a substitute. As I remarked in Chapter 2, jealousy is painful not least because it sees the object of love, once sacred, as now desecrated.

One cure for the pain of desecration is the move towards total *profanation*: in other words, to wipe out all vestiges of sanctity from the once worshipped object, to make it merely a thing *of* the world, and not just a thing *in* the world, something that is nothing over and above the substitutes that can at any time replace it. That is what we see in the spreading addiction to pornography—a profanation that removes the sexual bond entirely from the realm of intrinsic values. It involves wiping out one area in which the idea of the beautiful had taken root, so as to protect ourselves from the possibility of loving it and therefore losing it.

The other area in which this profanation regularly occurs is that of aesthetic judgement. Here too we are dealing with an attitude that tries to single out its object, to appreciate it for its own sake, to

regard it as irreplaceable, without substitutes, bearing its meaning inseparably within itself. I don't say that works of art are sacred things—though many of the greatest works of art started life in that way, including the statues and temples of the Greeks and Romans, and the altarpieces of medieval Europe. But I do say that they are, or have been, part of the continuing human attempt to idealize and sanctify the objects of experience, and to present images and narratives of our humanity as a thing to live up to, and not merely a thing to live. And this is true even of those works of brutal realism, like Flaubert's *Madame Bovary* and Zola's *Nana*, whose power and persuasiveness depend upon the ironical contrast between things as they are and things as people wish them to be. As I suggested, the temptation towards profanation, which manifestly exists in the sexual sphere, exists too in the aesthetic. Works of art become objects of desecration, and the more likely to be targeted, the more claims they make for their own sacred status. (Hence the routine profanation of the Wagner operas by producers enraged by, or estranged from, their presumptuous spiritual claims.)

Anthropological remarks

Culture emerges from our attempt to settle on standards that will command the consent of people generally, while raising their aspirations towards the goals that make people admirable and lovable. Culture therefore represents an investment over many generations, and imposes enormous and by no means clearly articulated obligations—in particular, the obligation to be other and better than we are, in all the ways that others might appreciate. Manners, morals, religious precepts and ordinary decencies train us in this, and they form the central core of any culture. But they are necessarily concerned with what is common and easily taught.

As I have been at pains to point out, aesthetic judgement is an integral part of these elementary forms of social coordination, and

aesthetic judgement leads of its own accord to other and
potentially 'higher' and more stylized applications. It is constantly
pointing away from our ordinary imperfections and fallings short,
to a world of high ideals. It therefore contains within itself two
permanent causes of offence. First it is urging upon us
distinctions—of taste, of refinement, of understanding—which
cannot fail to remind us that people are not equally interesting,
equally admirable, or equally able to understand the world in
which they live.

Secondly, because the democratic attitude is invariably in conflict
with itself—it being impossible to live as though there are
no aesthetic values, while living a real life among human
beings—aesthetic judgement begins to be experienced as an
affliction. It imposes an intolerable burden, something that we
must live up to, a world of ideals and aspirations that is in sharp
conflict with the tawdriness of our improvised lives. It is perched
like an owl on our shoulders, while we try to hide our pet rodents in
our clothes. The temptation is to turn on it and shoo it away. The
desire to desecrate is a desire to turn aesthetic judgement against
itself, so that it no longer seems like a judgement of *us*. This you see
all the time in children—the delight in disgusting noises, words,
allusions, which helps them to distance themselves from the adult
world that judges them, and whose authority they wish to deny.
(Hence the appeal of Roald Dahl.) That ordinary refuge of children
from the burden of adult judgement, is the refuge too of adults
from the burden of their culture. By using culture as an instrument
of desecration they neutralize its claims: it loses all authority, and
becomes a fellow conspirator in the plot against value.

Beauty and pleasure

The desire for desecration leads to its own kind of pleasure,
and you might be tempted to think that this too is an aesthetic
pleasure, a new phase of that *esthétique du mal* extolled by
Baudelaire. To see that this is not so we must briefly revisit the

discussion of Chapter 1. As I suggested in that chapter pleasure *in* must be distinguished from pleasure *that*. And I further argued that a distinction must be made between two broad kinds of pleasure *in*: the sensory and the intentional. The first proceeds directly from a stimulus, has an excitable form, and can be produced automatically. Such are the pleasures of eating and drinking, which are easily obtained and easily over-indulged and which require no particular cognitive capacities. (Even laboratory rats can achieve such pleasures.) The other kind of pleasure proceeds from an act of understanding: not a sensory gratification of the subject but a pleasing interest in an object. Such intentional pleasures have a cognitive dimension: they reach out from the self to lay hold of the world, and their primary focus is not the feeling of pleasure itself, but the object that gives rise to it. They are, if you like, *objective* pleasures, that take in the reality of the thing towards which they are directed. Pleasures of the senses are, by contrast, *subjective*; they are focused on the experience itself, and how it is for the one who feels it. Between the two kinds of pleasure are a host of intermediate cases—such as the pleasures of the wine connoisseur, which involve a distinctive kind of 'relishing', but which do not depend upon interpreting their object in terms of its content or meaning.

Aesthetic pleasure is focused on the presented aspect of its object, and this tempts people to assimilate it to the pure sensory pleasures, like those of eating and drinking. And a similar temptation bedevils the analysis of sex. There is a kind of sexual interest in which sensory pleasure eclipses the inter-personal intentionality and becomes attached to scenes of generalized and impersonal excitement—an image or tableau, to which the subject responds compulsively. This kind of sexual interest can easily reshape itself as an addiction. The temptation is to suppose that this depersonalized and sensory pleasure is the real goal of sexual desire in all its forms, and that sexual pleasure is a form of subjective pleasure analogous to the pleasures of eating and drinking—a claim explicitly made, for example, by Freud.

Pleasure and addiction

Cognitive states of mind are seldom addictive, since they depend upon exploration of the world, and the individual encounter with the individual object, whose appeal is outside the subject's control. Addiction arises when the subject has full control over a pleasure and can produce it at will. It is primarily a matter of sensory pleasure, and involves a kind of short-circuiting of the pleasure network. Addiction is characterized by a loss of the emotional dynamic that would otherwise govern an outward-directed, cognitively creative life. Sex addiction is no different in this respect from drug addiction; and it wars against true sexual interest—interest in the *other*, the individual object of desire. Why go to all the trouble of mutual recognition and shared arousal, when this short cut is available to the same sensory goal?

Just as there is sex addiction, arising from the decoupling of sexual pleasure from the inter-personal intentionality of desire, so too is there stimulus addiction—the hunger to be shocked, gripped, stirred in whatever way might take us straight to the goal of excitement—which arises from the decoupling of sensory interest from rational thought. The pathology here is familiar to us, and was interestingly caricatured by Aldous Huxley, in his account of the 'feelies'—the panoramic shows in *Brave New World* in which every sense-modality is engaged. Maybe the Roman games were similar: short cuts to awe, horror and fear which reinforced the ensuing sense of safety, by prompting the visceral relief that it is not I but another who has been torn to pieces in the ring. And maybe the 5-second cut which is the stock-in-trade of the B movie and the TV advert operates in a similar way—setting up addictive circuits that keep the eyes glued to the screen.

The contrast that I have been implicitly drawing between the love that venerates and the scorn that desecrates is like the contrast between taste and addiction. Lovers of beauty direct their attention

outwards, in search of a meaning and order that brings sense to their lives. Their attitude to the thing they love is imbued with judgement and discrimination. And they measure themselves against it, trying to match its order in their own living sympathies.

Addiction, as the psychologists point out, is a function of easy rewards. The addict is someone who presses again and again on the pleasure switch, whose pleasures by-pass thought and judgement to settle in the realm of need. Art is at war with effect addiction, in which the need for stimulation and routinized excitement has blocked the path to beauty by putting acts of desecration centre stage. Why this addiction should be so virulent now is an interesting question: whatever the explanation, however, my argument implies that the addiction to effect is the enemy not only of art but also of happiness, and that anybody who cares for the future of humanity should study how to revive the 'aesthetic education', as Schiller described it, which has the love of beauty as its goal.

Sanctity and kitsch

Art, as we have known it, stands on the threshold of the transcendental. It points beyond this world of accidental and disconnected things to another realm, in which human life is endowed with an emotional logic that makes suffering noble and love worthwhile. Nobody who is alert to beauty, therefore, is without the concept of redemption—of a final transcendence of mortal disorder into a 'kingdom of ends'. In an age of declining faith art bears enduring witness to the spiritual hunger and immortal longings of our species. Hence aesthetic education matters more today than at any previous period in history. As Wagner expressed the point: 'It is reserved to art to salvage the kernel of religion, inasmuch as the mythical images which religion would wish to be believed as true are apprehended in art for their symbolic value, and through ideal representation of those symbols art reveals the concealed deep truth within them.' Even

for the unbeliever, therefore the 'real presence' of the sacred is now one of the highest gifts of art.

Conversely the degradation of art has never been more apparent. And the most widespread form of degradation—more widespread even than the deliberate desecration of humanity through pornography and gratuitous violence—is kitsch, that peculiar disease which we can instantly recognize but never precisely define, and whose Austro-German name links it to the mass movements and crowd sentiments of the twentieth century.

In a celebrated article, 'Avant-garde and Kitsch', published in *Partisan Review* in 1939, Clement Greenberg presented educated Americans with a dilemma. Figurative painting, he argued, was dead—it had exhausted its expressive potential, and its representational aims had been bequeathed to photography and the cinema. Any attempt to continue in the figurative tradition would inevitably lead to kitsch, in other words to art with no message of its own, in which all the effects were copied and all the emotions faked. Genuine art must belong to the avant-garde, breaking with the figurative tradition in favour of 'abstract expressionism', which uses form and colour to liberate emotion from the prison of narrative. In this way Greenberg promoted the paintings of de Kooning, Pollock and Rothko, while condemning the great Edward Hopper as 'shabby, second-hand and impersonal'.

Look back at figurative art in the Western tradition and you will observe that, prior to the eighteenth century, there was primitive art, naive art, routine and decorative art, but no kitsch. Just when the phenomenon first appeared is disputable: maybe Greuze shows traces of it; maybe it had even been foreshadowed in Murillo. What is certain is that, by the time of Millet and the Pre-Raphaelites, kitsch was in the driving seat. At the same time fear of kitsch had become a major artistic motive, prompting the impressionist and cubist revolutions as well as the birth of atonality in music.

25. Garden gnomes: The Disneyfication of everyday life

It is not only in the world of art that we observe the steady advance of kitsch. Far more important, given its influence on the popular psyche, has been the kitschification of religion. Images are of enormous importance in religion, helping us to understand the Creator through idealized visions of his world: concrete images of transcendental truths. In the blue robe of a Bellini virgin we encounter the ideal of motherhood, as an enfolding purity and a promise of peace. This is not kitsch but the deepest spiritual truth, and one that we are helped to understand through the power and eloquence of the image. However, as the puritans have always reminded us, such an image stands on the verge of idolatry, and with the slightest push can fall from its spiritual eminence into the sentimental abyss. That happened everywhere in the nineteenth century, as the mass-produced votive figures flooded ordinary households, the holy precursors of today's garden gnomes.

Kitsch is a mould that settles over the entire works of a living culture, when people prefer the sensuous trappings of belief to the thing truly believed in. It is not only Christian civilization that has undergone kitschification in recent times. Equally evident has been the kitschification of Hinduism and its culture. Mass-produced Ganeshas have knocked the subtle temple sculpture from its aesthetic pedestal; in *bunjee* music the *talas* of Indian classical music are blown apart by tonal harmonies and rhythm machines; in literature the *sutras* and *puranas* have been detached from the sublime vision of Brahman and reissued as childish comic-strips.

Simply put, kitsch is not, in the first instance, an artistic phenomenon, but a disease of faith. Kitsch begins in doctrine and ideology and spreads from there to infect the entire world of culture. The Disneyfication of art is simply one aspect of the Disneyfication of faith—and both involve a profanation of our highest values. Kitsch, the case of Disney reminds us, is not an excess of feeling but a deficiency. The world of kitsch is in a certain measure a heartless world, in which emotion is directed away from its proper target towards sugary stereotypes, permitting us to pay passing tribute to love and sorrow without the trouble of feeling them. It is no accident that the arrival of kitsch on the stage of history coincided with the hitherto unimaginable horrors of trench warfare, of the holocaust and the Gulag—all of them fulfilling the prophecy that kitsch proclaims, which is the transformation of the human being into a doll, which in one moment we cover with kisses, and in the next moment tear to shreds.

Kitsch and desecration

Those thoughts return us to the earlier argument of this chapter. We can see the modernist revolution in the arts in Greenberg's terms: art rebels against the old conventions, just as soon as they become colonized by kitsch. For art cannot live in the world of kitsch, which is a world of commodities to be consumed, rather than icons to be revered. True art is an appeal to our higher nature,

an attempt to affirm that other kingdom in which moral and spiritual order prevails. Others exist in this realm not as compliant dolls but as spiritual beings, whose claims on us are endless and unavoidable. For us who live in the aftermath of the kitsch epidemic, therefore, art has acquired a new importance. It is the real presence of our spiritual ideals. That is why art matters. Without the conscious pursuit of beauty we risk falling into a world of addictive pleasures and routine desecration, a world in which the worthwhileness of human life is no longer clearly perceivable.

The paradox, however, is that the relentless pursuit of artistic innovation leads to a cult of nihilism. The attempt to defend beauty from pre-modernist kitsch has exposed it to postmodernist desecration. We seem to be caught between two forms of sacrilege, the one dealing in sugary dreams, the other in savage fantasies. Both are forms of falsehood, ways of reducing and demeaning our humanity. Both involve a retreat from the higher life, and a rejection of its principal sign, which is beauty. But both point to the real difficulty, in modern conditions, of leading a life in which beauty has a central place.

Kitsch deprives feeling of its cost, and therefore of its reality; desecration augments the cost of feeling, and so frightens us away from it. The remedy for both states of mind is suggested by the thing that they each deny, which is sacrifice. Konstanze and Belmonte in Mozart's opera are ready to sacrifice themselves for each other, and this readiness is the proof of their love: all the beauties of the opera arise from the constant presentation of this proof. The deaths that occur in real tragedies are bearable to us because we see them under the aspect of sacrifice. The tragic hero is both self-sacrificed and a sacrificial victim; and the awe that we feel at his death is in some way redemptive, a proof that his life was worthwhile. Love and affection between people is real only to the extent that it prepares the way for sacrifice—whether the *petits soins* that bind Marcel to Saint Loup, or the proof offered by

Alcestis, who dies for her husband. Sacrifice is the core of virtue, the origin of meaning and the true theme of high art.

Sacrifice can be avoided, and kitsch is the great lie that we can both avoid it and retain its comforts. Sacrifice can also be made meaningless by desecration. But, when sacrifice is present and respected, life redeems itself; it becomes an object of contemplation, something that 'bears looking at', and which attracts our admiration and our love. This connection between sacrifice and love is presented in the rituals and stories of religion. It is also the recurring theme of art. When, in the carnage of the Great War, poets tried to make sense of the destruction that lay all around, it was in full consciousness that kitsch merely compounded the fault. Their effort was not to deny the horror, but to find a way of seeing it in sacrificial terms. From this effort were born the war poems of Wilfred Owen and, much later, the *War Requiem* of Benjamin Britten.

So there, if we can find our way to it, is the remedy. It is a remedy that cannot be achieved through art alone. In the words of Rilke's 'Archaic Torso of Apollo': 'you must change your life'. Beauty is vanishing from our world because we live as though it did not matter; and we live that way because we have lost the habit of sacrifice and are striving always to avoid it. The false art of our time, mired in kitsch and desecration, is one sign of this.

To point to this feature of our condition is not to issue an invitation to despair. It is one mark of rational beings that they do not live only—or even at all—in the present. They have the freedom to despise the world that surrounds them and to live in another way. The art, literature and music of our civilization remind them of this, and also point to the path that lies always before them: the path out of desecration towards the sacred and the sacrificial. And that, in a nutshell, is what beauty teaches us.

Chapter 9
Concluding thoughts

The reader will have noticed that I have not said what beauty *is*. I have implicitly rejected the neo-Platonist view of beauty, as a feature of Being itself. God is beautiful; but not for *this* reason. And I have avoided the many attempts to analyse beauty in terms of some property or properties supposed to be exhibited by all beautiful things. For example, I have not discussed the tradition of thinking, which again goes back to Plotinus and the neo-Platonists, which sees beauty as a kind of organic wholeness, as in the definition given by Alberti: 'The beautiful is that from which nothing can be taken away and to which nothing can be added but for the worse.' Such a definition certainly seems to say something important; but ask the question 'worse in what respect?', and you will see that it is circular.

I have likewise said nothing about the view, popularized in the eighteenth century by Francis Hutcheson, that beauty 'consists in' *unity in variety*. That idea, taken up by a host of thinkers from Hogarth to Coleridge and beyond is one that still has its adherents. But the crucial phrase that I have placed in inverted commas is one that is never explained. Is this account of beauty a definition, an *a priori* insight into the nature of beautiful things, an empirical generalization, an ideal, or just a pious hope? Any attempt to prove the point as a generalization inevitably makes the terms 'unity' and 'variety' so vague as to cover everything from my garden (a mess,

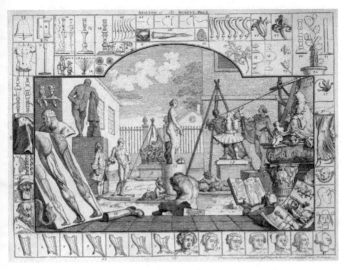

26. Hogarth, title page from *The Analysis of Beauty*: unity in variety

but bounded) to the most hideous communications tower (a unity, but with knobs on).

In my view all such definitions start from the wrong end of the subject, which is not about 'things in the world' but about a particular experience of them, and about the pursuit of meaning that springs from that experience. Does this imply that 'beauty is in the eye of the beholder', that there is no objective property that we recognize and about whose nature and value we can agree? My answer is simply this: everything I have said about the experience of beauty implies that it is rationally founded. It challenges us to find meaning in its object, to make critical comparisons, and to examine our own lives and emotions in the light of what we find. Art, nature and the human form all invite us to place this experience in the centre of our lives. If we do so, then it offers a place of refreshment of which we will never tire. But to imagine

that we can do this, and still be free to see beauty as nothing more than a subjective preference or a source of transient pleasure, is to misunderstand the depth to which reason and value penetrate our lives. It is to fail to see that, for a free being, there is right feeling, right experience and right enjoyment just as much as right action. The judgement of beauty orders the emotions and desires of those who make it. It may express their pleasure and their taste: but it is pleasure in what they value and taste for their true ideals.

Notes and further reading

1. General

Classic texts include:

Plato: *Ion*, *Phaedrus* and *Symposium*.

Plotinus, *Enneads*, 1, 6.

St Thomas Aquinas, *Summa Theologiae* I, q. 5, a. 1; I-II, q. 27, a. 1; I,
q.30, a. 8; II-II, q. 145, a. 2; I, q. 5, a. 4; I-II, q. 57, a. 3; *In Sententia
Ethicorum*, cap. 101, a. 7; *Super Sententias*, cap. 1, d. 31, q. 2, a. 1.

Anthony Ashley Cooper, third Earl of Shaftesbury, *Characteristics*,
1711.

Immanuel Kant, *Critique of Judgement* (*Kritik der Urteilskraft*), 1797.

G. W. F. Hegel, *Lectures on Aesthetics* (*Vorlesungen über die Aesthetik*,
delivered 1817–1829, published 1000).

Among more recent philosophical publications, the following have
much to say:

> George Santayana, *The Sense of Beauty* (New York, 1896).
> Jacques Maritain, *Art and Scholasticism*, tr. J. F. Scanlan (London,
> 1930).
> Samuel Alexander, *Beauty and Other Forms of Value* (London,
> 1933).
> Mary Mothersill, *Beauty Restored* (Oxford, 1981).
> Malcolm Budd, *Values of Art: Pictures, Poetry and Music*
> (Harmondsworth, 1997).
> John Armstrong, *The Intimate Philosophy of Art* (Harmondsworth,
> 2000).
> —— *The Secret Power of Beauty* (Harmondsworth, 2003).

Alexander Nehamas, *Only a Promise of Happiness: The Place of Beauty in a World of Art* (Princeton, 2007).
A reliable guide to the subject of aesthetics as it is currently understood and taught in English-speaking departments of philosophy is:
David Cooper, ed., *A Companion to Aesthetics* (Oxford, 1992).

My own work on aesthetics, which provides some of the background and detail that are missing from this book, is contained in the following four volumes:

Art and Imagination (London, 1974; South Bend, Ind., 1997).
The Aesthetics of Architecture (Princeton, 1979).
The Aesthetics of Music (Oxford, 1997).
The Aesthetic Understanding (South Bend, Ind., 1998).

2. Specific

These notes map the references, explicit or implicit, in the text. I list them by chapter, and then by section. I have not tried to give a complete bibliography, but merely to suggest further reading that might clarify the issues that I discuss.

Chapter 1

Kant's *Critique of Judgement*; David Hume, 'Of the Standard of Taste' (1757), available in any edition of Hume's essays. On metaphor, see Scruton, *The Aesthetics of Music*, ch. 3, and references therein.

The true, the good and the beautiful. Plotinus, *Enneads*, 1, 6; Plato, *Timaeus*; Kierkegaard, *Either/Or*, tr. D. F. and L. M. Swenson (New York, 1959); Wilde, *The Portrait of Dorian Gray*.

On whether beauty is a transcendental in the thought of Aquinas, see Etienne Gilson, 'The Forgotten Transcendental: *Pulchrum*', in *Elements of Christian Philosophy* (New York, 1960), 159–63, and Umberto Eco, *The Aesthetics of Thomas Aquinas*, tr. Hugh Bredin (London, 1988), ch. 2. Eco illuminatingly discusses the path from the neo-Platonist metaphysics of beauty, via the writings of Pseudo-Dionysus, to the scholastic contemporaries of Aquinas and to Aquinas himself.

Some platitudes. See Paul Horwich, *Truth* (New York, 1980): a defence of minimalism, as sufficient to generate all the platitudes concerning truth, and necessary if we are not to contradict them.

A paradox. Hume, 'Of the Standard of Taste', in *Essays*, and Kant, 'The Antinomy of Taste' in *The Critique of Judgement*.

Minimal beauty. I have discussed this at length in *The Classical Vernacular: Architectural Principles in an Age of Nihilism* (Manchester, 1992).

Some consequences. On the variety of aesthetic values, see Budd, *Values of Art*. On aesthetic extremism, see Walter Pater, *Marius the Epicurian* (1885); *The Renaissance* (1877). On 'fitting in' see A. Trystan Edwards, *Good and Bad Manners in Architecture* (London, 1924).

Two concepts of beauty. Budd, *Values of Art*.

Means, ends and contemplation. Friedrich Schiller, *Letters on the Aesthetic Education of Man*, tr. E. Wilkinson and L. A. Willoughby (Oxford, 1967); Oscar Wilde, *The Critic as Artist* (1890); and on the rise of the distinction between the fine and the useful arts, see P. O. Kristeller, 'From the Renaissance to the Enlightenment', in *Studies in Renaissance Thought and Letters*, vol. III (Rome, 1993).

Wanting the individual. Ludwig Wittgenstein, *Lectures and Conversations on Aesthetics, Freud and Religious Belief*, ed. Cyril Barrett (Oxford, 1965). Roger Scruton, *Sexual Desire* (London, 1986), ch. 5, 'The Individual Object'.

A caveat. See in general Scruton, *The Aesthetics of Architecture*. Louis Sullivan: *Louis Sullivan: The Public Papers*, ed. Robert Twombly (Chicago and London, 1988). What Sullivan actually said was 'form ever follows function'. For the opposite view, that function ever follows form, see Scruton, *The Classical Vernacular*. The relation between beauty and function is also interestingly discussed by Armstrong, *The Secret Power of Beauty*, ch. 2.

Beauty and the senses. The modern use of the term 'aesthetic' derives from A. G. Baumgarten, *Aesthetica* (Frankfurt am Main, 1750, Part II

1758). For Aquinas, see *Summa Theologiae*, 1, 5, 4 ad. 1, and Ia 2ae, 27, 1. See also Plato, *Hippias Major*, 297e ff., in which Plato rejects the dependence of beauty on eye and ear, since this would rule out the beauty of invisible and inaudible things, like ideas and institutions. Likewise the neo-Platonist tradition denies that beauty, in its primary manifestation, is a sensory quality. For St Augustine the beauty of earthly things belongs to them only by imitation of the divine beauty of God Himself. (*City of God*, II, 51.) This neo-Platonist view is also at the root of Islamic accounts of beauty. In the Sufi philosophy all things emanate from God, and return to him, attracted by love and desire: He is beauty, goodness and truth, which are manifestations of the One who is Being itself. See Doris Behrens-Abousef, *Beauty in Arabic Culture* (Princeton, 1999). On tastes and smells see F. N. Sibley, 'Smells, Tastes and Aesthetics', in John Benson, Betty Redfern and Jeremy Roxbee Cox (eds.), *Approaches to Aesthetics* (Oxford, 2006), and Roger Scruton, 'The Philosophy of Wine', in Barry Smith, ed., *Questions of Taste: The Philosophy of Wine* (Oxford, 2007). Ruskin's account of *theoria* versus *aesthesis* is contained in *Modern Painters*, vol. II, Part III, Sect. I, ch. I, paragraphs 2–10; the relevant excerpts can be found in Eric Warner and Graham Hough, eds., *Strangeness and Beauty: An Anthology of Aesthetic Criticism, 1840–1910*, vol. 1 (Cambridge, 1983).

Disinterested interest. Shaftesbury, *Characteristics*; Kant, *Critique of Judgement*.

Disinterested pleasure. Malcolm Budd, *The Aesthetic Appreciation of Nature* (Oxford, 2002), pp. 46–8 (discussing Kant). Scruton, *Art and Imagination*, ch. 7. On the types of pleasure see Bernard Williams, 'Pleasure and Belief', *Proceedings of the Aristotelian Society*, vol. 33 (1959). The question of pleasure and its cognitive implications (for example, whether there can be 'false pleasures') was first raised by Plato in the *Philebus*.

Objectivity. Hume, 'Of the Standard of Taste'; Kant, *Critique of Judgement*. F. N. Sibley and Michael Tanner, 'Objectivity and Aesthetics', *Proceedings of the Aristotelian Society*, Supplementary Volume 62 (1968).

Chapter 2

Charles Darwin, *The Descent of Man* (1871), chs. 19 and 20. Steven Pinker, *How the Mind Works* (London, 1997), pp. 522–4. Geoffrey Miller, *The Mating Mind: How Sexual Choice Shaped the Evolution of Human Nature* (New York, 2000). Ellen Dissanayake, *Homo Aestheticus: Where Art Comes From and Why* (Seattle, 1992). See also, for a naive statement of aesthetic Darwinism, Nancy Etcoff, *Survival of the Prettiest: The Science of Beauty* (London, 2000).

A point of logic. On the exaggerated claims made for evolutionary psychology see David Stove, *Darwinian Fairy Tales* (New York, 2006).

Beauty and desire. Plato, *The Symposium*.

Erōs and platonic love. Roger Scruton, *Death-Devoted Heart: Sex and the Sacred in Wagner's Tristan and Isolde* (New York, 2004), ch. 5.

Contemplation and desire. Roger Scruton, *Sexual Desire* (London, 1986), chs. 1 and 2.

The individual object. Scruton, *Sexual Desire*, ch. 5.

Beautiful bodies. Some of these thoughts have been taken in other directions by Max Scheler (*Formalism in Ethics*, 1972, Part 6), Maurice Merleau-Ponty (*The Phenomenology of Perception*, 1945, tr. Colin Smith, London, 1962) and Karol Wojtyła (Pope John Paul II) (*The Theology of the Body: Human Love in the Divine Plan*, Washington, 1985). E. T. A. Hoffmann's tale of Olympia the Dancing Doll is available in Hoffmann, *Weird Tales* (London, 1885), and of course in Offenbach's brilliant setting in *Tales of Hoffmann*. The idea that human beauty is responsive to fashion, and is both culture-dependent and without any universal standard is eloquently denied by Arthur Marwick, *It: A History of Human Beauty* (London, 2004). On table manners and their spiritual significance see Leon Kass, *The Hungry Soul: Eating and the Perfection of our Nature* (Chicago, 1999).

Beautiful souls. Hegel, *The Phenomenology of Spirit*, VI. C. c. For a modern attempt to make human virtue, as embodied in the human form, central to the experience of beauty, see David E. Cooper,

'Beautiful People, Beautiful Things', *British Journal of Aesthetics* (2008), pp. 247–60.

Beauty and the sacred. The first epic devoted to Troilus and Cressida was the *Roman de Troie* by Benoît de Sainte-Maure, a priest at the court of Eleanor of Aquitaine when she was wife of the King of France. Two later versions—the *Filostrato* of Boccaccio and the *Troilus and Criseyde* of Chaucer—are among the most refined explorations in literature of the chivalric ideals and their corruption by the real world of human sentiment. See in general, Scruton, *Death-Devoted Heart*, ch. 2.

Childhood and virginity. See the article in the Catholic Encyclopedia on *The Blessed Virgin Mary*.

Beauty and charm. Thomas Mann, *Joseph in Egypt*. Mann was clearly inspired by Racine's portrait of Phèdre, victim of *Vénus tout entière à sa proie attachée*.

Chapter 3

The topic of this chapter was brought into focus by R. W. Hepburn in 'Contemporary Aesthetics and the Neglect of Natural Beauty' (1966), reprinted in his *Wonder and Other Essays* (Edinburgh, 1984). See in general Malcolm Budd, *The Aesthetic Appreciation of Nature* (Oxford, 2005); Allen Carlson, *Aesthetics and the Environment* (London and New York, 2000). Key figures in the Enlightenment emphasis on natural beauty are Francis Hutcheson, Henry Home (Lord Kames) and Joseph Addison, along with Rousseau and Kant. An excellent introduction is Peter Kivy, *Francis Hutcheson and 18th Century Aesthetics* (repr. edn., 2003).

Universality. Kant, *Critique of Judgement*.

Two aspects of nature. On the 'indeterminate form' of landscapes see Santayana, *The Sense of Beauty*, p. 100.

Aesthetics and ideology. The Marxist argument is spelled out by Pierre Bourdieu, *Distinction: A Social Critique of the Judgement of Taste*, tr. Richard Nice (London, 1984); Terry Eagleton, *The Ideology of the Aesthetic* (Oxford, 1990). The concept of ideology derives from Karl Marx and Friedrich Engels, *The German Ideology* (1846).

A rejoinder. A full rejoinder to the Marxist dismissal of the aesthetic is contained in the last chapter of Scruton, *The Aesthetics of Music*.

The universal significance of natural beauty. Kant, *Critique of Judgement*.

Nature and art. On the censoring out of rural poverty see John Barrell, *The Dark Side of the Landscape: The Rural Poor in English Painting, 1730–1840* (Cambridge, 1980). Among those who have argued that to appreciate nature aesthetically one must see it *as* nature the most prominent are Allen Carlson and Malcolm Budd (cited above); others have argued that we can see nature aesthetically only if we bring to it the attitudes and expectations that we derive from the appreciation of art—notably Richard Wollheim, *Art and its Objects* (2nd edn., Cambridge, 1980), and Stephen Davies, *Definitions of Art* (Ithaca, NY, 1991). The articles by Budd are collected in *The Aesthetic Appreciation of Nature*; Carlson's argument is contained in *Aesthetics and the Environment*.

The phenomenology of aesthetic experience. For good instances of the phenomenology of aesthetic experience see Martin Heidegger, *Holzwege*, tr. Julian Young and Kenneth Haynes as *Off The Beaten Track* (Cambridge, 2002), especially the essay 'Why Poets?' (1946). The topic has been treated inconclusively in Mikel Dufrenne, *The Phenomenology of Aesthetic Experience*, tr. E. S. Casey (Evanston Ill., 1973). On intentional understanding see Scruton, *Sexual Desire*, ch. 1.

The sublime and the beautiful. Edmund Burke, *A Philosophical Inquiry into the Origin of our Ideas of the Sublime and Beautiful* (London, 1756); Immanuel Kant, *Observations on the Feeling of the Beautiful and Sublime*, 1764, and also *The Critique of Judgement*. The first known attempt to identify the sublime as a separate aesthetic category is that of the first-century AD writer Longinus, *Peri hypsous* (*On the Sublime*), which, however, deals with literary rather than natural examples. William Smith's translation of 1739 first awakened the enthusiasm in Britain for the sublime as an aesthetic ideal, though Boileau had already given the idea currency in France.

Landscape and design. On the rise of the Picturesque see Joseph Addison, *Essays on the Pleasures of the Imagination*, which appeared in *The Spectator* in 1712, Richard Payne Knight, *An Analytical Inquiry*

171

into the Principles of Taste (1806), and Christopher Ballentyne, *Architecture, Landscape and Liberty: Richard Payne Knight and the Rise of the Picturesque* (London, 2006). Also relevant is E. H. Gombrich, *Norm and Form: Studies in the Art of the Renaissance* (London, 1971), and the classic study by Kenneth Clark, *Landscape into Art* (London, 1949).

Chapter 4

Many of the ideas in this chapter are spelled out in Scruton, *The Classical Vernacular*. See also Yuriko Saito, *Everyday Aesthetics* (Oxford, 2007).

Gardens. On the aesthetics of gardening see David E. Cooper, *A Philosophy of Gardens* (Oxford, 2006).

Handiwork and carpentry. See Wittgenstein, *Lectures and Conversations on Aesthetics, Freud, and Religious Belief*; Trystan Edwards, *Good and Bad Manners in Architecture*.

Beauty and practical reasoning. See Scruton, *The Aesthetics of Architecture*. On the function of bird-song, see Darwin, *The Descent of Man*, pp. 875–81; Geoffrey Miller, 'Evolution of Human Music through Sexual Selection', in Nils L. Wallin, Björn Merker and Steven Brown, eds., *The Origins of Music* (Cambridge Mass., 2000), an essay which says true things about birds and questionable things about people. For some delightful reflections on the musical abilities of birds see Frans de Waal, *The Ape and the Sushi Master: Cultural Reflections by a Primatologist* (Harmondsworth, 2001), ch. 4.

Reason and appearance. Hegel, Introduction to the lectures on *Aesthetics*. Alain de Botton, *The Architecture of Happiness* (Harmondsworth, 2006).

Agreement and meaning. Scruton, *The Aesthetics of Architecture*, last chapter.

Style. James Laver, *Costume and Fashion, A Concise History* (London, 1995). Osbert Lancaster, *Homes Sweet Homes* (London, 1963).

Fashion. See Stephen Bayley, *Taste: The Secret Meaning of Things* (London, 2007); Lars Svendsen, *Fashion: A Philosophy*, tr. John Irons, (London, 2006); and Anne Hollander, *Sex and Suits* (New York, 1994).

Permanence and evanescence. See Saito, *Everyday Aesthetics*, and also Nancy Hume, ed., *Japanese Aesthetics and Culture* (Albany, NY, 1995).

Chapter 5

On art and beauty, see Armstrong, *The Intimate Philosophy of Art*; Budd, *Values of Art*; Richard Wollheim, *Painting as an Art* (London, 1984).

Joking apart. The literature taking off from Duchamp's urinal includes Arthur Danto's *The Transfiguration of the Commonplace: A Philosophy of Art* (Cambridge, Mass., 1981) and *The Abuse of Beauty: Aesthetics and the Concept of Art* (Open Court, 2003), which are among the most lively treatments of the subject, and George Dickie, *Art and the Aesthetic: An Institutional Analysis* (Ithaca, NY, 1974). See also John Carey, *What are the Arts For?* (Oxford, 2006).

Art as a functional kind. On the distinction between natural and functional kinds see H. Putnam, 'The Meaning of "Meaning"', in *Philosophical Papers*, vol. 2: *Mind, Language and Reality* (Cambridge, 1975). The view of art as a functional kind has been vigorously (but in my view unsuccessfully) attacked by Noël Carroll, *Beyond Aesthetics: Philosophical Essays* (Cambridge, 2001).

The description of Mao Ze Dong's sense of humour is contained in Jung Chang and Jon Halliday, *Mao: The Unknown Story* (London, 2006). On laughter generally see F. H. Buckley, *The Morality of Laughter* (Ann Arbor, 2003).

Art and entertainment. Benedetto Croce, *Aesthetic as Science of Expression and General Linguistic* (1902; tr. D. Ainslie, New York, 1922). R. G. Collingwood, *The Principles of Art* (Oxford, 1938), especially chapter on 'amusement art'.

An example. Birgitta Steene, *Ingmar Bergman: A Reference Guide* (Amsterdam, 2005).

Fantasy and reality. The distinction between 'fancy' and imagination goes back to S. T. Coleridge, *Biographia Literaria* (1817), ch. 14, but is more sharply defined in Scruton 'Fantasy, Imagination and the Screen', in *The Aesthetic Understanding*. Adam Smith's *Theory of the Moral Sentiments* appeared in 1759.

Style. R. Wollheim, 'Style Now', in *On Art and the Mind* (London, 1974).

Content and form. Cleanth Brooks, *The Well-Wrought Urn: Studies in the Structure of Poetry* (1974). The letter to Can Grande and the *Convivio* are both contained in Robert S. Haller, ed., *Literary Criticism of Dante Alighieri* (Lincoln, Neb., 1973).

Representation and expression. See Scruton, *Art and Imagination*; Nelson Goodman, *Languages of Art: An Approach to a Theory of Symbols* (Oxford, 1969).

Expression and emotion. See Santayana, *The Sense of Beauty*. Helen Gardner's book is *The Art of T. S. Eliot* (London, 1949).

Musical meaning. E. T. A. Hoffmann's review of Beethoven's Fifth appeared in the *Allgemeine musikalische Zeitung* for 1811, and is reproduced in all collections of Hoffmann's musicological writings.

Musical formalism. E. Hanslick, *On the Beautiful in Music*, tr. G. Payzant (Indianapolis, 1986). For an influential modern discussion see Peter Kivy, *Music Alone: Philosophical Reflections on the Purely Musical Experience* (Ithaca, NY, 1990).

Form and content in architecture. John Ruskin, *Stones of Venice* (1851–53), the guide which constitutes the second part, in which the church is referred to as the 'Salute'. Incidentally Ruskin produced several beautiful water colours of this church, viewed from the bridge over the Grand Canal. Geoffrey Scott, *The Architecture of Humanism: A Study in the History of Taste* (London and New York, 1914).

Meaning and metaphor. See Armstrong, *The Intimate Meaning of Art*; Scruton, *Art and Imagination*; Santayana, *The Sense of Beauty*.

The value of art. Schiller's *Aesthetic Education of Man* explores the connection between art and play, in a way that is illuminatingly discussed in Armstrong, *The Intimate Meaning of Art*, pp. 151–68. The connection is explored for another purpose and in the context of a theory of representation by Kendall L. Walton, *Mimesis as Make-Believe* (Cambridge, Mass., 1990). See also Budd, *Values of Art*.

Art and morality. See T. S. Eliot, *The Use of Poetry and the Use of Criticism* (London, 1933).

Chapter 6

For a wide-ranging sociological treatment see Stephen Bayley, *Taste: The Secret Meaning of Things* (London, 2006). More pertinent philosophically is Malcolm Budd, 'The Intersubjetive Validity of Aesthetic Judgements', *British Journal of Aesthetics* (2007).

The common pursuit. Plato's theory of music and *mimēsis* occurs in *The Republic*, Book VI, and is critically taken up by Aristotle in the *Politics*, Book VIII.

Subjectivity and reasons. The analysis of Brahms's 4th here suggested begins from Arnold Schoenberg, 'Brahms the Progressive', in *Style and Idea*, ed. E. Stein, tr. L. Black (London, 1959). Wittgenstein's Duck/Rabbit example is discussed in Part II s. 11 of *Philosophical Investigations*, tr. G. E. M. Anscombe (Oxford, 1953). The general question of the logical force of aesthetic reasons has been defined for all subsequent discussion by F. N. Sibley, in 'Aesthetic and Non-Aesthetic' and 'Aesthetic Concepts', both reprinted in *Approach to Aesthetics* (see above). Ruskin's judgement of Whistler led to a famous action for libel, from which neither man benefited.

The search for objectivity. On aesthetic universals see Denis Dutton, *The Art Instinct: Beauty, Pleasure and Human Evolution* (New York, 2008).

Objectivity and universality. For the comparison between Shakespearian and Japanese drama see *Shakespeare and the Japanese Stage*, ed. Takashi Sasayama, J. R. Mulryne, and Margaret Shewring (Cambridge, 1998).

Rules and originality. See the essays in Sibley, *Approach to Aesthetics*. Also Kant, *Critique of Judgement*, Part 1, s. 32.

The standard of taste. Hume's essay dates from 1757, and is available in any collection of his essays.

Chapter 7

Individuality. Kenneth Clark, *The Nude, a Study in Ideal Form* (London, 1956).

Heavenly and earthly beauty. See Sir Ernst Gombrich's reflections on Botticelli's Venus, 'Botticelli's Mythologies' in *Symbolic Images* (London, 1972), pp. 31–81.

Erotic art. Anne Hollander, *Seeing Through Clothes* (New York, 1993). On Manet, see Baudelaire's famous essay *Le Peintre de la vie moderne*, in any collection of his prose writings, and T. J. Clark, *The Painting of Modern Life: Paris in the Art of Manet and his Followers* (Princeton, 1985, rev. edn., 1999). See also the illuminating discussion by Nehamas, *Only a Promise of Happiness*, which deals with the Manet *Olympia* as a crux in the pursuit of artistic beauty.

Erōs and desire. Scruton, *Sexual Desire*.

Art and pornography. David Holbrook, *Sex and Dehumanization* (London, 1972). On Pico della Mirandola see Paul Oscar Kristeller, *Eight Philosophers of the Italian Renaissance* (Stanford, Calif., 1964).

Soft pornography. In praise of soft pornography, see Georges Bataille, *L'Érotisme* (Paris, 1952).

The moral question. The feminist complaint is articulated by Catherine MacKinnon in *Pornography and Civil Rights* (New York, 1988).

Chapter 8

Roger Scruton, *Modern Culture* (London, 2005); Anthony O'Hear, *Plato's Children* (London, 2007); Danto, *The Abuse of Beauty*; George

Steiner, *Real Presences: Is there Anything in What we Say?* (London, 1989). See also Wendy Steiner, *Venus in Exile: The Rejection of Beauty in Twentieth-Century Art* (Chicago, 2002).

The modernist apology. Harold Rosenberg, *The Tradition of the New* (New York, 1959). Robert Hughes, *The Shock of the New* (London, 1980). See also André Malraux, *The Voices of Silence* (*Les Voix du silence*) (Paris, 1949)—a celebration of the artist as the revolutionary subverter of bourgeois society. Malraux is stylishly debunked by Wyndham Lewis, in *The Demon of Progress in the Arts* (London, 1954), pp. 76–81.

Tradition and orthodoxy. T. S. Eliot, 'Tradition and the Individual Talent', in *Essays* (London, 1963). Arnold Schoenberg, 'Brahms the Progressive', in *Style and Idea*, ed. L. Stein (New York, 1975). Concerning the 'impulse to consecrate life', see Hans Urs von Balthasar, *The Glory of the Lord: A Theological Aesthetics*, 3 vols. (Edinburgh, 1986; orig. *Herrlichkeit*, 1962–6).

The flight from beauty. Wendy Steiner, *Venus in Exile*; Roger Kimball, *The Rape of the Masters: How Political Correctness Sabotages Art* (San Francisco, 2004).

Sacred and profane. For a striking anthropological-cum-literary theory of the sacred see René Girard, *La Violence et le sacré* (Paris, 1972; *Violence and the Sacred*, Baltimore, 1977). The issue is discussed in Scruton, *Death-Devoted Heart*. Other relevant texts are Mircea Elindo, *The Sacred and the Profane: The Nature of Religion*, tr. William R. Trask (New York, 1961), and Gerardus van der Leeuw, *Sacred and Profane Beauty: The Holy in Art*, tr. David E. Green (Nashville and New York, n.d.).

Idolatry. Some of the deeper issues here are discussed by Lenn E. Goodman, in *God of Abraham* (New York, 1996).

Profanation. Nietzsche, *The Antichrist*.

Anthropological remarks. Some of the ideas in this section are suggested in Nietzsche, *The Genealogy of Morals*.

Beauty and pleasure. Freud's account of sexual pleasure occurs in his 'Three Essays on Sexuality', in Sigmund Freud, *On Sexuality*, tr. and ed. J. Strachey and A. Richards (Harmondsworth, 1977).

Pleasure and addiction. For the psychology of TV addiction, see Mihaly Csikszentmihaly and Robert Kubey, summary of research in *Scientific American* (February 2002). The contrast between aesthetic pleasure and addiction is foreshadowed, in other terms, by John Dewey, *Art as Experience* (New York, 1934).

Sanctity and kitsch. On kitsch see Hermann Broch, 'Einigen Bemerkungen zum Problem des Kitsches' in *Dichten und Erkennen*, ed. Hannah Arendt (Zurich, 1955); Clement Greenberg, 'Avant Garde and Kitsch', *Partisan Review* (1939). The quotation from Wagner is from *Die Religion und die Kunst*, in *Gesammelte Schriften und Dichtungen* (2nd edn., Leipzig, 1888), vol. x, p. 211. The argument in this section has been expressed in other and more screwed-up terms by Theodor Adorno, in his assaults on the 'fetish character' of mass culture. See the essays and extracts in T. W. Adorno, *The Culture Industry*, ed. J. M. Bernstein (London and New York, 2003).

Kitsch and desecration. On the sociology relevant to this section see Christopher Lasch, *The Culture of Narcissism: Cultural Life in an Age of Diminished Expectations* (rev. edn., New York, 1991).

Chapter 9

Leon Battista Alberti, *De re aedificatoria* (Florence, 1485); R. Scruton, 'Alberti and the Art of the Appropriate', in *The Classical Vernacular*; Francis Hutcheson, *An Enquiry into the Original of our Ideas of Beauty and Virtue* (London, 1725); William Hogarth, *The Analysis of Beauty* (London, 1772).

Index of names

A

Addison, Joseph, 50, 170, 171
Adorno, T.W., 178
Alberti, Leonbattista, 101, 162, 178
Alexander, Samuel, 165
Angelico, Fra, 46
Aquinas, St Thomas, 3–4, 19, 54, 95, 165–6, 168
Aristotle, 54, 175
Armstrong, John, 165, 167, 173–5
Augustine, St, 54, 168
Austen, Jane, 5, 112
Avicenna (Ibn Sina), 95

B

Bach, J.S., 8, 112, 120, 122
Ballantyne, Christopher, 172
Balthasar, Hans Urs von, 177
Barber, Samuel, 99, 105, 106f
Barrell, John, 171
Bartók, Béla, 13, 93, 141
Basho, Matsuo, 54
Bataille, Georges, 176
Baudelaire, Charles, xiii, 3, 140–141, 147, 153, 176
Baumgarten, A., 167
Bayley, Stephen, 173, 175
Beaumarchais, P. A. Caron de, 120

Beethoven, Ludwig van, 8, 93, 97, 100–101, 107, 141, 174
Behrens-Abousef, Doris, 168
Bellini, Giovanni, 122, 158
Berg, Alban, 111, 139
Bergman, Ingmar, 86, 87f, 173
Bernini, Gian Lorenzo, 8, 41, 89
Bharata, 54
Bieito, Calixto, 144, 148
Blake, William, 55, 117
Boccaccio, Giovanni, 170
Boethius, 54
Botticelli, Sandro, 13, 35, 127–8, 132, 176
Button, Alain de, 172
Boucher, François, 125, 126f, 130, 134–6
Bouguereau, William-Adolphe, 96
Bourdieu, Pierre, 53, 170
Brahms, Johannes, 83, 100, 114–115, 175, 177
Bramante, Donato, 10
Britten, Benjamin, 91, 145, 161
Broch, Hermann, 178
Brooks, Cleanth, 94, 174
Brown, 'Capability,' 64
Browning, Robert, 103
Brummel, Beau, 78
Buckley, F.H., 173

Budd, Malcolm, 25, 57, 165, 167–8, 170–171, 173, 175
Bunyan, John, 110–111
Burke, Edmund, 61, 122, 171

C

Canova, Antonio, 3
Carlson, Allen, 57–8, 170–171
Carroll, Noël, 173
Celan, Paul, 95
Cervantes, Miguel de, 84
Cézanne, Paul, 55, 85, 146
Chang, Jung, 84, 173
Chaucer, Geoffrey, 35, 44, 170
Chekhov, Anton, 21
Chikamatsu Monzaemon, 120
Chopin, Frédéric, 91
Clare, John, 56, 58
Clark, Kenneth, Lord, 125, 172, 176
Clark, T.J., 176
Claude Lorraine, 64
Coleridge, Samuel Taylor, 90, 162, 174
Collingwood, R.G., 85–6, 95, 173
Confucius, 54
Constable, John, 56–7, 97
Cooper, David, 166, 169, 172
Corot, J-B., 59, 146
Correggio, Antonio Allegri da, 133
Croce, Benedetto, 85–6, 95–7, 100, 105, 173
Csikszentmihaly, Mihaly, 178

D

Dahl, Raold, 153
Dante Alighieri, 33, 35, 94, 132, 148, 174
Danto, Arthur, 140, 173, 176
Darwin, Charles, 31, 169, 172
Davies, Stephen, 171
Dawkins, Richard, 30
de Kooning, Willem, 142, 157
Deleuze, Gilles, 53

Descartes, René, 137
Dewey, John, 178
Dickens, Charles,
Dickie, George, 173
Disney, Walt, 159
Dissanayake, Ellen, 30, 169
Dryden, John, 38, 132
Duccio di Buoninsegna, 85
Duchamp, Marcel, 82–3, 173
Dufrenne, Mikel, 171
Dutton, Denis, 175

E

Eagleton, Terry, 53, 170
Edwards, A. Trystan, 167
Eliade, Mircea, 177
Eliot, T.S., 91, 97, 139, 142–3, 145, 174–5, 177
Engels, Friedrich, 170
Etcoff, Nancy, 169

F

Fauré, Gabriel, 13–4
Fichte, J.G., 77
Finlay, Ian Hamilton, 68
Flaubert, Gustave, 3, 140, 147, 152
Freud, Sigmund, 154, 167, 172, 178
Friedrich, Carl Gaspar, 52, 59

G

Galuppi, Baldassare, 103
Gardner, Helen, 97, 174
Gautier, Théophile, 109
Gezelle, Guido, 55
Gilson, Étienne, 166
Giotto, 85
Girard, René, 177
Goethe, J.W. von, 42, 93
Gombrich, Sir Ernst, 172, 176
Goodman, Lenn, 177
Goodman, Nelson, 174

Beauty

Grass, Gunther, 107
Greenberg, Clement, 157, 159, 178
Greuze, Jean-Baptiste, 157
Grünewald, Matthias, 96
Guardi, Francesco, 146

H

Halliday, Jon, 84, 173
Hanslick, Edouard, 100-101, 174
Harpignies, Henri-Joseph, 59
Haydn, Joseph, 17, 90-91
Hegel, J.W.G., 20, 41, 77, 82, 169, 172
Heidegger, Martin, 171
Hepburn, R.W., 170
Hoffmann, E.T.A., 41, 100, 169, 174
Hogarth, William, 162, 163f, 178
Holbrook, David, 176
Homer, 7, 31
Hopper, Edward, 142, 157
Horwich, Paul, 167
Hughes, Robert, 177
Hume, David, 33, 122-3, 166-8, 176
Hume, Nancy, 173
Hutcheson, Francis, 50, 162, 170, 178
Huxley, Aldous, 155

J

James, Henry, 140
Janáček, Leoš, 7, 142
Jekyll, Gertrude, 68
John of the Cross, St, 43
Johnson, Samuel, 65
Joseph II, Emperor of Austria, 144

K

Kafka, Franz, 43
Kant, Immanuel, 19, 22-4, 26-7, 49-50, 52, 54, 57, 61, 63, 65, 69, 79, 109, 133, 145, 165-8, 170-171, 176
Kass, Leon, 169
Keats, John, 13, 108
Kent, William, 64
Kierkegaard, Søren, 3, 166
Kimball, Roger, 177
Kivy, Peter, 170, 174
Klee, Paul, 91
Knight, Richard Payne, 171-2
Kristeller, O., 167, 176
Kubey, Robert, 178

L

Lancaster, Sir Osbert, 172
Lasch, Christopher, 178
Laver, James, 172
Leonardo da Vinci, 112
Lewis, Wyndham, 177
Lippi, Fra Filippo, 46, 132
Longhena, Baldassare, 8f, 10-11, 101, 103
Longinus, 171
Lucretius, 38
Lukács, György, 53

M

MacKinnon, Catherine, 176
Mahler, Gustav, 106, 109
Malraux, André, 177
Manet, E., 129f, 130, 141-2, 176
Mann, Thomas, 7, 47, 170
Mantegna, Andrea, 96
Mao Ze Dong, 84, 173
Maritain, Jacques, 165
Martini, Simone, 46f, 47
Marwick, A., 169
Marx, Karl, 170
Mary Virgin, St, 45-6, 132, 170
Masaccio, 89
Matisse, Henri, 143
Mendelssohn, Felix, 52
Messiaen, Olivier, 55

Index of names

Michelangelo, 35, 93, 121
Miller, Geoffrey, 31–2, 169, 172
Milton, John, 131–2
Molière (Jean-Baptiste
 Poquelin), 84
Mother Teresa, 42
Mothersill, Mary, 165
Mozart, W.A., 13, 17, 84, 90–91,
 118, 144, 160
Mucha, Alphonse, 112
Murillo, Bartolomé Esteban, 157

N

Nash, Paul, 58
Nehamas, Alexander, 166
Nietzsche, F.W., xiii

O

Offenbach, J., 169
O'Murphy, Louise, 135
Ossian (W. McPherson), 52
Owen, Wilfred, 161

P

Palladio, Andrea, 74, 75
Pater, Walter, 12, 167
Picasso, Pablo, 90, 107
Pindar, 2
Pinker, Steven, 31, 169
Pissaro, Camille, 91
Plato, 2, 12, 20, 33–5, 39, 41,
 47–8, 54, 114, 131–2, 145, 165–6,
 168–9
Plotinus, 2, 3, 12, 162, 165, 166
Pollock, Jackson, 142, 157
Pope, Alexander, 90
Pound, Ezra, 142
Poussin, Nicolas, 59, 64, 146,
 149
Prévost, Abbé, 2
Proust, Marcel, 7
Putnam, Hilary, 173

R

Racine, Jean, 132, 170
Rembrandt, 96, 128–9
Rilke, Rainer Maria, 56, 161
Rosenberg, Harold, 177
Rothko, Mark, 142, 157
Rousseau, Jean-Jacques, 52, 65, 170
Ruskin, John, 19, 101–2, 115, 168,
 174–5

S

Saito, Yuriko, 172–3
Santayana, G., 165, 170, 174
Scheler, Max, 169
Schiller, Friedrich von, 14, 42, 107,
 156, 167, 175
Schlegel, F., 42
Schoenberg, Arnold, 93, 107,
 141–143, 175, 177
Schubert, Franz, 108–9, 111, 142
Scott, Geoffrey, 102–3, 105, 174
Shaftesbury, 3 Earl of, 22, 49, 52,
 165, 168
Shakespeare, William, 10, 83,
 93–6, 131, 143, 175
Sholokhov, M, 110
Sibelius, Jean, 142
Sibley, F.N., 168, 175–6
Smith, Adam, 90, 174
Steele, Danielle, 112
Steene, Birgitta, 173
Steiner, George, 176–7
Steiner, Wendy, 177
Sterne, Lawrence, 84
Stösslová, Kamila, 7
Stove, David, 169
Sullivan, Louis, 18, 167
Svendsen, Lars, 173

T

Tanner, Michael, 168
Tchaikovsky, P.I., 122

Tennyson, Alfred, Lord, 14
Titian, 125–6, 128–130, 132–4, 136
Tolstoy, Leo, 111
Turner, 146, xiv

U

U2, 112
Utrillo, Maurice, 91

V

van der Leeuw, Gerardus, 177
Van Gogh, Vincent, 90–93
Vaughan Williams, Ralph, 58, 143
Velazquez, 85
Verdi, Giuseppe, 143
Vergil, 93
Verlaine, Paul, 122

W

Waal, Frans de, 172

Wagner, Richard, 3, 100, 152, 156,
 169, 178
Walton, Kendall, 175
Warhol, Andy, 83
Wedekind, Frank, 111
Wesendonck, Mathilde, 7
Whistler, James Abbott
 McNeill, 115–117, 175
Wilde, Oscar, 3, 15, 59, 166–7
Williams, Sir Bernard, 168
Wittgenstein, Ludwig, 17, 117,
 167, 172, 175
Wojtyła, Karol, (Pope John
 Paul II), 169
Wollheim, Richard, 171, 173,
 174
Wordsworth, William, 7, 52,
 56–7, 65, 90
Wren, Sir Christopher, 9

Z

Zola, Émile, 139, 146, 147, 152

Index of subjects

A

addiction, 155–56
aesthetic, 19–20
aesthetic judgement, 14, 27, 29, 32, 49, 112–123, 152
aesthetics of everyday life, 67–81
appearance, 73–7
architecture, 10, 15, 18, 64–5, 68–71, 76, 79, 101–3, 113
art, 82–111
art and nature, 56–60

B

beautiful souls, 41–3
beauty, two concepts of, 13–14, 139–140
beaux-arts, 18
belief, 2
birdsong, 59, 72–3
bodies, 39–41, 136–38, 147
bourgeoisie, 53

C

capitalism, 53
carpentry, 69–76
childhood, 45–7

clothes, 113
content and form, 91–5
Counter-Reformation, 103

D

desecration, 144–161
desire, 16–17, 37–9, 47
disinterestedness, 22–6, 47–8, 52, 86, 138

E

embodiment, 40–1, 125, 138, 148
emotion in art, 96–9
ends and means, 14–15, 22–3, 53
enjoyment, 6
Enlightenment, 15, 123, 144
Entäusserung, 77
entertainment, 85
erōs, 33–5, 39, 124–138
evolutionary psychology, 29–33
expression, 95–103

F

fantasy, 88–90, 133, 135, 136, 138
fashion, 78–9, 114

figurative language, 104–6
film, 86–8
fine and useful arts, 15, 17
fittingness, 80–1
friendship, 26
function, 17
functional kinds, 83

G

game theory, 75
gardens, 67–9
good, 2, 3

H

heresy of paraphrase, 94–5
homosexuality, 35

I

ideology, 52–4
idolatry, 149–150
imagination, 88–90
individuality, 16–17, 37–9, 42, 50,
 98, 124–27, 131–32
intentionality, 25–6, 154–55
intrinsic values, 15

J

Japanese aesthetics, 79–80, 120
jealousy, 44, 151
Job, book of, 93
jokes, 83

K

kitsch, 89, 112, 156–161

L

landscapes, 13, 50, 55–6, 58–60,
 63–5, 146
laying a table, 70–1
lust, 41

M

Marxism, 52–3
metaphor, 1, 104–6
minimal, beauty, 7–13
modernism, 141–43
morality, 24, 63, 65, 124, 136
morality and art, 109–111
music, 99–101

N

narrative, 20–1
natural beauty, 49–66
neo-Platonism, 162
nihilism, 160

O

objectivity, 6, 26–7, 118–123
obscenity, 41, 138

P

phenomenology, 59–60, 67, 68
photography, 86, 88
planning laws, 113
platitudes concerning beauty, 4–6,
 24, 33–4, 46–7
play, 107
pleasure, 23–6, 153–56
pornography, 132–35
practical reason, 71–4
pre-Raphaelites, 157
profanation, 151–52
Psalms, book of, 93
purposiveness without purpose,
 65, 66, 70

R

reasons, 71–4, 114–118
redundancy, 75–7
relativism, xiii, 83

religion, 31, 43, 145–151, 158–59
representation, 89, 95–9

S

sacred, the, 43–5, 66, 145, 147–48, 157
sacrifice, 160–61
Sancta Sophia, 18
Selbstbestimmung, 77
sensory pleasure, 19
sexual desire, 33–9, 131–33, 151–52, 154
sexual selection, 31–2, 59, 72
shame, 128–29
sport, 31
Sta Maria della Salute, 8–11, 101
style, 77–9, 90–1
subject, 43–5, 137
sublime, the, 61–3
Sun, The, 135
sympathy, 90

T

taste, xiii, 5–6, 83–4, 112–123
tastes and smells, 21
tea ceremony, 80
therapy, 17
tradition, 142–43
tragedy, 89, 160
transcendentals, 3, 166
truth, 2–4, 108–9, 139
Turner prize, xiv

U

universality, 27, 49–50, 54–6, 119–120
utility, 73–4

V

values, 2–4, 10–13, 15, 106–8, 163
virginity, 45–7

Beauty

Expand your collection of
VERY SHORT INTRODUCTIONS

1. Classics
2. Music
3. Buddhism
4. Literary Theory
5. Hinduism
6. Psychology
7. Islam
8. Politics
9. Theology
10. Archaeology
11. Judaism
12. Sociology
13. The Koran
14. The Bible
15. Social and Cultural Anthropology
16. History
17. Roman Britain
18. The Anglo-Saxon Age
19. Medieval Britain
20. The Tudors
21. Stuart Britain
22. Eighteenth-Century Britain
23. Nineteenth-Century Britain
24. Twentieth-Century Britain
25. Heidegger
26. Ancient Philosophy
27. Socrates
28. Marx
29. Logic
30. Descartes
31. Machiavelli
32. Aristotle
33. Hume
34. Nietzsche
35. Darwin
36. The European Union
37. Gandhi
38. Augustine
39. Intelligence
40. Jung
41. Buddha
42. Paul
43. Continental Philosophy
44. Galileo
45. Freud
46. Wittgenstein
47. Indian Philosophy
48. Rousseau
49. Hegel
50. Kant
51. Cosmology
52. Drugs
53. Russian Literature
54. The French Revolution
55. Philosophy
56. Barthes
57. Animal Rights
58. Kierkegaard
59. Russell

60. Shakespeare
61. Clausewitz
62. Schopenhauer
63. The Russian Revolution
64. Hobbes
65. World Music
66. Mathematics
67. Philosophy of Science
68. Cryptography
69. Quantum Theory
70. Spinoza
71. Choice Theory
72. Architecture
73. Poststructuralism
74. Postmodernism
75. Democracy
76. Empire
77. Fascism
78. Terrorism
79. Plato
80. Ethics
81. Emotion
82. Northern Ireland
83. Art Theory
84. Locke
85. Modern Ireland
86. Globalization
87. The Cold War
88. The History of Astronomy
89. Schizophrenia
90. The Earth
91. Engels
92. British Politics
93. Linguistics
94. The Celts

95. Ideology
96. Prehistory
97. Political Philosophy
98. Postcolonialism
99. Atheism
100. Evolution
101. Molecules
102. Art History
103. Presocratic Philosophy
104. The Elements
105. Dada and Surrealism
106. Egyptian Myth
107. Christian Art
108. Capitalism
109. Particle Physics
110. Free Will
111. Myth
112. Ancient Egypt
113. Hieroglyphs
114. Medical Ethics
115. Kafka
116. Anarchism
117. Ancient Warfare
118. Global Warming
119. Christianity
120. Modern Art
121. Consciousness
122. Foucault
123. The Spanish Civil War
124. The Marquis de Sade
125. Habermas
126. Socialism
127. Dreaming
128. Dinosaurs
129. Renaissance Art

130. Buddhist Ethics
131. Tragedy
132. Sikhism
133. The History of Time
134. Nationalism
135. The World Trade Organization
136. Design
137. The Vikings
138. Fossils
139. Journalism
140. The Crusades
141. Feminism
142. Human Evolution
143. The Dead Sea Scrolls
144. The Brain
145. Global Catastrophes
146. Contemporary Art
147. Philosophy of Law
148. The Renaissance
149. Anglicanism
150. The Roman Empire
151. Photography
152. Psychiatry
153. Existentialism
154. The First World War
155. Fundamentalism
156. Economics
157. International Migration
158. Newton
159. Chaos
160. African History
161. Racism
162. Kabbalah
163. Human Rights
164. International Relations
165. The American Presidency
166. The Great Depression and The New Deal
167. Classical Mythology
168. The New Testament as Literature
169. American Political Parties and Elections
170. Bestsellers
171. Geopolitics
172. Antisemitism
173. Game Theory
174. HIV/AIDS
175. Documentary Film
176. Modern China
177. The Quakers
178. German Literature
179. Nuclear Weapons
180. Law
181. The Old Testament
182. Galaxies
183. Mormonism
184. Religion in America
185. Geography
186. The Meaning of Life
187. Sexuality
188. Nelson Mandela
189. Science and Religion
190. Relativity
191. The History of Medicine
192. Citizenship
193. The History of Life
194. Memory
195. Autism

196. Statistics
197. Scotland
198. Catholicism
199. The United Nations
200. Free Speech
201. The Apocryphal Gospels
202. Modern Japan
203. Lincoln
204. Super conductivity
205. Nothing
206. Biography
207. The Soviet Union
208. Writing and Script
209. Communism
210. Fashion
211. Forensic Science
212. Puritanism
213. The Reformation
214. Thomas Aquinas
215. Deserts
216. The Norman Conquest
217. Biblical Archaeology
218. The Reagan Revolution
219. The Book of Mormon
220. Islamic History
221. Privacy
222. Neoliberalism
223. Progressivism
224. Epidemiology
225. Information
226. The Laws of Thermodynamics
227. Innovation
228. Witchcraft
229. The New Testament
230. French Literature
231. Film Music
232. Druids
233. German Philosophy
234. Advertising
235. Forensic Psychology
236. Modernism
237. Leadership
238. Christian Ethics
239. Tocqueville
240. Landscapes and Geomorphology
241. Spanish Literature
242. Diplomacy
243. North American Indians
244. The U.S. Congress
245. Romanticism
246. Utopianism
247. The Blues
248. Keynes
249. English Literature
250. Agnosticism
251. Aristocracy
252. Martin Luther
253. Michael Faraday
254. Planets
255. Pentecostalism
256. Humanism
257. Folk Music
258. Late Antiquity
259. Genius
260. Numbers
261. Muhammad
262. Beauty

READING GUIDES
Very Short Introductions

Whether you are part of a reading group wanting to discuss non-fiction books or you are eager to further your thinking on a *Very Short Introduction*, these reading guides, written by our expert authors, will provoke discussions and help you to question again, why you think what you think.

PHILOSOPHY
A Very Short Introduction
Edward Craig

This lively and engaging book is the ideal introduction for anyone who has ever been puzzled by what philosophy is or what it is for.

Edward Craig argues that philosophy is not an activity from another planet: learning about it is just a matter of broadening and deepening what most of us do already. He shows that philosophy is no mere intellectual pastime: thinkers such as Plato, Buddhist writers, Descartes, Hobbes, Hume, Hegel, Darwin, Mill and de Beauvoir were responding to real needs and events – much of their work shapes our lives today, and many of their concerns are still ours.

'A vigorous and engaging introduction that speaks to the philosopher in everyone.'

John Cottingham, University of Reading

'addresses many of the central philosophical questions in an engaging and thought-provoking style ... Edward Craig is already famous as the editor of the best long work on philosophy (the Routledge Encyclopedia); now he deserves to become even better known as the author of one of the best short ones.'

Nigel Warburton, The Open University

www.oup.com/vsi